BECOMING

BECOMING

The Photographs of Clementina,
Viscountess Hawarden

CAROL MAVOR

DUKE UNIVERSITY PRESS

DURHAM & LONDON

1999

© 1999 Duke University Press

All rights reserved

Printed in the United States of America on acid-free paper ∞

Typeset in Fournier by B. Williams & Associates

Designed by Amy Ruth Buchanan

Library of Congress Cataloging-in-Publication Data appear

on the last printed page of this book.

For Grandma (again).

Thanks for the call.

Augustine is beautiful.

For I have always wanted to be touched by the dead;
I have wanted them to haunt me; I have even hoped
that they will rise up and inhabit me.

—*Peter Stallybrass*

CONTENTS

ACKNOWLEDGMENTS

Although I must face the fact that I have really grown up now, I can happily say that my early experiences as a graduate student still stir me. Helene Moglen, Page duBois, Hayden White, amd Patricia Patterson took my hand, my eyes, my mind, and more and said "Look." I said "Thanks," and I am still saying "Thanks," and I plan to keep on saying "Thanks" for a very long time.

Della Pollock, Joy Kasson, and Jacquelyn D. Hall read this book long before it was a book and continued reading until it became a book. Their help was smart, critical, and joyful. They have perfected the art of saying the painful things without pain (well, without so much pain). A special star shines over Della. Amy Ruth Buchanan is as brilliant as she is willing, and she is extremely willing. In addition to being the ideal travel companion (on-call photo critic, server of tea, itinerary enthusiast), she has listened to all of the ideas in this book and has consistently provided me with her own solid readings and observations. (She has a star, too.) Jane Blocker told me to take a whole chapter out of this book and I did. Of course I did. Everyone who knows Jane knows what I am talking about. Elin is elin. She makes the world meaningful and beautiful.

I always brag about my editor, Ken Wissoker, shamelessly dragging out the "my" part. I cannot help it. But even beyond his impressive reputation, Ken is truly a spectacular editor. Most people only dream of having an editor so smart, so thoughtful, so responsive, so enthusiastic, so perfectly opinionated. And if that were not enough, he is also a dear friend. Only Ken could be both with such absolute integrity.

Jennifer Bauer, Elizabeth Howie, and Benjamin Harvey did a lot of the tedious work for this book and they probably have no idea how lucky I was to have them at my side. My heart especially goes out to poor Jen-

nifer, who actually said yes when I asked her if I could read the entire book aloud to her. (In case you are worried about further abuse, she is currently safely abroad, busily researching in Scotland.)

Of course, there are many more who helped me. Susan Stewart read an early draft of the book and kept me on track. Richard Howard made the effort to sit way up front when I presented a version of this book's third chapter, "Sapphic Narcissa." To put it mildly, he is an active listener—all of his laughs and oohs and aahs will keep me going for a long time. And he was kind enough to open himself up to my greedy desire to know more about Roland Barthes. He made me overflow with satisfaction. Jennifer Doyle, Eve Kosofsky Sedgwick, Alison Ferris, Corinna Durland, Martin Durrant, Melanie Pipes, Rachel Frew, James Kincaid, John Williams, Laura André, Peggy Quinn, Lindsay Fulenwider, Jerry Blow, Mark Haworth-Booth, Mary Kelly, David Hart, Mary Sheriff, Patricia Failing, Betty and George Woodman, and Ursula Slavick have given much to me (and by much, I mean everything from the toughest intellectual questions to the perfect chocolate chip cookie—and by the way, Laura, you give both). Jenni Holder is possibly one of the most patient and sensitive people I have ever encountered.

Thanks go to the University of North Carolina's Institute for Arts and Humanities for granting me valuable research time while writing this book. Generous funds for obtaining pictures and the rights to reproduce them were provided through University Research Council Grants as well as a Scholarly Publications and Artistic Exhibitions and Performances Grant.

Thanks to my mother and father. Their unfaltering belief in me, which began when I was so small, so long ago, has turned out to be the most precious gift.

Thanks to Oliver for his love, his Peter Pan wit, his cleverness and red hair. Thanks to Ambrose for his love, laughing all the time, drawing birds, and being wise. Thanks to Augustine for his little pats on the back and winning ways and for traveling so well while still inside while I was gathering what is inside this book.

Again, my love to Kevin. Again, all kinds of it. May it always be so.

DISCLAIMER

Sally Mann does not endorse the interpretations that I have ascribed to her photographs in *Becoming*. In particular, she is adamantly opposed to my use of the term "erotic." However, in the interest of critical and artistic freedom, she has been gracious enough to allow me to reproduce her photographs in this book. I admire and appreciate Sally Mann not only for her photography, but also for her strong convictions and generosity.

"ONLY, MY SECRET'S MINE,

AND I WON'T TELL"

It is the mother who guarantees the privacy of the home
by maintaining its respectability, as essential a defense against
incursion or curiosity as the encompassing walls
of the home itself.

—Laura Mulvey, "Melodrama Inside and Outside the Home"[1]

Clementina, Viscountess Hawarden (1822–1865), one of the pioneering women of British photography, took sensual photographs of her daughters in the isolation of her London home.[2] By whisking away all of the furniture and the Victorian bric-a-brac one is accustomed to seeing in the upper-class homes of the period, Hawarden transformed the first floor of her South Kensington residence into a photographic studio: a private space for taking pictures of her daughters in theatrical poses. *She disappears underneath the photographer's black cloth, which is one with her own dark dress, as if a layer of her voluminous skirt has been pulled up and over her head. Her delicate hands, white and stained with photographic chemicals, protrude as they adjust the knobs that control the accordionlike bellows of her wooden camera. The mother tilts and focuses the image of her daughters that appears upside down on the screen at the back of her large camera box, a cabinet of sorts. The process takes several long minutes.*[3]

Even the mise-en-scène of Hawarden's photographic production emphasizes privacy: she saw her daughters' beautiful faces, but her face remained hidden. Not surprisingly, Hawarden never ventured into self-portraiture. There is only one photograph that is believed to be *possibly*

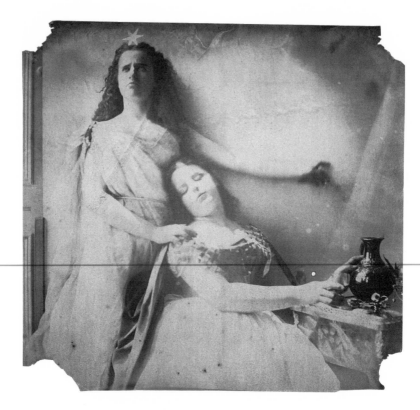

Figure 1 *Clementina with a star on her head;*
Florence sits next to the "curvaceous vase."

a self-portrait, an image that is just as likely to be a portrait of her look-
alike sister, Anne Bontine.

Despite the brevity of Hawarden's photographic years, 1857–1864,
she managed to produce over eight hundred photographs (while giving
birth to the last three of her eight children).[4] Hawarden's oeuvre focuses
almost entirely on her lovely adolescent daughters (Isabella Grace,
Clementina, Florence Elizabeth), her collection of pretty objects (an
Indian traveling cabinet, a cheval glass, a Gothic-style desk, a small
wooden chair with a padded floral-patterned seat, a shell-covered box, a
silver goblet, a tambourine, a concertina, a curvaceous vase), and closets
of fancy dress (the breeches and tights of a page, the elaborate dress and
headdress of Mary, Queen of Scots, the black lace of a Spanish dancer,
the skirt and broom of Cinderella, a riding habit, the Orientalized dress

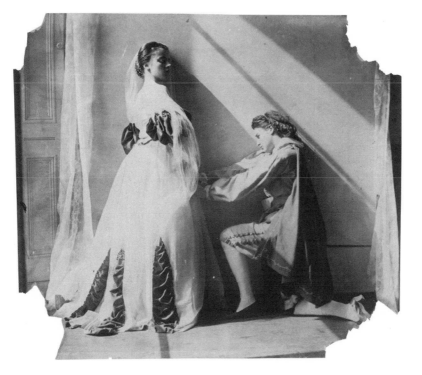

Figure 2 *Florence as Mary, Queen of Scots,*
and Clementina as her kneeling page.

of a concubine; see figs. 1 and 2). Like many Victorian mothers of her
class, Hawarden collected photographs of her growing girls and either
she or another family member or servant or friend pasted them into al-
bums. But unlike the standard images found in Victorian family albums,
these photographs overflow with folds of sexuality and an invitation to
touch: a daughter pulling up her dress and underskirts to reveal an ankle
criss-crossed with ribbons; a daughter in her corset and petticoat before
a mirror; two daughters in pounds of petticoats and silk, one nestling her
head on the breast of the other; a sister dramatically, yet subtly, pulling
on a tender lock of her sister's hair (plate 1).

Even the edges of the photographs give way to touching. After being
torn from the family albums (for reasons still unclear), they were do-
nated to London's Victoria and Albert Museum by Hawarden's grand-
daughter, another Clementina (Clementina Tottenham), who had inher-

ited 775 photographs from her mother. The pictures arrived in 1939. No longer in the heart of the home (the family album), but in the Museum's humidity-controlled, acid-free environment, their scarred borders, their ripped and cut edges, remain poignant signs, permanent scars, of their short but dramatic flight from Hawarden's home (5 Princes Gardens, South Kensington) to one of England's premiere cultural institutions (right around the corner). Their palpable edges, always overlooked (even misleadingly "repaired" in the only published book of Hawarden's pictures), mark a transformation from the often dismissed maternal collection to the official paternal space of the museum.[5] Hawarden's pictures raise significant issues of gender, motherhood, and sexuality as they relate to photography's inherent attachments to loss, duplication and reduplication, illusion, fetish. Hawarden's photographs demand analysis from psychoanalytic, feminist, and cultural-historical points of view. Yet, little has been published on Hawarden and only a limited number of her images have been reproduced.

Hawarden, like the other "great" Victorian woman (and also amateur) photographer Julia Margaret Cameron (1815–1879), never overtly compromised her maternal image as the devoted mother. Whereas Cameron did not begin photography until her children were grown (when she was forty-eight), Hawarden began taking pictures during her twilight years of childbirth (at age thirty-seven). Hawarden avoided the potential conflict between her roles as mother and artist by remaining focused on her children. (As Susan Sontag has written in regard to our current Kodak culture, "Not to take pictures of one's children, particularly when they are small, is a sign of parental indifference."[6]) Hawarden exhibited her work only twice, in 1863 and in 1864, both times as an amateur at the Photographic Society of London. In short, Hawarden was appreciated for her photographic work but never well-known. She may have intended more for her photography, but her premature death in 1865 at age forty-two, along with the difficulties faced by any artist of her gender, cut short any such possibilities.

Hawarden and her work will always remain young, a brief moment marked by death, absence of information, mature life, images of self, di-

aries. Lewis Carroll, a man who left an excess of information (letters, diaries, books, photographs) *and* secrets all his own records meeting Hawarden only once (diary entry for 24 June 1864).[7] Yet, Carroll would see Hawarden from a distance a short month later (diary entry for 22 July 1864). Writing of this missed meeting, Carroll unknowingly, yet poignantly, foreshadows the evanescence that now characterizes Hawarden: "went to call on Lord Hawarden to get the prints I bought—& was just in time to see Lady Hawarden get into her carriage and drive off."[8] Taking many secrets with her—such as how her oeuvre would or would not develop, what she would or would not photograph after her children were grown and gone from home, the significance of her focus on women and the relationships between them—Hawarden would die just six months after Carroll's fleeting glance of her being carried off by her carriage. Leaving so much (how many other families have been so excessively documented?) and so little behind, Hawarden and her work perpetuate a state of "just missed."

Nowhere is Hawarden more fixed as "just missed" than in the magical, yet mournful, photograph that makes a spectacle out of her leggy "humanoid" camera reflected in the mirror (fig. 3).[9] As Virginia Dodier has observed, "except for the faint suggestion of a disembodied hand in the act of removing and replacing the lens cap, there is no sign of Lady Hawarden in the mirror."[10] Hawarden's daughter Clementina, sensual for the pose of her right hand that reaches up to her head like an odalisque, girlish for her severely parted hair and plain dress, presents the image of her mother missed by the mirror yet captured as camera–tripod–fleeting hand (fig. 4). Left with only this ghostly image of Hawarden, I long for the body lost to the camera, lost in the mirror. In turn, I fetishize her camera—caught by her nearly lost, almost impossible to see disembodied hand.

Hawarden's photograph hails Nadar's famous photograph (taken with his brother Adrien Tournachon), *Pierrot the Photographer* (1854–55; fig. 5). At the center of both photographs is a picture of a camera looking/reflecting back at the photographer himself/herself. In the image by Nadar, the mime (who is by definition a mimic, silent like a photo-

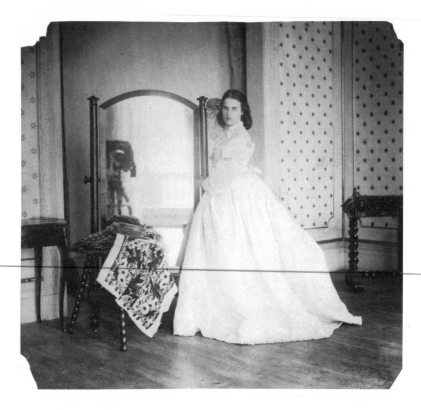

Figure 3 *"Her leggy 'humanoid' camera reflected in the mirror."*

graph) is dressed in Pierrot's characteristic white costume, which here brilliantly reflects shadows, like a mirror (like Hawarden's cheval glass), like a photograph, like light-sensitive paper giving way to image.[11] In Hawarden's photograph, "Clementina" can be understood as both mother and daughter, just as in Nadar's photograph "the magician" can be understood as both Nadar and Pierrot.[12] (Both the photographer and the mime are tricksters of illusion.) In these pictures, both Hawarden and Nadar are complex absent and present doubles of their respective humanoid cameras: they are linked to their cameras as if the shutter cord were umbilicus.[13]

Hawarden's body, umbilically linked to her daughters as the photograph is to its referent, is emphatically maternal and homosocial in its reduplication. To begin with, what is most apparent in the few written documents that have survived is Hawarden's success as a mother, an

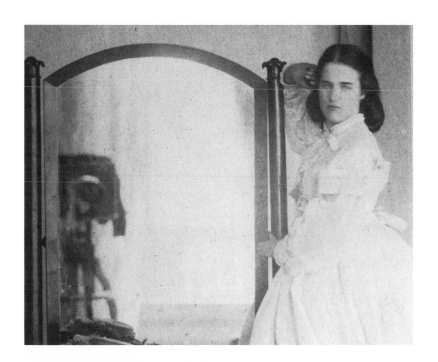

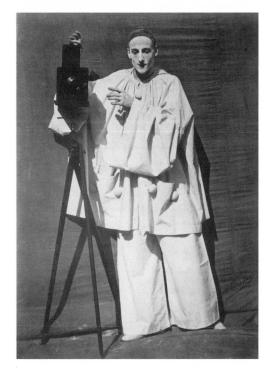

Figure 4 *"The body lost to the camera, lost in the mirror."*

Figure 5 *Nadar and Adrien Tournachon.* Pierrot the Photographer, *1854–55.*

image of maternal goodness and excessive giving that seemingly never faltered. For example, her sister exclaimed that she was "a great baby lover."[14] Likewise, her uncle Mountstuart Elphinstone wrote that he "never saw nicer children or better brought up. It seems strange in Clemy who could never keep her own shawl in order & whose devotion to her children seemed enough to spoil a whole generation, but her good sense and regard to duty has kept all right."[15] Furthermore, the pictures themselves strongly suggest that photography was an activity to be shared with her daughters. In one photograph, a daughter appears to be wearing a darkroom apron; others (through the gestures and expressions of the daughters) suggest a playful reciprocity between photographer and model. One might say that Hawarden documented a female world of love between mother and daughter and between daughters as sisters. But how are we to understand this love? What are we to do with the same-sex tenderness, longing, cross-dressing, caressing, sexuality, flirtation, longing, voyeurism, and unveiling depicted?

Specifically, why is eroticism, let alone the homoeroticism, of Hawarden's pictures emphatically overlooked in the writings on Hawarden? Why does eroticism remain a secret (in the limited essays, books, and museum catalogues on Hawarden) when it is so visible? *Becoming: The Photographs of Clementina, Viscountess Hawarden* responds to this question, chipping away at those "cultural guardians" that have maintained the invisibility (the interiority) of Hawarden's pictured erotics: her class, her gender, her image as a productive mother, the isolation of her studio and her photographs, our conception of Victorianism as it marks historical difference and distance.

It is as if Hawarden's pictures, despite their erotic visibility, have remained in the closet of her suprainteriorized world. And, given the fact that she must have used a converted closet as a darkroom, Hawarden's closet is doubly resonant: it is the secret chamber, both metaphorically and architecturally, where her pictures were developed. Inside this closet, Hawarden imagined and developed her interiorized secret: pictures of same-sex erotic desire, an inner secret that may have been a secret to herself as well. Yet, the point is not to "uncloset" Hawarden, for Hawarden was not a homosexual woman. Hawarden's closet is simply, as

Eve Kosofsky Sedgwick might argue, "the closet of imagining *a* homosexual secret."[16]

*

I tell my secret? No indeed, not I:
Perhaps some day, who knows?
But not today; it froze, and blows, and snows,
And you're too curious: fie!
You want to hear it? well:
Only, my secret's mine, and I won't tell.

— Christina Rossetti, "Winter: My Secret," 1862[17]

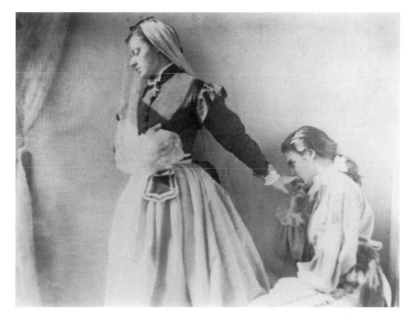

Figure 7 *"Clementina tasting Isabella's perfect fingers."*

... at just the right degree of openness, the right density of abandon-
ment," the *jouissance*, the punctum, the bliss, the pleasure, the part-word,
the fragment, the rhythm, the absence, the edge, the tongue, the sen-
tence, the nudge, the voice, the close reading, the intimate reading that
touches.[2] I project a Hawarden photograph onto the wall (Clementina,
Isabella, and Florence become almost lifesize, but not, as if they were
inhabitants of Marie Antoinette's three-quarter-scale village, "The
Queen's Hamlet," hidden in the gardens of Versailles). Bathed in the
light of the image, which at times becomes part of me (as when I point to
Clementina's captivating finger in chin, a foreshadowing of the delight-
ful erotocomic queer ballet fingers of Mark Morris, her toes made avail-
able by a shoe kicked off, or to Clementina tasting Isabella's perfect
fingers, Isabella's sheer veil cascading down her shoulder and wrapping
around her other hand to both obscure and emphasize touch), I guide my
students outside the frame (figs. 6 and 7). I take their hand and we go. Yet
we remain within. Together with and through them (the photographs
and the students) and now, I hope, through and with you, I / we desire to
be outside of its frame, yet of the picture.

The erotic photograph, on the contrary (and this is its very condition), does not make the sexual organs into a central object; it may very well not show them at all; it takes the spectator outside its frame, and it is there that I animate this photograph and it animates me.[3]

In the classroom, we let Barthes take our "hand . . . at just the right degree of openness, the right density of abandonment." We animate the image and we become animated: fired, stirred, kindled, cheered, heartened, quickened, vivified, brightened, buoyed. We do not touch the photographs. We do not touch each other. *It is as if I* (we) *had words instead of fingers, or fingers at the tip of my* (our) *words.*

That is *just* it. The erotic, as Barthes feels it and others who know the *jouissance* (the delicious ambiguity of a slowly rushing orgasmic pleasure and an ungenital pleasure at once) of reading, of looking, of teaching, yes and "of being." Coming. Becoming. As Richard Howard put it in his introduction to the English translation of Barthes's *Pleasure of the Text*: "The Bible . . . calls it 'knowing' while the Stuarts called it 'dying,' the Victorians called it 'spending'; and we call it 'coming'; a hard look at the horizon of our literary culture suggests that it will not be long before we come to a new word for orgasm proper—we shall call it 'being.'"[4]

My erotic finger-words pinch at the prudery of ideological analysis, the Protestantism of objective looking, the pride of the sexual organs in limiting our imagination of the erotic body. And sometimes, when outside of the frame, but of a Hawarden picture, a piece of something comes (a word, a tear, resentment, boredom, delight) and pinches back. For me, that is being/erotic.

*

I seek what will touch me (as children we hunted in the
countryside for chocolate eggs that had been hidden there)
. . . I await the fragment that will concern me
and establish meaning for me.

—Roland Barthes, *Sollers écrivain*[5]

A QUEER NOTE

"Everything is queer today,"said Alice.
—Lewis Carroll, *Alice's Adventures in Wonderland*[1]

Even though Alice is only seven years old in Wonderland, her blossoming, shooting, falling, swelling, leaking, shrinking body, a body that cannot decide whether it wants to be tiny or big—rather it wants to be tiny *and* big—is a body anticipating adolescence. "I'm quite tired of being such a tiny little thing!" (57). "That's quite enough—I hope I shan't grow anymore" (57). Just as she dreamed it, Alice's adolescence did come, at least in *real* life, as it did to Alice Liddell, the real little girl of Wonderland fame (whether or not she or her scholar–lover-of-only-girls–friend, whacked-out Lewis Carroll, the Oxford professor, Mr. Do-do-do-do-Dodgson, wanted her to). Like all of us privileged with growing up, she grew into *it* and in spite of *it*, some years after getting back out of the White Rabbit's hole and crossing through Looking-Glass's narcissism. But what is *it*?

> "Found *it*," the Mouse replied rather crossly: "of course you know what 'it' means."
> "I know what 'it' means well enough . . . " said the Duck: "it's generally a frog or a worm"(47).

The meaning of *it*, adolescence, is as wavery as the body that *it* inhabits, ranging from nonnormative behavior to plain just not being cute anymore, as in being fourteen years old, becoming a young lady; as in buying your first tampons. (Before I started my period, or as scholars, especially Victorianists say, "my menarche," my school anticipated the blessed event by handing over to me, in a plain white envelope, as if it

were pornography, a really scary pink booklet with a cameo *Lady* on the cover, entitled *You Are a Young Lady Now*. After reading *it* from cover to cover—and finding out about *it*, of which I can honestly say that, at that time, I had never even heard of *it*, periods at least, at least not the bleeding kind, and that pornography would have been less shocking than *it*—I could honestly boast, "Thank God I am not yet *it*, at least not yet a *Lady*.")

Now, I am beyond *it*, yet I find that I still fall for *it*. "Down, down, down. Would the fall *never* come to an end?"(27). I fall, as an adolescent, someone who is grown, but not. (But not what?) I fall for "some other world magically different from the world of family and school."[2] I once fell for Carroll. (Joseph Litvak, who is informing my theory of adolescent falling, fell for Proust.) Now—no longer beckoned down by a White Rabbit's twitching whiskers, ticking watch, waistcoat with pocket, fan, and tiny white kid gloves (Hélène Cixous's "penis on paws"[3])—I fall for Hawarden. She is my new magical person. She beckons me with daughters, especially Clementina, and crinoline.

Just as "reading Proust can induce a fantasy of *being* Proust,"[4] gazing into Hawarden's picture-world can induce a fantasy of *being* Clementina. At the center of this delight, this secret treasure, is the thrill of becoming Clementina not once, but twice: as mother and daughter, looker and object of the look, adolescent and woman, model and photographer, Clementina and Clementina. As Alice remarks over and over in Wonderland, it is all a bit queer:

> "They were indeed a queer-looking party."(45)
> "She was getting so well used to queer things happening."(90)
> "How queer it seems."(56)
> "I should think you'll feel a little queer."(68)
> "It was a queer-shaped little creature."(86)
> "See that queer little toss of her head."(162)

Yet, this second little note is trying to work against the Alice/Carroll epithet with which it began: "Everything is queer today." A queer approach should not, although it often does, happen too easily.

Hawarden is *particularly* queer. Not only through the same-sex eroticism of her pictures and the ways in which the eroticism of her pictures

has been closeted, but also through photography's inherently reduplicative process of sameness.[5] And just as this last ribbon, or perhaps less elegantly, this third handful of tangled hair, of *Becoming*'s p-p-p-prefatory braid is a step into queer representation, adolescence is queer.

Nonnormative, peculiar, sugared in shame, as in drinking Coke and eating pancakes with lots of maple syrup for breakfast, as in giving stupid presents to the object of your first affection (your first fall), as in ruptures and awkward hair and ruptures of awkward hair, as in clothes that can be described as nothing else but "adolescent" (in my case / history, purple knit hot pants, real Christian Dior sheer violet hose over not-yet-shaven legs, matching striped sweater of various bumbleberry colors and putrid pink featuring the ever popular faux "layered look" to give the appearance of wearing a short-sleeved sweater over a long-sleeved one, impossible mocha-brown suede wedgies with ankle strap buckles — all worn as awkwardly as possible by a body that had no idea of how to present such an ungainly, unwieldy, uncomfortable, unskillful spectacle, while anxiously awaiting or suffering from a period): adolescence is more often closeted than performed with reverie.[6] Thereby, for me and anyone less pampered (psychologically, materially) than the Hawarden girls (that certainly would be almost everyone), Hawarden's queerness is not available as lived experience, but rather as the fantasy of, the desire for, adolescence as incommensurable beauty.[7]

Hawarden's obsessional photographs of adolescence not only prompt fantasy, they evoke a practice of adolescent reading. This book's introductory chapter, "Adolescent Reverie," takes on Julia Kristeva's desire to read as an adolescent does: wavery, androgynous, fresh, irreverent. But queer theorists, like Sedgwick and Litvak, have also turned to that awkward age as a model for theorizing queer reading practices. For example, Sedgwick's brilliant introduction to her edited volume *Novel Gazing: Queer Reading in Fiction* (which, appropriately enough, at least in my mind, features a Hawarden photograph of Clementina and Isabella on its cover), discusses how the far-ranging essays included (i.e., the writings are on queer texts and authors as well as nonqueer ones) become specifically queer, attain their "*queer* specificity," not only from being informed by "gay / lesbian studies and queer theory movements in literary criticism" but by actively refusing a "predetermined idea about what

makes the queerness of a queer reading."[8] Determined like an adolescent, they are determined yet not predetermined; they read differently: "Often these readings begin from or move toward sites of same-sex, interpersonal eroticism—but not necessarily so. It seems to me that an often quiet, but very palpable presiding image here—a kind of *genius loci* for queer reading—is the interpretive absorption of the child or adolescent whose sense of personal queerness may or may not (*yet?*) have resolved into a sexual specificity of proscribed object choice, aim, site or identification."[9]

Likewise, Litvak points out, with grave disappointment, that we choose to evade the awkwardness of adolescence in favor of finding, rediscovering, reading our fantasy of and for the child: "But if the structural intermediacy of adolescence accounts for its reputation as that awkward age, what is the content of this awkwardness? In our eagerness to reclaim the child, inner or otherwise, do we seek to evade (or with greater cunning, indirectly to reach) her even more embarrassing, and even more exciting older sibling?"[10]

The parameters of the child, unlike those of the adolescent, as James Kincaid has made clear, are solidly false, as solid as they are false.[11] The fantasy of the child, pure tabula rasa, is ripe and ready for our own predetermined inscriptions: pink, blue, pants, skirt, dress-up, play, sailor cap, wide-brimmed hat, short socks, knee socks, naughty or nice. After years of such "abuse," the child becomes adolescent and chooses his or her own clothes (his or her own sartorial ego) and is thereby prone to (according to adult standards) falling into any number of quite unsuccessful looks, patterns, styles.[12] Our desire for the child is the lure of the "blank page." But it is the adolescent (and all that he or she has to offer) who is left out when desire is so stunted and stilted. The loss is both theirs and ours.

Only in Carroll's photographs can little Alices remain child-perfect. Different from in the photographs, Alice as story, as *histoire*, is gorged in words that cannot impede her growth spurts. Approaching monstrous adolescence, as when her neck grows and leaves the rest of her body behind, she grows unevenly at best. Spurned by the fears and anxieties familiar to adolescence, part girl and part more, Alice sheds buckets of

tears of shame. "'You ought to be ashamed of yourself,' said Alice, 'a great girl like you,' (she might well say this), 'to go on crying in this way! Stop this moment, I tell you!' But she went on all the same, shedding gallons of tears, until there was a large pool all around her"(36). (As Barthes has written, "Who endures contradictions without shame?"[13]) Disproportionate, she is no longer just girl.

Alice's new adolescent appetite, ranging from the voracious to the delicate, is signaled with the turn of nearly every page: from being accused of eating eggs by the Pigeon, to her disappointment in finding the orange marmalade jar empty, to quickly finishing off a drink that tastes "a sort of mixed flavour of cherry-tart, custard, pineapple, roast turkey, toffy and hot buttered toast"(31), to passing out comfits (hard sweetmeats) as prizes, to eating a cake with currants that spell out EAT ME, to eating cakes out of pebbles, to swallowing bits of mushroom, to imagining whether cats eat bats or bats eat cats, to talking about cats who eat mice and dogs who eat rats, to a mouse nearly drowning. Alice's eclectic tastes emphasize her impurity, her indignity, what the Pigeon can see as nothing short of cannibalism. Awkward growth, outrageous appetites, she is becoming teenager, becoming monster. The Pigeon to Alice: "You're looking for eggs, I know *that* well enough; and what does it matter to me whether you're a little girl or a serpent"(76). She is *looking* like an adolescent.

Like Alice, like Barthes, I too am looking for eggs: good- and bad-object eggs, chocolate and golden eggs, eggs to find me adolescent, to seek me my reader.

*

> *Ce lecteur, il faut que je le cherche (que je le "drague"),*
> sans savoir où il est. *Un espace de la*
> *jouissance est alors créé.*
>
> *I must seek out this reader (must "cruise" him) without*
> knowing where he is. *A site of bliss is then created.*
>
> —Roland Barthes, *Le Plaisir du texte*
> *(The Pleasure of the Text)*[14]

ADOLESCENT REVERIE

I find that there are still ecstasies and loves in me, and
that these feelings are rooted in my adolescence.
—Helene Deutsch, *Confrontations with*
Myself: An Epilogue [1]

The reader [is] . . . a speechless child who simply wants
to be an adolescent!
—Julia Kristeva, "The Adolescent Novel"[2]

Virginia Woolf once commented that childhood was lodged inside Lewis Carroll, like a hard jelly; as his very essence, it laconically drove his very being: his photographs, his social life, his desires, his writing.[3] Later, T. J. Clark performs Carroll as child-at-core again when he writes, "What above all is impaled and immortalized in the Alice books is the madness involved in having the 'child' do so much representational work—having her be your whole way of looking at, and making nonsense of, the adult world. This is a lot to ask of a photograph, I know. But Dodgson [Carroll] was capable of it."[4]

Alice often represents Carroll's fearful knowledge that all little girls not only have the potential to grow up, but do. For example, in his original illustrations for the *Alice* manuscript (*Alice's Adventures Underground*), Carroll draws Alice as embodying the onset of puberty's frightening growth (fig. 8). As she fills up the entire rabbit house as womb, ready to burst out into an adult world, we find that not only was the rabbit late—"Dear, dear! I shall be too late!"[5]—but it was also too late for

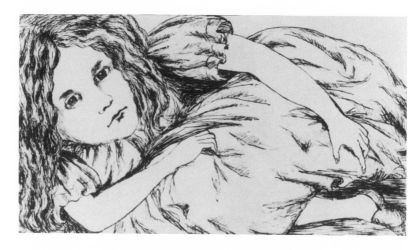

Figure 8 *Lewis Carroll,* Alice's Adventures Underground, *ca. 1864.*

Alice: "Alas! it was too late: she went on growing and growing, and very soon had to kneel down: in another minute there was not room even for this, and she tried the effect of lying down, with one elbow against the door, and the other arm curled round her head . . . 'I'm grown up now' said she in a sorrowful tone, 'at least there's no room to grow up any more *here.*'"[6]

Lewis Carroll would probably never have photographed the young woman on the brink of adolescence that caught the eye of Sally Mann: her eyes "sybiline, foreboding," her arm, almost violently, clutched by a father hidden in the shadows of the peeling playhouse that she is growing out of (fig. 9).[7] This girl is not child: she is twelve. In contrast to Alice, Mann's growing girl has stepped outside. Though she clings to the open door of her playhouse, her eyes and her bent and prettily posed leg take her outward. She did not get her arm stuck in the window or her leg caught up a chimney; she got out before she got too big to ever get out (fig. 10).

Mann, most famous for her photographs of her own children collected in her popular and controversial book, *Immediate Family* (1992), first came to notoriety with the publication of her earlier book, *At Twelve* (1988). *At Twelve* features a range of photographs of twelve-year-old

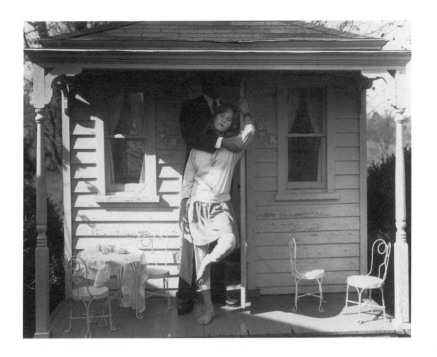

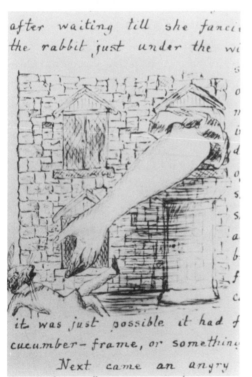

girl-women who were living in Mann's hometown of Lexington, Virginia, girls who were not Mann's own children: some poor, some middle-class, one with a baby of her own, another on the boy's softball team, a few with a pretty-princess confidence that turns my stomach, one an actual Pre-teen Miss Rockbridge. At least half of them look bored. One made paper flowers to stick in her mud-laden, bare-branched, full-of-car-bodies yard on Easter Sunday. Some have hope. Most are colored by doom. All are confronting the troubling sexuality of being twelve. Below the girl with her aging childhood house (complete with a small table, four chairs, and tiny real china teacups, teapot, sugar bowl, and creamer), Mann tells us: "Lewis Carroll wrote that a girl of twelve is one on whom no shadow of sin has fallen, but one who has been touched by the 'outermost fringe of the shadow of sorrow.'"[8] The focus of this introduction is the shadow of adolescence, its dark ambiguity, especially its sexuality (which Carroll veiled as sinful fringe), as it operates in the photographic work of two women: Clementina Hawarden and Sally Mann, two mothers who took sensual, often erotic photographs of their own children some 120 years apart.

Though it is unusual enough to be a serious photographer who is also a mother, who uses her children not only as primary subjects but as erotic subjects, my comparison is even more significant than that: Both Hawarden and Mann make us dream an uncomfortable past. Hawarden unsettles our cultural imagination of the past by revealing the maternal bourgeois Victorian woman's homosocial world as, in fact, homoerotic. Mann troubles the past by using her images as wavery quotes of Carroll or Julia Margaret Cameron — as when she turns a picture like *Double Star* into a startling *Kiss Goodnight* (figs. 11 and 12). Both photographers make us question our own familial pasts by eroticizing the child and his or her relationship to the mother, the family, the culture. Their pictures set us to dreaming, and not all dreams are comfortable.

But most significant is this: Hawarden and Mann not only use adolescents for photographic subjects, their approach is also effectively adolescent. Their work is indebted to the open structure of adolescence, which emphasizes the multiple and often discomforting contradictions between

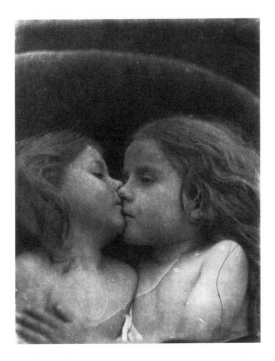

Figure 11 *Julia Margaret Cameron, Double Star, 1864.*

Figure 12 *Sally Mann,* Kiss Goodnight, *1988.*

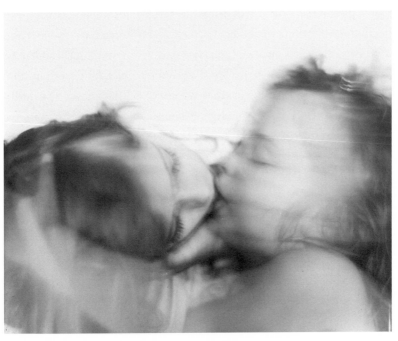

adulthood and childhood, masculinity and femininity, responsibility and play, sexuality and innocence.

Within the respective prudery and brazenness of their times, Hawarden and Mann each represent their daughters in a variety of poses and costumes that suggest familial eroticism. Both mothers, for example, show their girls in underwear (figs. 13 and 14)—revealing pretty ankles—blossoming with the sensual appeal of pounds of petticoats (figs. 15 and 16). Yet unlike Mann, whose pictures often hold the pouts and grumpiness of sibling rivalry and encroaching adolescence (fig. 17), Hawarden's photographs feature daughters in performances of same-sex closeness: one daughter seemingly pouring out tears in the lap of her sister (fig. 18); a sister (dramatically, yet subtly) pulling on a tender lock of her sister's hair.

Going through boxes of Hawarden's photographs at the Victoria and Albert, I am struck by the obsessional attention that Clementina Hawarden gave to her adolescent daughters. I am envious of the attention that the girls received from their mother, the sensual interaction between them, their sense of style. Beneath the surface of the photographs, beneath the whispering of petticoats, linen, water-marked silk, suppressed giggles, coiled hair (plate 2), weary sighs, is the unfamiliar sound (at least in my personal experience) of a mother's voice filled with passion for the adolescent, and very sexual, beauty of her daughters. She speaks softly in paper, glass, collodion, and emulsion: "I adore you. You are beautiful. I want to capture you in my pictures, to hold you forever." Hers are pictures taken in the intimacy of one room, pictures seen mostly by her daughters themselves or family members, within the home, within the boxes and albums collected for preserving them. They are not, as is the case with Mann's photographs, spectacle for the outside world. And unlike Mann, whose son, Emmett, is there as much as her two daughters (fig. 19), Hawarden did not focus much of her photographic attention on her only son, Cornwallis (fig. 20)—as if even the image of masculinity would undo the privacy of her pictures. Doubly interiorized within the confined space of the first-floor studio and the pages of the family albums, Hawarden's photographs represent seclusion, even exclusion.

I wonder how it felt to be the adolescent Clementina kneeling in the sunlit corner of the drawing room, by the window, by the starred wallpaper, in double fluffy frothy meringue skirts, hair brushed out in all its glory, surprisingly down (loose) for a Victorian girl of her age, who should be pinning her hair up (fig. 21). Kissed all over by the sun and the gaze of her mother, Clementina is fifteen and full of splendor. Empty space and bright light all around her, she appears free and waiting, even hopeful of what lies ahead. While she basks in the warm pleasures of the moment, her view out the window suggests the open possibilities of a young life not yet determined. Staring at Clementina staring out the window, I become (perhaps) inordinately focused on the tasseled pull (near the top left of the photograph). The tassel, attached to a window shade or curtain that cannot be seen, holds the potential of shutting off not only Clementina's view but also our own. (If the tassel were pulled, the light would no longer be sufficient for picture taking.) Yet, the silky fist-sized tassel begs to be held (fondled even) and pulled, so as to darken the lightness of this moment (not just the lovely sunlight streaming in through the windows, but the virginal whiteness of Clementina's cupcake skirts, her prayerful attitude, her hair so clean, her face so radiant). On the edge between worlds (inside and outside, dark and light), like an adolescent who has no choice but to play at being an adult and a child, the tassel is flirtatious. Clementina, aware of her mother's gaze, of the gazes that would befall her once the picture was developed, pretends to look out the window and offers us her crinoline as deliciously as she can. She must have felt flirtatious.

Clementina, did you feel flirtatious when you stood up in a corner of the drawing room at another window just like the other one, with your hair bunned at each side, playing at modesty? (plate 3). Lips frozen still by the "flat Death"[9] of photography and her actual death in 1901, Clementina's lips will never part to answer me. But her off-the-shoulder blouse, indulgent in the dangers of revealing an implicitly present but unseen breast, murmurs yes: it flirts. Her blouse copies the conceit of the tassel (which is pictured in even tighter focus than in the previous photograph). Both the blouse and the tassel want to be pulled; they both pull at me.

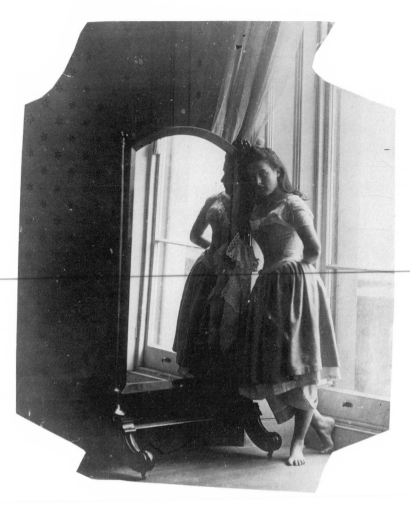

Figure 13 *Clementina in cream-colored "underwear" before the mirror.*

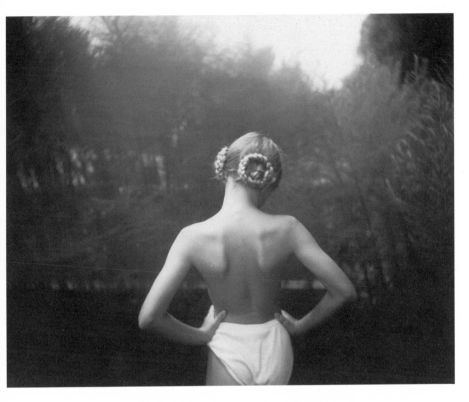

Figure 14 *Sally Mann*, Vinland, *1992*.

Figure 15 *"The sensual appeal of pounds of petticoats."*

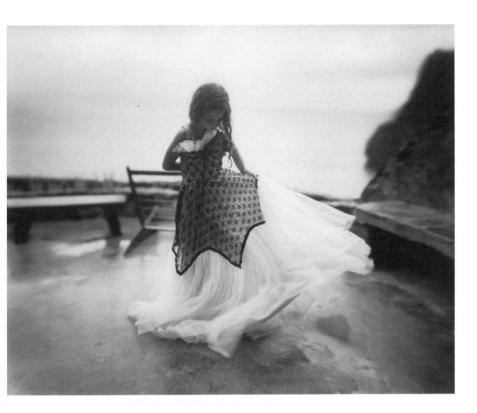

Figure 16 *Sally Mann*, Virginia at 9, *1994*.

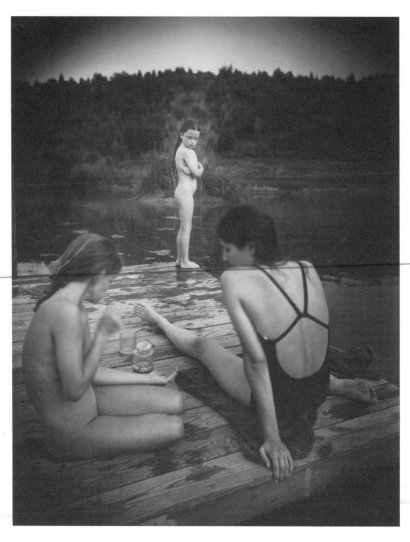

Figure 17 *Sally Mann,* The Big Girls, *1992.*

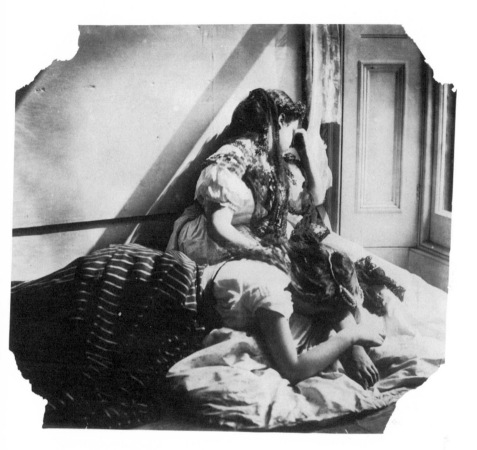

Figure 18 *"One daughter seemingly pouring
out tears in the lap of her sister."*

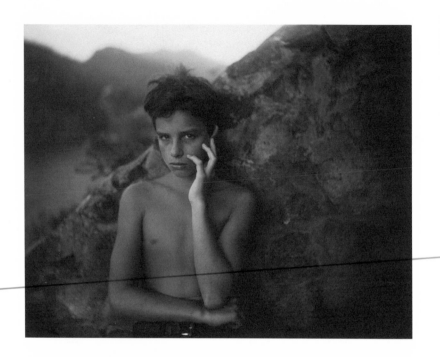

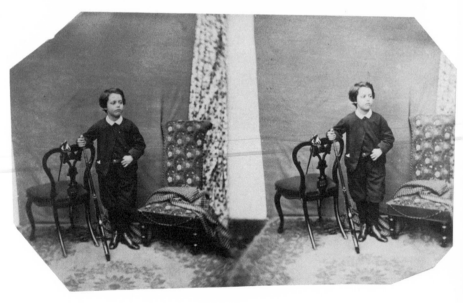

Figure 19 *Sally Mann*, Rupture, *1994*.

Figure 20 *Cornwallis, an "image of masculinity."*

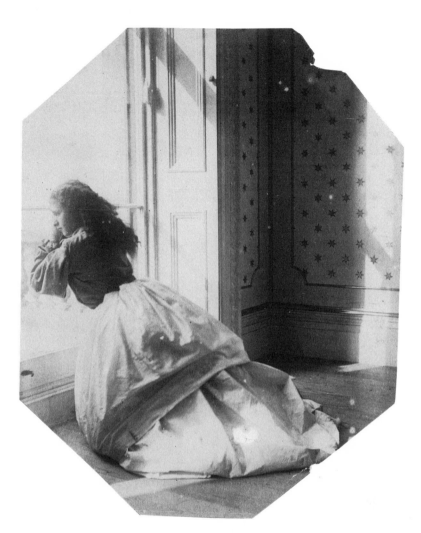

Figure 21 *"Clementina kneeling in the sunlit corner
of the parlor . . . [her] hair brushed out."*

All historical research, whether the objects of study are from a long time ago or yesterday, feeds on a desire to know, to come closer to the person, object, under study. Though we go to great pains to cover up our desire, to make our voice objective, to see that our findings are grounded, to dismiss our own bodies, we flirt (some of us more overtly, others more secretly) with the past. Flirting, as a game of suspension without the finale of seduction, keeps our subjects alive — ripe for further inquiry, probing further research. The more we flirt, the more we fantasize about our subject, the more elusive and desirable it becomes.

Hawarden amplifies my desire to flirt with subjects of representation, especially those from the past. Flirting is at the heart of Hawarden's photographs and my method: not only because Hawarden's primary subjects were her adolescent daughters and because flirting (usually) begins with and is associated with adolescence, but also because the most successful flirtatious acts, like Hawarden's most successful photographs, are surprising and subtle acts of eroticism.

Filtered and flirted through the lens of my own adolescence, my desire is not just for her pictures or her closeness to her beautiful daughters, it is for a mother who could have, who would have, indulged in my adolescent beauty: a beauty as unbecoming as it was becoming.

Hawarden's photographs are in love with adolescence. They have what Julia Kristeva finds in Helene Deutsch's surprising autobiography, *Confrontations with Myself: An Epilogue*: "the freshness of an adolescent reverie."[10] Looking at Clementina and Isabella in their beautiful dresses or in pants (fig. 22) or in underwear or in Cinderella costume (fig. 23), as they gently tug at one another's clothes (fig. 24) or pull on the other's lock of hair or sniff a sister's essence or use a chair as a substitute lover/sister or stare defiantly into the camera as only an adolescent can (Isabella's Medusa gaze turns air into glass and stops us in our tracks; fig. 25) — there is reverie. Reverie: dream, vision, illusion, fancy, figment, fantasy. These are the nouns that pose on this mother's (photographic) plates, which serve no food; rather, they make a feast for the eyes.

There is something so fresh about their reverie. For, despite the near monotony of the pictures themselves, the girls present themselves differently: in each one there is an open structure to the variety of (contradic-

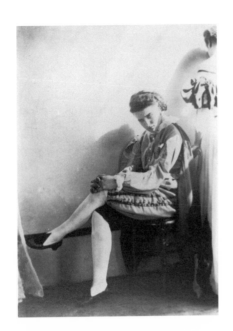

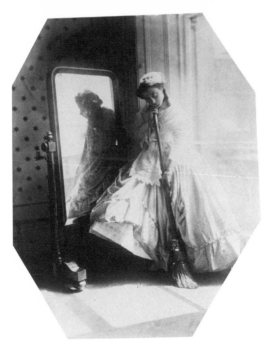

Figure 22 *Clementina "in pants."*

Figure 23 *Isabella "in Cinderella costume."*

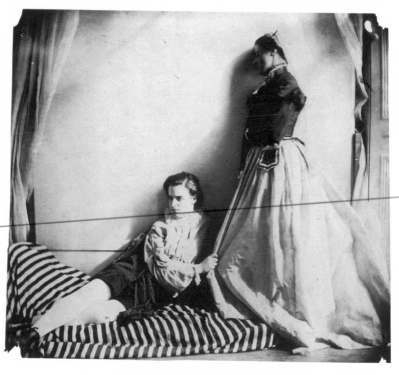

Figure 24 *"They gently tug at one another's clothes."*

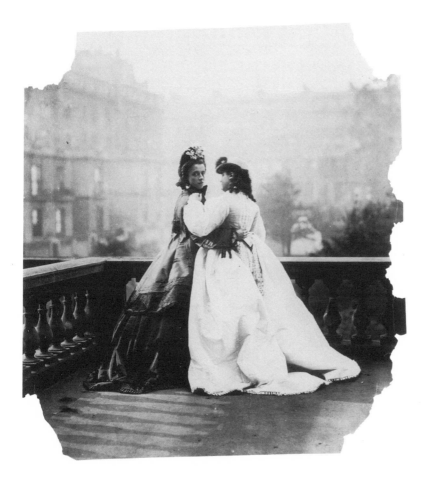

Figure 25 *"Isabella's Medusa gaze turns air
into glass and stops us in our tracks."*

tory) expressions that they give and their mother takes. For example, sometimes, and this even includes those pictures in which the girls are in the most outrageous poses and costumes (fig. 26), they manage to look surprisingly serious. At other times, their lips and eyes cannot hide their smirks, their near giggles (fig. 27); and in still other pictures, their expressions look not unlike family photographs of myself, forced by a mother to dress for some long-forgotten occasion. (Together I and the Hawarden girls face the camera: silently defiant and readably bored.)

Though adolescence keeps childhood at hand, it is important to emphasize that the adolescent is not a child. As I argued in *Pleasures Taken*, the child of the Victorian period, as well as today, was artificially constructed as natural. The Victorians claimed that the child was sexless, thereby creating the child as extrasexually taboo, so much so that the child became sexually enhanced and omnipresent (from John Everett Millais's paintings to soap advertisements in the *London Illustrated News*;

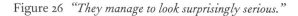

Figure 26 *"They manage to look surprisingly serious."*

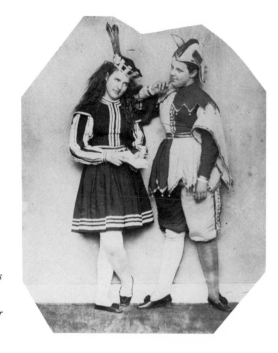

Figure 27 *"Their lips
and eyes cannot hide
their smirks, their near
giggles."*

fig. 28). Both the imagery and the literature of the period emptied the
image of the child to create something that was supposedly innocent,
without sexuality, and in need of protection. The result was the tiny,
beautiful androgyne (overflowing with saccharine erotics), perfect for
Pears' Soap advertisements and feeding Victorian moral-conscious con-
sumption. Sex *supposedly* without sex. But however false the construc-
tion of the child was (and still is), its parameters feel clear when com-
pared to those of the adolescent. Though we might not know what
childhood *really* is, our cultural imagination has produced a fantasy of
the child that is pure, innocent, recognizable. Adolescence lacks such
distinction; instead, it is smudged by sexuality, changing bodies and
body fluids.

I remember my own adolescence as time fractured between being un-
interested at school, making out with my boyfriend (with somewhat
greater interest), shopping, and passing long hours in my own room. I
spent a lot of time in that room, mostly talking on the telephone and pos-
ing in front of the mirror in clothes that might carry me through the next
school day. (Is adolescence ever more than posing?) I even had my own

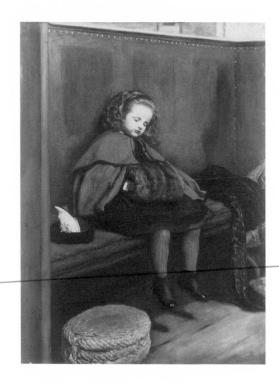

Figure 28
John Everett Millais,
My Second Sermon,
1864.

bathroom—the ideal bathroom—that could be entered without ever leaving my room. There, in the bathroom within my room, I could try on frosty lipsticks in silver tubes, strange-colored lip glosses in seafoam-green pots, various shades of pink or lavender or blue or gray or brown eye shadows in deep purple cases, black mascara, violet mascara, brown mascara. It was the 1970s. I was a middle-class *only* child; nearly all of my material desires were met.

Yet, despite my considerable economic freedom, I always made the wrong choices. Though I tried, I knew I had no real style. My bedroom gave testimony to my lack. My white canopy bed, white dresser, and desk with matching chair, in that 1960s and '70s period style of "girl furniture" advertised as French Provincial, was just there, as it was in millions of other girl bedrooms across the country. I had picked it out when I was eight years old. Rather than trying to change it, I lived with it. My white shag rug was perversely extra long. My telephone (like my Schwinn 10-speed bike) was clunky and bright yellow. Everything else

was a dreary pink; especially reprehensible were the heavy pink linen curtains that darkened my room and my spirit. Middle-classdom weighed on me, made me feel bad, but I willingly gave in to it all.

My style, which really was not a style at all, was not *Sassy*; it was *Seventeen*. It was dumb. And I knew it. While style is not everything, it is something when your entire adolescent world is based on consumption. (I had no other real interests. I did not read. I did not make things. I hardly listened to music.) Looking back, I am tempted to attribute my lack of style to the period. After all, there was no MTV; there was no *Sassy* magazine; girls still took vacuous home economics classes; I had never been to a thrift store; the adolescent middle-class white boys I knew were all the same; girl bands and indy rock were not yet rolling; there was no *My So-Called Life* on television, no Claire Danes to fall in love with, not even a Wynona Ryder. But the fact is that I did not have the courage to be stylish. Yet there were a few who did. There were the girls with the wild never-combed sexy bleached matted hair, multiply pierced ears, ankle bracelets, and short-cropped fuzzy sweaters. They were the original "surfer chicks," who cut school to make the long, winding drive through the Santa Cruz mountains to hit the beach and surf in the cold, cold waves of Steamers Lane. Given that this was the 1970s, they really were pioneers. And there was that beautiful senior girl, a blousy loner, who wore her silky blonde hair up in a bun. She had cool rayon dresses from the 1940s and a beaded sweater. Drawn to her from a distance, I could not understand her. Yet to this day, nameless, she sticks in my mind, sensually, poignantly, sitting on a bench, still eating lunch. There may have been others, certainly a boy or two, but they are not in my memory.

My adolescence, characterized by both an excess of time and a time of great loss, saddens me. For me, as is the case for most, adolescence felt much more like an end than a bridge. I envy those who can claim their adolescence as a time of wild abandon, experimentation, great contemplation, resistance, anger, frantic journal writing, poetry writing, name-changing—a time when they discovered painting or Indian food or dance or photography or downtown or Paris. Though they may be lying in part or whole, my adolescence does not even prompt such stories. My

adolescence must have been something, but it feels like it was nothing. No songs, just a flat hum.

My sense of my own adolescence feeds my desire for Hawarden's pictures (and Mann's too). These images speak to my desire, although not to my actual experience. I fantasize having the adolescence that is pictured by Hawarden: a site of excess beauty, play, confidence, eroticism shared by mother and daughters, between sisters. Part of my fantasy rests on the seamless production of Hawarden's photographs, coupled with a lack of historical information and family documents. As is the case in most family albums (which delete images of familial tension and unhappiness), it is difficult, if not impossible, to find in Hawarden's pictures the jealousy, competition, uneasiness, rage, coldness, frustration, envy, scheming, secrecy, pain that is routine, if painfully so, to mother and daughter and between sister and sister. (I have no sisters, not even a brother, to prick me with the reality of sibling life.)

Yet despite her weakness for prettying up maternal, filial, and sisterly relationships, Hawarden's focus on the unfocused quality of Victorian adolescence subverts the familial. Just as Deutsch claimed "herself as an eternal adolescent," Hawarden pictures herself, through her daughters, as perpetual adolescent (most blatantly through her own namesake and favored model, Clementina). Deutsch, like Hawarden, is skilled in making use of the hard jelly of adolescence that resides within her. Deutsch, even in her ninetieth year of life, writes of herself as a perpetual adolescent: "I feel that my Sturm and Drang period, which continued long into my years of maturity, is still alive within me and refuses to come to an end. I feel that there are still ecstasies and loves in me, and these feelings are rooted in my adolescence."[11]

For Kristeva, it is this secret adolescence that resided within Deutsch that makes her writings so powerful. According to Kristeva, adolescence is the desired space of the writer (artist):

> Betrayal by and of the page, bisexuality and cross-dressing, filiations, fledgling seducers: These certainly do not exhaust the adolescent images and conflicts that articulate the great moments of novel-writing. To these characteristics could be added

the sort of Bildungsroman that recounts the close connection between adolescents and the novel (Tristram Shandy, Julien Sorel, Bel Ami). Nevertheless, these themes provide a general indication of the degree to which the polyphony of the novel, its ambivalence, and its postoedipal (albeit perverse) flexibility are indebted to the open adolescent structure.[12]

It is important to distinguish Kristeva's celebrated notion of the novelist/artist as adolescent from the cliché of the artist as eternal child. To do so, it is helpful to recall some famous examples of the modern/artist/child, all the while keeping in mind that modernism, especially modernist art (its beginnings assured in the mid–nineteenth century through Manet, the Impressionists that followed, the invention of photography, the fetishization of material culture), grew hand in hand with the invention of a new understanding of childhood: as free, unsullied, playful, utopically in touch with the world.[13] One such example of the conflation of modernism, the artist, and the child can be found in Baudelaire's *The Painter of Modern Life* (written between 1859 and 1860 and published in 1863). For Baudelaire, the skill of an artist turned on his ability to find "childhood recovered at will."[14] For "the child sees everything as a *novelty*; he is always *intoxicated*."[15] In *The Painter of Modern Life*, Baudelaire specifically celebrates the artist Constantin Guys, whom he sees as a "man-child, as a man who is never without the genius of childhood."[16] Likewise, Freud believed that to find childhood is to make art. And D. W. Winnicott saw the early years of playing with transitional objects as the first step toward a cultural life that included the making of art: the artist's creation of objects is an extension and refinement of childhood play.[17]

But while we have reverence for the man-child artist, even when he is a father (whether he is Pablo Picasso or Julian Schnabel), we do not like mothers to become children. This is one reason we become so uncomfortable when a mother makes art, for in doing so, the mother becomes also child. For example, when an artist like Mann (as mother/artist/child) uses her children as subject matter, her motherhood is targeted for criticism, often taking precedence over her art. Ever since the appear-

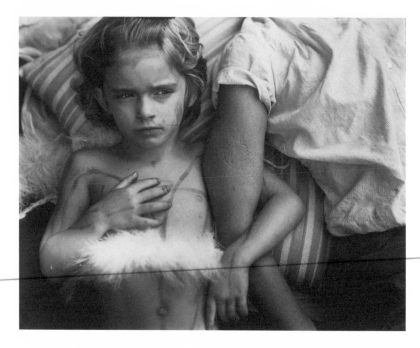

Figure 29 *Sally Mann*, Jessie Bites, *1985*.

ance of *Immediate Family* and its touring show in 1992, Mann has been the art world's mother-scapegoat for defining the bad mother who has uninnocentized her children. We are uncomfortable with her scratching, wetting, charming Virginia who plays in the dirt, gets hangnails, holds weasels, wears eye makeup, collects morels, isn't afraid to get near tobacco spit, and sleeps as if dead with the ancient, wrinkled, arthritic Virginia who raised her mother.[18] We do not want to see that Jessie bites her mother (fig. 29). We are sickened when Emmett holds two skinned squirrels. Mann's children (like all children) are not perfect paper dolls. Yet she has been vigorously attacked in everything from the *Wall Street Journal* to the *Times Literary Supplement* and even in my hometown's *Independent* for not showing what children *really* are (innocent). As a result, Mann has, more often than not, been pinned by the media as an irresponsible mother. Julian Bell's *TLS* review of *Immediate Family* goes so far as to condemn Mann's "nursery garden"[19] with strong inferences of maternal pedophilia and sadism:

Mann doesn't exactly exploit; rather, she works up a hothouse fetor of familial self-importance in which everything is flaunted so long as it is possessed of vitality. The results just happen to make wonderful material for paedophilia. If they record anything, it is not "grand themes" but the look of children who have been too much looked at. Jessie pouts and preens as if it were her destiny; Ginnie is learning to do the same; Emmett, the eldest, scowls and well he might, Mummy is still behind her box ... I don't doubt that Sally Mann's children are doing better than most, but since she offers them thus for my inspection, I'll say that seems a rotten way to bring them up.[20]

We do not like mothers to become artists/children. And here I mean something close to the idea of the "real child": unpredictable, narcissistic, intoxicated with life, the enfant terrible as well as the tender, loving, and lovable child. When an artist uses her children as subject matter, her motherhood is all too readily there and is thereby perverted by the childlike narcissism that we associate with the creative act. The result is a "cussed, wavery, unfinished quality ... [that is] too tricky [for many of us] to handle."[21] To be both mother (full-fledged adult) and child is to be the adolescent.

Mann, as artist, as mother of her subjects, is like a child playing with toys and friends. Like the child who replays a torturous memory on a playmate or teddy bear, as when the child plays at being the doctor or bad mommy, Mann replays her memories on her own children. The resulting pictures are confrontational and, at times, violent. Freud writes in *Beyond the Pleasure Principle*:

> It is clear that in their play children repeat everything that has made a great impression on them in real life and that in doing so they ... make themselves master of the situation. But on the other hand it is obvious that all their play is influenced by a wish that dominates them the whole time — the wish to be grown-up and to be able to do what grown-up people do. It can also be observed that the unpleasurable nature of an experience does not

always unsuit it for play. If the doctor looks down a child's throat or carries out some small operation on him, we may be quite sure that these frightening experiences will be the subject of the next game; but we must not in that connection overlook the fact that there is a yield of pleasure from another source. As the child passes over from the passivity of the experience to the activity of the game, he hands on the disagreeable experience to one of his playmates and in this way revenges himself on a substitute.[22]

Likewise, there is a sense of violence when the girl crosses over that certain threshold into adolescent life. This violence can be attributed to not only the onset of menstruation and other seemingly abrupt changes that take place upon the body, but also to the break from the mother, the second cutting of the umbilicus, which frees growing girls into an inward retreat: into their rooms, into their minds, into and away from their bodies. *Becoming*, the adolescent girl is other than child.

Mann's *The Big Girls* is a picture of becoming adolescence (see fig. 17). Tender, innocent-looking Virginia shivers and holds her otter-body in a moment of physical and emotional coldness. Her big sister, Jessie, is with another older girl, a young woman; they share drinks in cool glasses and a closed intimate conversation. The bodies of the two big girls speak their differences. Jessie's unclothed, lean, smooth body tenderly utters her age: her thighs are held tightly together in anticipation of puberty; her upper arms are in touch with an androgynous torso that still knows no breasts; her right arm is a perfect fitting for the adolescent L of her own sitting body. In contrast, the body of Jessie's older friend conveys knowingness: she sports a strong swimmer's back and a black crisscross suit whose straps repeat the V lines of her own legs splayed unselfconsciously out at Virginia. Despite the open legs, the two take no notice of Virginia, whose child eyes stare at Jessie's cautious entrance into the secret garden of thorny adolescence. Virginia feels excluded. But so do we, as we stand in the same place as the mother's camera. As Jessie enters adolescence her urge for self-expression cuts at her own tender body, which turns away from Mann. Mann's tender eyes picture the scene with

calculated coldness. Virginia looks at the big girls; Mann, who has been both child and adolescent and is mother, looks at her little girl looking at the big girls. The success of Mann's pictures is her ability to be the woman-child: the adolescent.

In a diptych entitled *Jessie at 12* (1994), Mann and daughter Jessie play out the (violent, becoming) retreat into adolescence. Picture 1: eyes closed, right hand in a gesture of deep thought, long blond hair as site of sexuality and girlishness; our eyes are filled with the awe of her slender beauty and a general unease in viewing a body that I would have thought would have already retreated its nakedness from the eyes of the mother, from public view (plate 4). Picture 2: with the click of the shutter, the wink of an eye, Jessie's hair is cut off (plate 5). What loss, what violence, what beauty. Staged in exactly the same pose, perhaps only an hour or so later, Jessie is totally transformed. Boyish, girlish, androgynous, independent, aggressive, she no longer speaks blondness: she speaks the language of short dark hairs. She *becomes* her mother's adolescent reverie.

Hawarden, unlike Mann, has escaped the readings of the bad mother, so much so that many viewers passionately deny the sexuality of her photographs. Yet, both artists share qualities that aggressively challenge our traditional concepts of the good mother: a presentation of their children as sexual; a father that "is absent most of the time—and not even missed";[23] and a mom who is almost completely absent in their pictures ("we look for the photographer in the eyes of her children, but she remains elusive"[24]). Yet Mann is always thickly coated in perversion, pornography, and rottenness, and Hawarden remains the untainted angel-mom. Virginia Dodier, an expert on Hawarden, rarely if ever addresses the sexuality of the images. Why is eroticism, let alone the homoeroticism, of all those beautiful girls subtly yet dramatically touching each other, passionately gazing into each other's eyes or even into the eyes of their own twinned reflection never more than tangentially considered in the writings on Hawarden?

Typically, eroticism is conveniently erased by the Art of Hawarden's pictures. For example, when considering yet another of the photographs of Clementina dressed in her Victorian undergarments before a mirror (plate 6), Dodier writes: "Visitors to the Photographic Society exhibi-

tions were probably aware that the girls in Lady Hawarden's photographs were her daughters. But could . . . [this] photograph . . . which shows Clementina in a state of undress, have been exhibited? Perhaps. The issue of decency would have been mitigated by the photograph as an art object."[25] I agree with Dodier that if such a photograph was shown, it would have been deemed decent, but not so much because it was elevated to the status of art (Dante Gabriel Rossetti showed plenty of painted women as art that were labeled indecent by Victorian art critics), but because it was made by a bourgeois mother of important social standing. Like Julia Margaret Cameron, Hawarden as mother remained as artificially pure as childhood itself.[26] And even today, when such categories as motherhood and childhood have been effectively problematized, viewers like Dodier seek to keep Hawarden benign, as empty as childhood itself.

At the heart of this desire to see innocence (or banality or just plain art) where there is sexuality is something even bigger: a need to construct history as empty (innocent), like a child. As representative of the Victorian past, Hawarden must remain empty, so that we can fill her (the past) and her photographs of her children with something safe. In a beautiful, if disturbing, lecture entitled "Dreaming the Past," James Kincaid argues that "all history is kiddie lit. That is, we construct an emptiness, a child, and set it to dreaming." In other words, we glorify the past, just as we glorify the child. Kincaid elaborates:

> The past is not so much malleable as it is vacant, fillable with whatever we have to have—and in that way it is like a child (the way we have learned to think of the child) and like desire. The past—our literary and historic pasts included . . . is an emptiness we fill in. Here's how it goes: we construct a history we can interrogate in order to avoid any questions being asked of us. In order for that to happen, the past has to tell a story so compelling and so in accord with our desire that it seems to be a story told by no one and coming from nowhere—that way, the past can function to naturalize the present, make it seem not a story at all, not even a fact—but something we take so for

granted it disappears. What we imagine we know becomes truth, where we are becomes everywhere, what we desire is granted, our constructions become nature. In order for the past to do all of this for us, it has to be told in such a way, we have to write our history in such a way as to keep us from being aware of us. The past must be told as a complex game, absorbing enough to make us forget permanently that such a game, such a construction of air and dream and wish-fulfillment and guilt and denial and aching eroticism is the only prop we have for our present.[27]

Kincaid's claim that historians make the past vacant, fillable, in order to fill it with their own desire suggests not only the emptiness of a constructed childhood, but also a blank site that never talks back, that never takes you back by flirting back.

Later in the same text, Kincaid calls on his own mother to reiterate his point: "Mother always said to make things difficult if you can; otherwise life is remarkably flat. The most difficult thing I know is to dream an uncomfortable past — our dreams are so resolutely comfy." Though many try to make Hawarden "comfy," I take pleasure in seeing Hawarden's pictures as anything but flat. Though they are beautiful and prettied up, I am arguing that Hawarden's photographs "dream an uncomfortable past." Her history, her pictures should not be written or read as "childhood," but as (uneasy) adolescence.

Likewise, through sheer recognition of the violence this kind of dream commands on categories of Art, Motherhood, Middle-Class Life, Mann also pictures an uneasy adolescence. It is there in her pictures from *At Twelve,* in the images of her children before they reach adolescence, in her photographs of children as adolescents, insisting that our histories (academic and personal, from the first photographs to the most recent, from childhood to yesterday) dream the uncomfortable pasts that they are.

Like wet collodion on a glass plate, life is fragile. Adolescence seems especially fragile; as a turn toward sexuality, as a step into death, as a fall into the unknown, as seepage beyond the frame, it contains all the

fragility of a glass plate coated in guncotton dissolved in ether trying to develop into a photograph.[28]

In the light of day, Sally Mann photographed her daughter Jessie wearing already-bloomed night-blooming Cereus blooms over her breasts: a mermaid in wilted sea shells (fig. 30). *Still* a young girl, how could Jessie have blossomed already? Like the title of Mann's traveling exhibition and its corresponding catalogue (both of which feature the photograph *Night-blooming Cereus*), adolescence is *Still Time*: still time for childishness; still time for adolescence itself; still time to take pictures; still time for sexuality; still time for adulthood.[29] Still, the night-blooming Cereus blooms only at night and only once—like the strained click of a camera shutter at night.[30] Still time. Still time for loss.

When Clementina is caught by her mother as if ready, but not quite ready, to close the magnificent window frame that leads out to the balcony of 5 Princes Gardens, she appears to know about such things (fig.

Figure 30 *Sally Mann*, Night-blooming Cereus, *1988*.

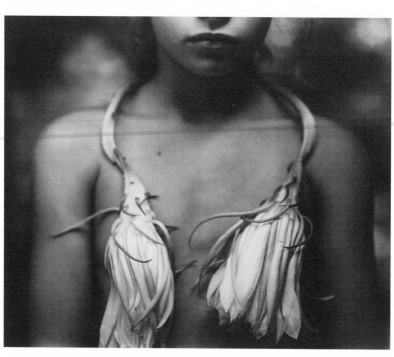

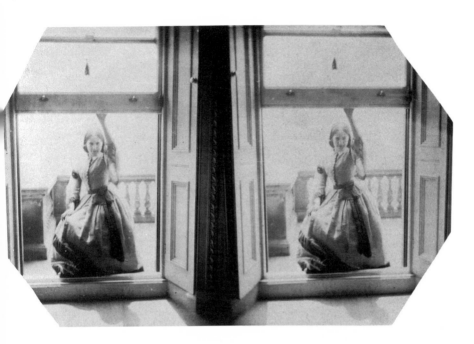

Figure 31 *"Clementina is caught by her mother
as if ready, but not quite ready, to close the magnificent
window frame."*

31). It is all there in her knowing, kind eyes, her sweet, encouraging
smile. As if taking our hand into hers, she sustains the moment just a lit-
tle bit longer; she keeps us here by staying there. Before the window is
pulled down, before the close of the camera shutter, before the close of
her bloom, before the death of her mother, before her death, and before
the always already blossoming of Jessie, Clementina stands before us:
becoming, she is adolescent reverie. From her, from Jessie emerge the
words of Alice herself when *"Still* she went on growing, and as a last re-
source she put one arm out the window, and one foot up the chimney,
and said to herself 'now I can do no more — what *will* become of me?'"[31]

 Pleasures Taken was my child-book.

 Becoming is my adolescent reverie.

REDUPLICATIVE DESIRES

Allow me to begin with four stories—four images—four mirror images, even—of what it means to look at and through the photographs of Clementina Hawarden.

ONE

The professor of art and her prize student were looking at lovely and sensual slides of Hawarden's photographs of her daughters. Flashing through the repetitive, though always captivating, images, the two women sat still in the darkened room, quietly remarking on the subtle gestures between the sisters: a pull on a lock of hair, a squeeze on an arm. The professor told her student that the photographs were about love between women and love of the self and self-love performed for the gaze of the mother. The student, a young poet on her way to graduate school in New York, told the art professor that her writing professor had once told her that "young women often write their first stories about an erotically charged, fantasized, twin sister." The art professor was disappointed to hear that these stories were always terrible.

TWO

The young professor felt that she had finally grown up. Her advisor from graduate school had been invited to lecture at the university where she taught. Proud of her new independence as a real professor, she invited her advisor to her seminar. On the day of the seminar, her advisor showed up wearing the same dress as she.

This made her feel all hot and embarrassed, as if they had been discovered as mother and daughter, or sisters, or as the perverse subjects of a Diane Arbus photograph. Yet, she also felt a certain delight, an almost sexual charge, from their presence in duplication. The class members tried not to be obvious with their inevitable double takes. She fed their desire (and maybe her own) by telling them that the whole thing was planned.

THREE

The big party was at the famous professor's big house. Everyone looked smart and seemed to be working on their second Ph.D., rather than their first. Afterward, an older female professor felt compelled to tell her what the other women graduate students had been asking about her: "Was her femininity serious or parody?" With a sinking feeling inside her stomach and with a big smile and a roll of her eyes on her outside, she quipped, "Of course it's parody." But in her mind, she thought, "My God, I really don't know. But I'm never wearing a Laura Ashley dress again."

FOUR

She walked into the office and the chairman pulled her aside. He began making some remarks about her student — how the student dressed differently now — how the student had changed her hair. Continuing on, laughing yet serious, and full of odd suspicion, he asked her where she got that dress anyway. She lied, of course. She would rather die than tell him that two of her students had given it to her. "You know," he said, after masterfully managing to weave together her style of dress, her student's style of dress, and the kind of critical theory that she had been introducing to her students, "you gotta watch out for those Professor-Wanna-Bes, not all of them are capable of the demands of critical theory." But what he was really saying was "One of you is enough!"[1]

If Clementina Hawarden (a mother of eight) has taught me anything, it is that one is never enough.

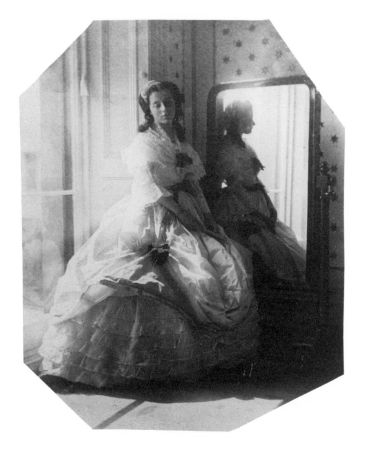

Figure 32 *Isabella in fancy dress, "the mirroring
of the mother through the daughters."*

In Hawarden's excessively productive world, whether through her
production of eight children, or through her production of hundreds of
images of her daughters, or even through her fetishization of select fem-
inine objects within the pictures themselves, the female body infinitely
reproduces itself, like a photograph.

Hawarden displays women as *ontologically* fetishistic by picturing
passion as a kind of feminine doubling of the mother herself, as simula-
tion. For example, the photographs that focus on mirrored images in ac-
tual mirrors and windows as mirrors suggest not only feminine narcis-
sism, but also the mirroring of the mother through the daughters (fig.
32).[2] And by matching, twinning, and coupling girls with objects that

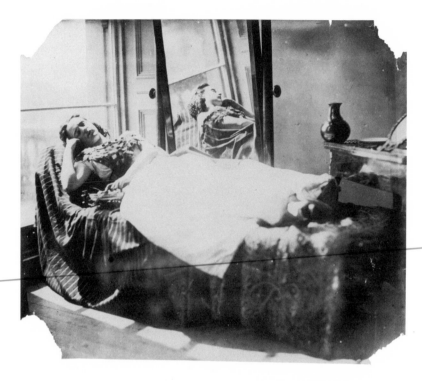

Figure 33 *We see Clementina "in the jug and in the mirror."*

suggest the sensuous femininity of her daughters, Hawarden fetishistically simulates her body and, in turn, those of her daughters.[3] Consider, for example, the familiar curvy vase that suggests Clementina's own blossoming breasts, turned-in waist, and hands on hips as handles made bountiful through pleats, gathers, and layers of sensual fabric—doubly so, in that we see her in the jug and in the mirror (fig. 33). Or see Isabella as a reflective collectomania[4] of feminine things: in the (Pandora's[5]) box decorated with shells that perches atop a table crowned by a narrow-figured vase that suggests her own slim lines; in the string of pearls; in the jeweled button; in the epergne (this time, it is not filled with fruit); in the two tiaras, one she wears on her head, the other she clenches to her breast (plate 7). Consider the concertina[6] that spreads its bellows like Clementina's own skirt (fig. 34).

Such doubling, twinning, coupling, mirroring that is already inherent to the work is doubly emphasized by Hawarden's frequent production of

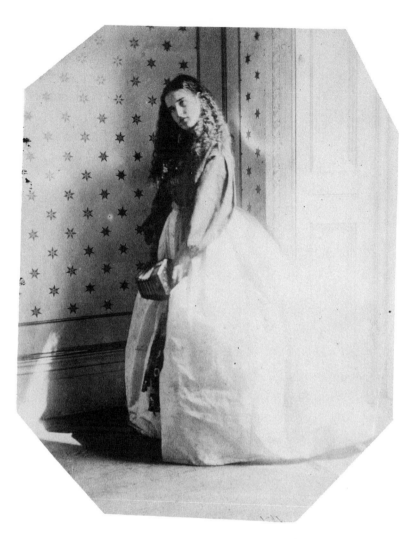

Figure 34 *"The concertina that spreads its bellows like Clementina's own skirt."*

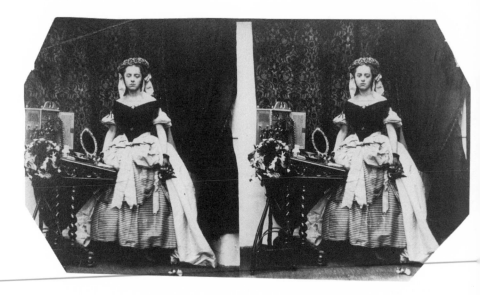

Figure 35 *"Isabella, in a billowy dress."*

stereoscopic photographs. One example is the stereo of a young Isabella in eighteenth-century-style dress (fig. 35). Isabella, in a billowy dress pregnant with excess, poses alongside a Gothic-style desk. The picture features Isabella as one with a spillage of girl metaphors: an Indian cabinet from whose open drawers flow eye-catching beads, an easel-back mirror that perches on the desk like an empty picture frame waiting to be filled with the image of this beautiful girl. Flowers are everywhere: she holds a bouquet of them in her hand; she wears a flower wreath on her head; another wreath of flowers decorates the plant stand; a lone flower sleeps on the carpet.[7] And thanks to her mother's stereoscopic camera, such feminine reduplication (performed by objects and daughter alike) is pictured not once, but twice.

Hawarden displays women as ontologically fetishistic, but does she, in the words of Emily Apter, "feminize the fetish"? Naomi Schor, among the first to inscribe the fetish with the female body, would say no. Schor understands the female fetish, rather, as a perversion stolen from men, as simulacrum. Apter, on the other hand and in direct response to Schor, takes such objects as Guy de Maupassant's fiction and Mary Kelly's *Postpartum Document* as "real" female fetishes that prove women to be per-

verts in their own right. Though I am drawn to Apter's brilliant writing on the ways female fetishism has been limited and misunderstood as a "simulacrum" of the "real" male perversion—or as a perversion stolen from men, "a sort of 'perversion theft'"—my path is somewhat different.[8] Rather than arguing whether or not Hawarden's maternal love objects are simulation or thievery, or whether or not Hawarden is necessarily a deviant by her own (female) right, this chapter makes palpable the curious relationship between Hawarden's fetishistic photographs and the conceptual framework of femininity itself. My analysis of Hawarden's photographs does not so much pull the feminized fetish into view as perform its reduplicative desire.[9]

Whereas the word *duplicate* is used in various ways—as an adjective to describe something as "being the same as another," as a noun that defines "either of two things that exactly resemble each other," as a verb that emphasizes the process "to make double or twofold"—the definition of the verb *reduplicate* is "to make or perform again."[10] I am engaged with the action of reduplicate's (re)performative character. Hawarden's photographs use her daughters to reperform Hawarden's desire again and again: through the repetition of her daughters, who are themselves repetitions of her (especially Clementina); through the fetishistic objects—such as the Gothic-style desk, whose elaborately carved legs mirror daughter Clementina's own ringlets (plate 8), or the concertina, the vase, the guitar (fig.36)—objects that appear to stand in for an absent daughter, as if the daughter and the object were sisters, as if the daughter and the object were a couple; through the reflected images of her daughters in the mirror that Hawarden often used as a prop; and through the endless repetition of the photograph itself, as is beautifully registered in the image of Clementina and Isabella sharing a photograph of Florence (plate 9).[11]

If we look closer at this curious image of the two older girls with a photograph of their younger sister, Clementina seems to hold an insistent desire for Isabella. In fact, Clementina appears actually to have pushed Isabella into the corner of the picture so as to be on top of her, as if she were a camera's close-up lens. In opposition to Isabella's space of tight confinement, the empty space behind Clementina gives her body

Figure 36 *Florence and the guitar.*

a certain driving force, mirroring the push of her own bustle, the play of
her flirtatious hair ribbon. Clementina's eyes focus on Isabella's escaping
tendrils, which amorously play on what I know to be, from other pho-
tographs, a beautiful white neck. Inhaling the perfume of her sister's
prissy prettiness, Clementina displays what seems to be an unremitting
eroticism. The essence of her body, quietly, yet insistently, requires that
her sister share her sweet looks. Clementina's hand pertinaciously poised
on her sister's shoulder pulls Isabella in as she simultaneously pushes
against her. Isabella's gaze is elsewhere, but her neck is tickled by Cle-
mentina's gaze: a breath not from her mouth, nor from her nose, but
from her eyes. Silent, odorless, hot. The back of Clementina's expressive
hands touch and fit into that beautiful space below Isabella's breasts.
Clementina is becoming: she is coming into the sexuality and changing
body of Isabella; she is coming into her own sexuality; and she is very
becoming. Isabella will not be able to hold her stiff Victorian ladyhood

much longer. Eroticism pushes out the picture's overt narrative of staged grief, like a crinoline under a skirt, a crinoline that they share with each other and with their mother.

As Peggy Phelan has demonstrated, the photograph, like the female body itself, is infinitely reproducible. They are ontological equivalents.[12] There is no real singular woman hiding behind the masquerade of womanliness, just as there is no singular photograph.[13] In Hawarden's photographs, the relationship between the category of woman, the photograph, and the female fetish reflect each other's reflections, constituting a supra–*mise en abyme*.

Indeed, Hawarden houses "femininity as always already stolen" (a tantalizing phrase that I have already stolen from Leslie Camhi).[14] Like the nineteenth-century department store that would become so spectacular toward the end of the century, with its elaborate displays of silks, gloves, hats, laces, and more, Hawarden displays for the viewer her beautiful collection of dresses and accessories, the beautiful bodies of her girls, and her collection of small and tiny objects that go in and out of view of the camera's eye (the silver cup, the Gothic desk, the wooden doll, the toy village; fig. 37), which are either held in a hand, perched on

Figure 37 *"The toy village."*

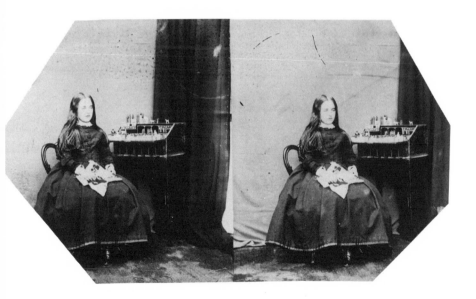

Hawarden's desk, presented on her table, stuck in the drawer of her Indian cabinet, or placed on the mantel. Hawarden's desire, like that of the Victorian female kleptomaniac, is contagious. I want a collection (girls, dresses, objects, photographs) of my own. I take what is already stolen (thereby ridding me of any guilt) and reduplicate its desire in my (writing) body.

MOTHER/DAUGHTER/DOLL

As girls, many of us had a collection of dolls. It is hard to say whether or not Hawarden as a girl possessed such things; the Victorian commodification of childhood with all of its ensuing products, such as dolls and books and clothes and perambulators, was more the stuff of her daughters' lives than of hers. But once grown, Hawarden played with her daughters like dolls. As objects dressed to entice and to invite play, Hawarden's pictures of her lovely daughters beckon touching, dressing, redressing, combing, brushing, hugging. Hawarden's daughters, as part-objects of the mother/photographer, mirror not only each other but also their mother. Hawarden's imaging of her girls as dolls represents not only an appetite for beautiful things, an appetite for young feminine bodies, but also an appetite for self (in that the daughters are born into a culture that makes them into little mothers). I am reminded of Christina Rossetti's "Goblin Market" (1859). Like Hawarden's photographs, the poem fecundates with the delicious fruits of a doubling, ripe, adolescent, female body:

> Apples and quinces,
> Lemons and oranges,
> Plump unpecked cherries,
> Melons and raspberries . . .
> Figs to fill your mouth.[15]

Halfway through the poem, Lizzie—the twinned "little mother" to her self-same sister Laura—offers herself as (homo)erotic sacrament, cooing and wooing:

Did you miss me?
Come and kiss me.
Never mind my bruises,
Hug me, kiss me, suck my juices
Squeezed from goblin fruits for you.
Goblin pulp and goblin dew.
Eat me, drink me, love me;
Laura make much of me.[16]

Hawarden's sensual, maternal appetite for her girls is not unlike that of Lizzie and Laura for each other: both represent an eating of the other and an eating of the self.

Like the mother of twelve-year-old Janey ("Petal Pie") in Kirsty Gunn's haunting contemporary novel, *Rain* (1994), Hawarden knew that her daughters, especially (perhaps) her daughter Clementina, would become her: "Sitting at her dressing-table that night, somewhere under her smooth expression she knew it. That I would take her limbs, her hair. That some day I would become her, smooth with cosmetics and calm to the mirror's surface."[17] I know that, as a child, my own mother imagined me as a miniature copy of herself and I have always felt in turn that I was her mirror. Our connected identities register my birth as never complete. Through such pro*longing* of the Oedipal period, the mother identifies with her mother once again, longs for her and her lost childhood, becomes mother and child, and makes her own child a fetishistic object in an attempt to satisfy her double loss. (Because the child is "cut" from the mother, the child marks maternal loss; yet the child also makes the mother feel whole again and thereby marks maternal plenitude. As a result, the child really is a mother's fetish par excellence.) The birth of a girl, especially, is an everlasting process of reduplication between mother and child, between stereoscopic images. (One of my students recognized this complex imaging and reimaging in an old high school photograph of her mother and wrote: "Not only does it have a sense of aura because it is old, but because it is my mother/me. Like the multiple photographic copies of this image, I am a copy of my mother."[18])

Luce Irigaray has argued that a female's desire for the mother is one

of connection and reduplication, so much so that it has affected women's gestures and play. Spinning around Freud's famous *fort-da* story (which features Freud's grandson Ernst throwing a spool on a string back and forth as a symbolic mother-object whose coming and going he can control), Irigaray claims that this kind of male-gendered play, which distances the child from the mother's body, is difficult, if not impossible, for a girl.[19] Few girls can reduce their mother's image, their own reduplicative image, to that of a reel. Rather than physically throwing a (symbolic) reel on a string back and forth, many little girls dramatize their situation of close proximity to the body of the mother by replaying (the mother) with dolls. Drawn to the mother-centered imaginary over the father-ruled symbolic, the little girl *plays* out her situation and reproduces around and within her an energetic circular movement that protects her from abandonment, attack, depression, loss of self. Spinning around is also, but in my opinion secondarily, a way of attracting. The girl describes a circle while soliciting and refusing access to her territory. She is making a game of this territory she has described with her body.[20]

Hawarden's photography is girl play with a camera. Her photographs dramatize a close proximity to her own mother, who was also fond of fancy dress.[21] A scrapbook compiled by Hawarden's mother contains engraved clippings from "serial publications such as Heath's *Book of Beauty* and Finden's *Byron's Beauties*" and must have "nurtured" this shared and multigenerational love of sartorial drama.[22] Likewise, Hawarden turned her daughters into (glass and paper) dolls. Together, mother-daughter/daughter-mother play in a circle described by mother as camera eye. The photographs give us access to this inviting territory. Yet, like a mother's arms around her child or a child's arms around her doll, or like a jump rope that whisks its way above a girl's head and under her feet, we are at the same time refused access.

In one stereograph, Clementina plays with her jump rope while being held by her mother's camera (fig. 38). The rope, by traveling from the grasp of one hand and then up to the other, makes a beautiful U: it mimics the looseness and playful pleasure of Clementina's one-side-only ponytail, which itself (like string, yarn, or cord) serpentines its way down from her ear to her breast to her waist. The jump rope bars us from

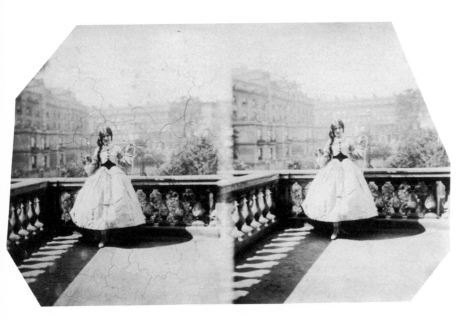

Figure 38 *The jumprope "mimics the looseness and playful
pleasure of Clementina's one-side-only ponytail."*

Clementina, just as the balcony, with its short stone wall, bars her from
the outside world. Such markers (rope, stone wall) magnify the intensity
of the privacy of Hawarden's undecorated rooms, our limits to discover-
ing the secrets at hand, and photography's own trick of giving way to a
real space that is unreal.

 In yet another jump-rope picture, Isabella has her back to the camera
and Clementina faces out with her eyes down. Between the two sisters,
they hold the jump rope: it makes a short, dark, squat (umbilical) U that
draws them together (fig. 39). The picture looks staged. The balcony, in
this picture and many others, jets out from the Hawarden home and
makes a platform stage for the girls. Here, as they often do, they perform
play as a play. Interpretations flow. The jump rope becomes the cord to a
camera shutter. Barthes suddenly, though not unexpectedly, emerges on-
stage and insists that his clever line be heard: "A sort of umbilical cord
[une sorte de lien ombilical] links the body of the photographed thing to
my gaze."[23] Irigaray spins out from the wings while skipping rope and
blurts out: "If the mother — and girls' identities in relation to her — is in-
voked in girls' play, and if they choose to play with a cord, they skip

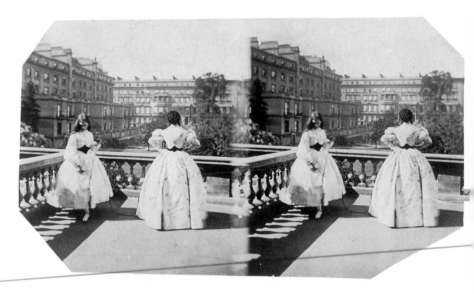

Figure 39 *"The two sisters . . . hold the jump rope."*

around, while turning the cord over their bodies . . . They describe a circular territory around themselves, around their bodies."[24]

Playing in an oedipal continuum, refusing the abandonment of the circular gestures and circular inscriptions of a maternalized territory, Hawarden's pictures of her doll-like daughters reinscribe, recite the mother-daughter continuum of a love of same. Hawarden's body is there; it is just, as Mary Kelly has remarked in regard to our cultural distancing of the maternal body, *"too close to see."*[25]

In the photograph of Clementina in a dark riding habit and her sister Isabella in an off-the-shoulder white dress, two self-same daughters come full circle as mirroring images of dark and light, Nycteris and Photogen, masculine and feminine, the object of desire and her pursuer (fig. 40).[26] Isabella, inside the Hawarden home with her back toward us, hair prim and proper, keeps her body protected and out of our view. Clementina, outside the window frame, outside the interior of the home, out on the porch, with her hair loose, opens her body for Isabella and toward us. The differences between Isabella and Clementina enhance the subtle touching that is going on between these women. For though Clementina's gaze into Isabella's eyes is enough to make the viewer

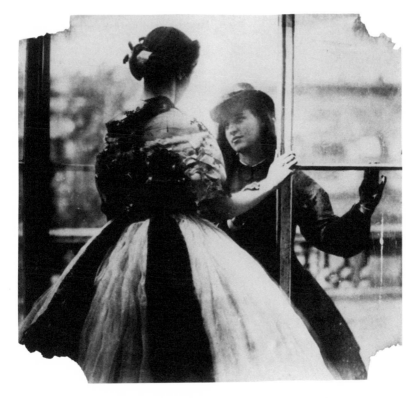

Figure 40 *"Clementina in a dark riding habit and . . .
Isabella in an off-the-shoulder white dress."*

blush, it is her bare right hand that causes me to swoon. Stripped of the
dark glove that her left hand so openly displays, Clementina's lovely un-
gloved hand ever so softly but firmly clenches Isabella's right arm. I can
feel the pressure. Like Lizzie and Laura in "Goblin Market," the Hawar-
den sisters seem to be offering two ways of life in one twinning body:
that of the "mindful" Lizzie / Isabella, whose controlled feminine desire
stands "white and golden . . . / Like a lily in a flood," and that of "curious
Laura" / darling, adventurous Clementina, who "sucked and sucked and
sucked the more / Fruits which that unknown orchard bore; / She
sucked until her lips were sore."[27] Like rings around a stone cast into a
pond, the circles of Clementina's hat and brim, the circle of the black lace
sash that cinches Isabella's small circle of a waist, the circle of their skirts,
the circling of Isabella's rolled hair that wraps the curve of her beautiful

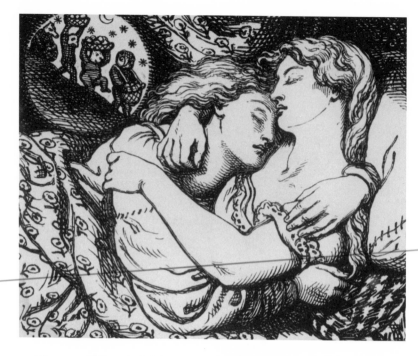

Figure 41 *Dante Gabriel Rossetti, woodblock design for the frontispiece of his sister's* Goblin Market and Other Poems.

head—all serve to echo the more general and prohibitory halo that the sisters have materially and gesturally inscribed around themselves. "Like two pigeons in one nest," Isabella and Clementina create an inviting bower into which we, as wingless outsiders, cannot enter.[28]

Look again at the photograph in which Clementina and Florence are caught as if recreating a tableau vivant from Delacroix's *The Death of Sardanapalus*, where circles are, again, repeated (see fig. 18). Clementina's arms not only bury her gaze but also encircle her face, like the tiara that she so sweetly wears. Florence's left arm gestures around not only to shut her eyes with pretty fingers but also to partially complete the fragment of a curve that her left arm begins; together, her lovely round arms, crowned by the circles of her puff sleeves, give rise to the suggestion of a tender moon. Like Ophelia, Florence's head is encircled by a wreath. Like a lover, Florence's fingers twirl Clementina's tendrils. Like Dante Gabriel Rossetti's woodblock design for the frontispiece of his sister's

Goblin Market and Other Poems, Clementina and Isabella photographi-
cally repeat the touch, the curling up of Lizzie and Laura (fig. 41). All
fabric and skirts, curls and crowns, they nestle together, they nest to-
gether: no sight, just touch all around. Out of the picture and into the
erotic circles of my own ear, I hear and feel Clementina and Florence
murmuring, whispering, repeating, reduplicating Lizzie and Laura as
they softly chant all of "Goblin Market"'s 567 lines of female sexuality
over and over:

> Folded in each other's wings,
> They lay in their curtained bed:
> Like two blossoms on one stem,
> Like two flakes of new-fall'n snow,
> Like two wands of ivory
> Tipped with gold for awful kings.
> Moon and stars gazed in at them,
> Wind sang to them lullaby,
> Lumbering owls forbore to fly,
> Not a bat flapped to and fro
> Round their rest:
> Cheek to cheek and breast to breast
> Locked together in one nest.[29]

But are these photographs all pleasure?

CORSET HOUSE

In the photograph of Clementina with her hair tenderly pinned back, her
eyes mercifully closed in honor of the warm light that illuminates not
only her face but also her arms, her breasts, her dramatic skirt that puffs
out with all the drama and humor of a freshly baked brioche turned up-
side down, she appears to be locked into a nest not of homosocial plea-
sure and sensuality, but rather of relentless domesticity (fig. 42). I am es-
pecially troubled by Clementina's twisted hands. Coiled around one
another, nearly entwined with the window's curtains, her outstretched
arms become nearly indistinct from the fabric that binds them. A chignon

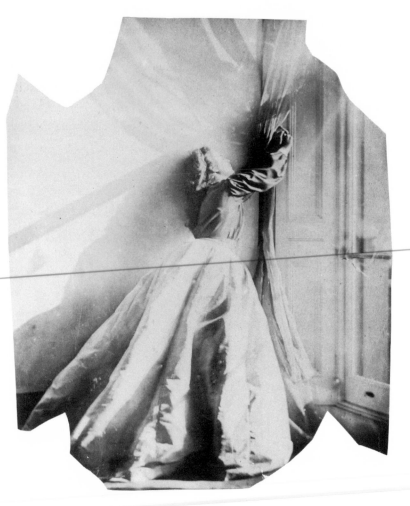

Figure 42 *Clementina's "outstretched arms become nearly indistinct from the fabric that binds them."*

of hands and fabric. She is tied up in desire (withheld). Tongue-tied speech. Breathless beauty. I am made breathless by her churning beauty. Tearing beauty. Clementina tears at the picture's frame as if in anticipation of the picture's own eventual tearing from the photographic album.

Pulling at the fabric that mirrors the dress that houses her body, her long, extended gesture suggests the desperate tearing off of the yellow wallpaper in Charlotte Perkins Gilman's famous story of her own nervous breakdown. In the story and in real life, Gilman's illness confines her to a large garret room, in which she is not allowed to touch pen and paper again until she is well. But shutting her in only made her increasingly mad. She begins to imagine a female figure creeping through and behind the wallpaper, who is of course the narrator and the narrator's double, in much the same way that Lizzie and Laura have been read as Rossetti and her double. In a climactic moment, Gilman writes, "I pulled and she shook. I shook and she pulled, and before morning we had peeled off yards of that paper."[30] Hawarden has pictured her double, daughter Clementina, as creeping out from photographic paper. With clipped wings and closed eyes, our Clementinas (as the Victorian "angels in the house") are grounded to the home—pinned to the wallpapered walls—blind to (and blinded by) the outside world that lies just beyond the glazed walls that frame them like a Victorian glass house for picture taking.

A picture such as this suggests that the lives of Hawarden and her daughters have been, as Emily Dickinson wrote in regard to her own life, "shaven, and fitted to a frame."[31] In fact, as we have seen, all kinds of frames—house frames, picture frames, camera frames, door frames, window frames—fit the girls as tightly as their well-fitted dresses. Consider the photograph of Isabella standing by the fireplace with her back to the camera (fig. 43). Notice how the dramatic shadow line that runs across the floorboard, only to slope down her dress and off toward the hem of her skirt as an unpalpable velvet ribbon, marks her as one with the wall. She is kin to the quiescent book on the mantel, the hushed (yet gaping) mouth of the fireplace, the frozen, unflickering wallpaper stars. Unlike Holly Hunter's character in Jane Campion's film *The Piano*, who uses her crinoline cage to make an inventive, fanciful, delightful im-

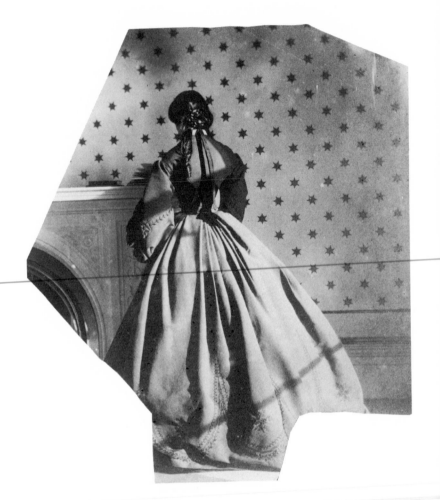

Figure 43 *"Isabella standing by the fireplace with her back to the camera."*

Figure 44 *Beverly Semmes*, Housedress, *1992*.

promptu house on a deserted New Zealand beach, Isabella as house/ dress does not outwardly make subversion out of feminine fashion. (But the contemporary artist Beverly Semmes does, when she plays out her 1950s inspired ironic subversion of feminine deaesthetics with *House-dress;* fig. 44). In contrast to Campion's heroine — who is known as a silent woman yet fills the world with the sonorous sound of her piano, the loud popping, slapping rhythms of her signing and the scratchy noise of her frantic scribblings on a tiny writing tablet encased in silver and stone and worn like a lover's locket — Isabella is stilled, as still and silent as an empty household. Hawarden has pictured Isabella as becoming do-mestic space, as becoming compliant to the space that houses both her-self and her daughter. Likewise, in a photograph of Isabella in a spotted overdress that falls from her waist and past her buttocks in crumpled waves, like shed skin, like a butterfly's chrysalis, we find that she is mot-tled as one with the starred wallpaper (fig. 45).

Hawarden's talent for corsetting woman as architecture comes full tilt (doubly so) in the stereograph of Isabella out on the balcony (see fig. 15). Again the bottom of her dress is cut and patterned by a dark diagonal line. But this time the line is not shadow: it is the work of a seamstress.

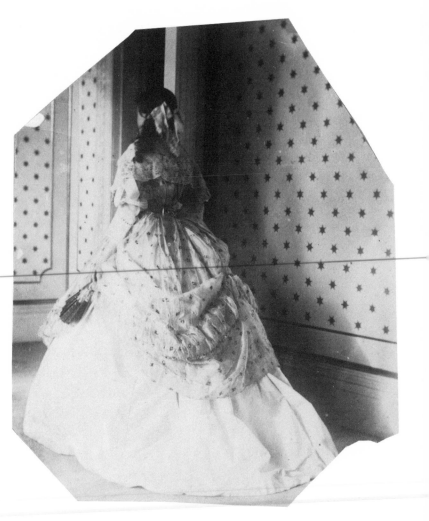

Figure 45 *"Isabella in a spotted overdress."*

Figure 46
Louise Bourgeois,
Femme/Maison
(Woman House),
1947.

And what a line it is. The photograph transforms the dress's bold deco-
ration into a full-fledged thrust, whose sole purpose becomes the cre-
ation of a dynamic (if invisible) vertex out of a pinched encounter with
the downward roofline. In keeping with the picture's dramatic lines,
Isabella shields her face with a fan to perfectly align her right hand and
arm with the line of the descending roof. Through this carefully orches-
trated gesture, Isabella is caught by her mother's camera-eye as becom-
ing house, not unlike the fragmented female figure in Louise Bourgeois's
Woman House (fig. 46).

Whether or not Hawarden's photographs were intended as conscious
critiques of the tight-fitting domestic life of the bourgeois Victorian
woman, they often suggest, as Dickinson writes in "The Soul has Ban-
daged moments—," "the soul has moments of Escape—/ When burst-
ing all the doors / She dances like a Bomb abroad."[32] Although there are

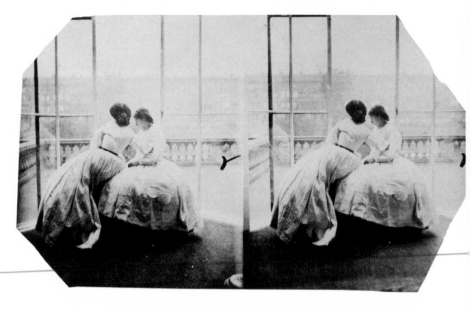

Figure 47 *"Hawarden has burst through the back door."*

no pictures of the girls dancing, one image, in particular, manages Dickensonian "moments of escape."

In an eerie stereograph of Clementina and Isabella, Hawarden has burst through the back door (fig. 47). The gauze curtains, which typically veil Hawarden's windows and subdue at least some of the light, have been cast aside to flood the room with too much light, too much white. The camera's distance from the subject, the effect of the girls huddled together, along with the overwhelming expanse of white make for a lonely image. Though "on either side of the girls are their images in the window glass, like ghostly companions," there is no sign of their mother.[33] If the center door of the French window were closed instead of opened, we would see a ghost of Hawarden behind her camera. The door, however, is open. Hawarden's image, shadowless and nowhere to be found, has fled through the open glass. Instead of Hawarden, we get a subtle bluster of aesthetic white air.[34]

But we also get something else. In the picture's foreground is a headrest, used in earlier years to keep the model still but probably never used by Hawarden.[35] Barthes describes the headrest as "a kind of prosthesis invisible to the lens, which supported and maintained the body in its pas-

sage to immobility."[36] Contemplating the headrest's role in the history of photography in relation to his anxiety about having his own picture taken, Barthes writes, "This headrest was the pedestal of the statue I would become, the corset of my imaginary essence."[37] Here, Barthes is referring to the "field of forces" that come together at the click of the shutter. He elaborates:

> In front of the lens, I am at the same time: the one I think I am, the one I want others to think I am, the one the photographer thinks I am, and the one he makes use of to exhibit his art. In other words, a strange action: I do not stop imitating myself, and because of this, each time I am (or let myself be) photographed, I invariably suffer from a sensation of inauthenticity, sometimes of imposture (comparable to certain nightmares) . . . I am neither subject nor object but a subject who feels he is becoming an object: I then experience a micro-version of death.[38]

I see the headrest (empty and unused, more familiar to her than to the girls, strangely anthropomorphic when seen in full) as Hawarden's corset, as a stand-in image of her. The headrest, a tripod for the body, reaches into the picture's space; obtrusive and slightly threatening, it has an ominous effect. (I am reminded of the image of Isabella and Clementina holding the photograph of Florence, mourning her present absence.) Yet, Hawarden did not corset herself—not outwardly at least. This photograph makes conspicuous Hawarden's refusal to become image. Closer to her own mortality, perhaps she preferred to avoid the camera's inflictions of microdeaths.

In her *Dada Poem Wedding Dress*, Lesley Dill presents one of her enigmatic paper dresses, stamped with an image of a real biological heart (a votive) amongst black letters (Dada-style, in that the varied size and boldness of the typography suggest sound), which spell out what is only implied in Hawarden's corseted dresses: Dickinson's "The Soul has Bandaged Moments" (fig. 48). A dip at the waist gives way to a body (there and not there), with the words "MOMENTS OF ESCAPE." Up and down the sleeves, letters straight and reversed (looking-glass-style) puff out and suck in the heaves and sighs of "THE SOUL HAS BANDAGED

Figure 48 *Lesley Dill,* Dada Poem Wedding Dress, *1994.*

MOMENTS." The tight fit of the dress's bodice, coupled by its impossible wedding-dress train, gathers paper whispers of inescapable dirt and tears yet to come. This "aloof beauty"[39] can do nothing more than wait for her dirt to be collected, wait for the rips to mar her perfection. Loose threads tangle their way off the skirt's hem and at the wrists — inviting the shredding, the ruining yet to take place. They catch me in pain with each inconceivable step, with each unforgiving gesture, like tendrils of hair caught on an unfastened hook and eye. Minuteness is all.

Yet these same tender strings also invite care: they suggest the compacted roots of a plant removed from a pot too small. Perhaps they have grown out from the white paper veins that metaphorically pump dry white milk throughout the dress. I want to tenderly shake these white veins free. I want to run my fingers through them, pulling them apart, as

if the veins were hair. I want to reconstitute what has become dehydrated, so that they can flow with nourishing milk.

But the shredding did take place. The dress was ripped to shreds at the 1994 New York Dada Ball. Dill describes the tearing performance: "As the words of the poem were being recited by four women in black pants and tops unrolling white ribbons, two more of us began ripping the dress apart word by word. The dress no longer represented an aloof beauty, protected by this skin/dress/bandage of words . . . the performer, now dressless, was painted with the same words of the poem on her nude body. With silent dignity she pulled a red ribbon from her mouth, mutely testifying to the survival and strength of the spirit."[40]

While the drama of loss and mortality looms heavily over Dill's dress, threatening to trivialize Hawarden's luscious efforts, both artists, read but not seen, quietly, even boldly, re-present female bodies (including their own absent bodies) as uncorseted by skin, dresses, emulsion, headrests. Hiding in the light,[41] both Dill and Hawarden use feminine fragilities (spoken through folds, gathers, puckers, hourglass shapes, paper, thread) as "bandaged moments . . . of escape" to dance "like a Bomb abroad." Hawarden dances in aesthetic white air, swallowing the key that might close the door. Dill dances to a silent song sung by a red ribbon tongue, never to be swallowed. Swallows that fly.

PLAYTIME

> *All children talk to their toys; the toys become actors in the great drama*
> *of life, reduced in size by the camera obscura of their little brains.*
> —Baudelaire, "A Philosophy of Toys"[42]

But now I must ask myself: Am I so anxious to categorize the Victorian woman as suffering in her domestic flat(ness) that I have been blind to Hawarden's ironic gusto? After all, within Hawarden's oeuvre are a cast of photographs that are clearly not images of stifling, domestic, and psychological corseting; rather, they clown around in the petticoat layers of Hawarden's comic exaggeration and judicious play.

I see photoplay in Clementina and Florence as jesters.

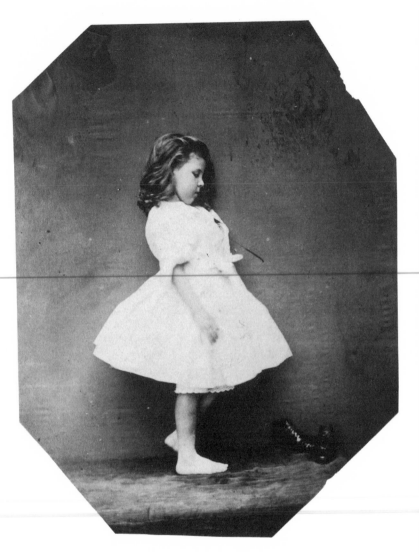

Figure 49 *Elphinstone "as elfin statuette."*

Figure 50 *"Clementina and Isabella as silly lovers
undone by the elder's faux mustache."*

As elfin statuette, Elphinstone Agnes (Hawarden's seventh child),
stands on a draped box, wearing a white dress and bloomers and no shoes
(fig. 49); conscious of her mother's gaze and seemingly mine too, she de-
terminedly defies our look by staring down at a lovely pair of "surreal
. . . shiny button boots," ready to sprout real toes (like Magritte's famous
boots or like Marcel Mariën's Surrealist pair of shoes (1949) that take to
the stairs on their own without a body).[43] Whose idea was it to take the
shoes off to make it look as if a body remained inside? Elphinstone's gaze
claims the boots as her own *sculpture involuntaire*—even if they were
posed by her mother or a sister offstage.

I see more photoplay in the image of Clementina and Isabella as silly
lovers undone by the elder's faux mustache (fig. 50).

Could, then, the photograph of Clementina ready to roll herself up in

Figure 51 *"The family dog."*

Figure 52 *Photograph of a hysterical woman, taken
under the direction of Jean-Martin Charcot.*

her mother's curtains (curtain/play; see fig. 42) be a wryly humorous
image? Is it ironic? Or is it sentimental?

Sentiment goes out the window when the image is compared to
Hawarden's hilarious photograph of the family dog (fig. 51). Stretched
between two chair backs that have been carefully positioned on the bal-
cony, the dog becomes a droll duplicate of the girls' suspended feminin-
ity. I laugh. But my laughter gives rise to hysterical flashbacks. For the
dog's scrupulous maintenance of a difficult pose is not far from Clem-
entina's own difficult stretching before the camera and, in turn, pho-
tographs of the Victorian hysteric in positions of "intense immobility."[44]
Flash back to Gilman's own story of hysteria. Flash forward to Charcot's
image of a hysterical woman, suspended and snapped between chair
backs (fig. 52). Curtain-woman, dog-woman, chair-woman. A flash of
vertigo. Home, sanitarium, or circus? The dramatic pose of Clementina,
the poised body of the dog, and the shocking image of the hysteric are el-
liptic. Do you laugh or cry? Is Hawarden's focus on her daughters as if
dolls or pets a serious, critical commentary on the Victorian woman's
plight? Is it pure comic reflexivity? Is it an unabashed, albeit ironic, ex-

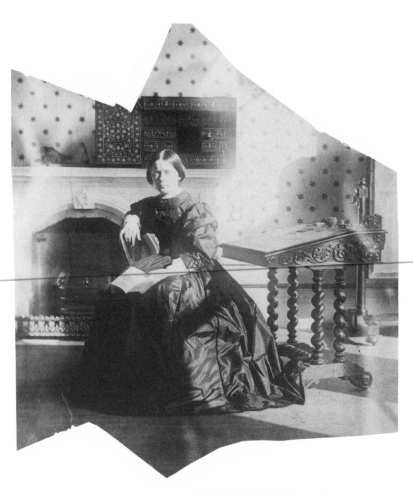

Figure 53 *"An older woman."*

pression of Hawarden's fetishization of her daughters and dogs? Is it parody and she just doesn't know it? Is it just another sentimental image of a Victorian, bourgeois woman? Caught, again, between chair backs.

One photograph, however, does not afford such play, either on the part of the model or in our reading of the image: Hawarden's picture of an older woman (fig. 53). This image stands apart in Hawarden's body of photographs of beautiful young women and girls. Though the picture is rendered somewhat consistent by the familiar interior and mantel, the repetition of the decorated Indian traveling cabinet, and the often used Gothic-style desk, the viewer is immediately surprised to find that the focus is on a postadolescent female. The woman, with her hair so severely parted, her face so guarded, so sure in its refusal of sensuality, is actually young, possibly in her thirties, as Hawarden was when she took this picture. But amidst the eroticism so prominently displayed in the endlessly repeated images of Hawarden's adolescent daughters, this woman's conservative dress and stern posture mark her as older, as radically different from Hawarden's very young, very soft, very appealing girls. Upon closer inspection, one sees that the familiar mirror, which has so often and so beautifully captured Clementina's ripe beauty, is now flush with the wall, far from this unnamed model's body, far from the danger of catching even a fraction of her body. Victorian propriety is not forsaken. With her right hand on the chair back, she looks as if she is prepared to stand up — to take charge, if necessary. Book in hand, desk behind her, she might be a governess to the girls.

Equally as surprising as finding this older woman within Hawarden's body of work is the discovery of an object that is tucked into one of the drawers of the Indian traveling cabinet: a small doll. It is the governess's duty to keep the girls at work, to keep the dolls in their drawers. The doll, barely visible, stands above and to the right of the not old, not young woman, as if it were locked in a stage box. Eerily, the doll is left alone in the pulled-out drawer-turned-balcony. Percariously perched, she gives off an aura of danger. This doll most certainly does not represent the sensual, loving, often erotic, continual proximity of the body of the mother with her daughters. This daughter-doll has been cast away. Like the (off-frame) image of Sally Mann and her large-format camera hovering over

Figure 54 *"The empty room."*

her daughter Virginia, whose sleeping, staining body hovers over a cast-away doll in *The Wet Bed*, "the daughter plays with the doll, the mother plays with her daughter."[45] The raising of the dress on the doll in Mann's picture and the placing of the stiff doll in the drawer of Hawarden's picture suggest the manipulation of their own living daughter-dolls. Hawarden and Mann suggest (photo)graphic exposures of less utopic, even horrific, practices of maternal desire.[46] But mothers are also daughters, and daughters often manipulate their own mothers as dolls.

Hawarden's photographs of her doll-like daughters is an extension of her collection of beautiful things. And the "collection," as Susan Stewart has written, is a "form of art as play, a form involving the reframing of objects within a world of attention and manipulation of context."[47] Daughters made miniature in the dollhouse-like structure of the home, the photograph itself, and especially the stereoscope suggest that Hawarden's supra-interiority is a space of manipulated pleasure and empowerment. Whether the doll in the cabinet is read as a miniature reduplication of a daughter or possibly as a miniature reduplication of Hawarden herself (imagined and placed in the cabinet by one of Hawarden's daughters), either way it suggests the pleasure that girls often achieve by controlling their dolls, their favored me/not-me possessions. As Stanley G. Hall has noted in his *Study of Dolls*, "Even feared and hated objects excite pleasure when mimicked on a small scale."[48]

SOMETHING SACROSANCT: THE EMPTY ROOM

Hawarden's image of the empty room, the room without her dolls, is, for me, the image that gives way most dramatically to Hawarden's "just *too close to see*" body (fig. 54). This mise-en-scène does not distract the viewer with Hawarden's usual tableau vivant of dressed-up girls; rather, the photograph (without models) forces the viewer to turn to the photographer. The fact that neither Clementina nor Isabella nor any of the other Hawarden daughters—not even the older woman—are pictured with the familiar chair, the familiar Indian cabinet, the familiar Gothic-style desk, in the familiar corner of the room with the familiar star-patterned

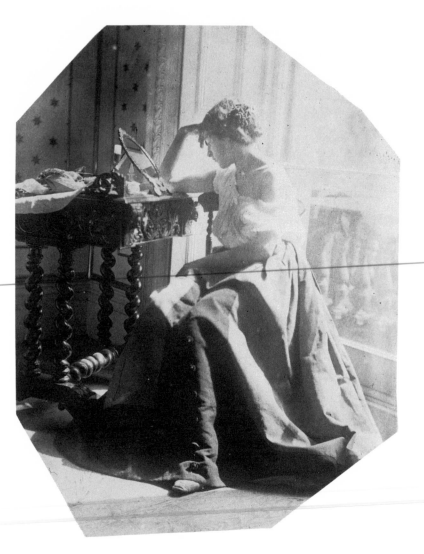

Figure 55 *"Clementina sits before . . . the mirror perched upon
its table top that begs for her reflection."*

wallpaper creates a desire to fulfill. Because I have seen these objects before, I turn to the corners not pictured to see what is not there.

This photograph is imbued with Hawarden's invisible body: it saturates the print without being seen/scene. The girls (who may be off at a party, or out on a day trip with their father, or in another part of the house) leave the space open: open like the book on the chair (which, not coincidentally, features a woman and children), open like a camera shutter in a dark room.[49] Like a wide-open camera shutter, the picture begs to be illuminated.

I am simultaneously drawn in (by the interiority of the picture, that which is "'in-frame,' the abducted part-space, the place of presence and fullness") and out (to that which is "exterior" and on the borderlines). Though I have "no empirical knowledge of the contents of [what Christian Metz refers to as] the off-frame . . . [I] cannot help imagining . . . the off-frame, hallucinating it, dreaming the shape of . . . [its] emptiness."[50] Out there, in the picture's off-frame, I see Hawarden alone in the room, behind her beautiful wooden box camera. Off-frame gives way to cinema's voice-off, a voice who is "not visible," who exceeds "the limits of the frame" but is a body within the film, and who is usually "brought within the field of vision at some point or another."[51] Voice-off, unlike voice-over, is not disembodied; neither is Hawarden. I hear the click of her camera shutter.

The strong desire to picture the off-frame, even to hear its voice-off, is a direct result of the highly repetitive vocabulary that Hawarden uses. Hawarden's lexicon includes the familiar utterance of the Gothic-style desk (initiates see it often). It makes a dramatic appearance in the empty room. When Clementina sits before it, she refuses to look into the mirror perched upon its table top that begs for her reflection (fig. 55). In an early stereograph of Clementina and Florence, we find the two girls like overgrown, stiff figurines, sentinels hand in hand, guarding the desk that stands before them, upon which is perched another open book (fig. 56). Tweedle-Dee and Tweedle-Dum, Clem in white tights, Flo in striped tights, both in billowy, ridiculous, ribboned meringue, twin dresses, exactly Diane Arbus–alike; they are creepy and cute. "Goblin Market" doubles, they seem to have popped out from the pages of the book.

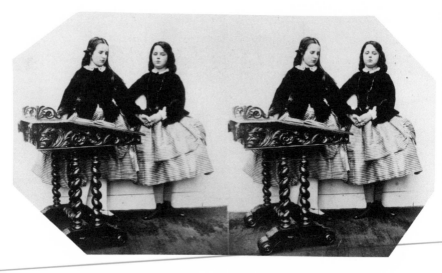

Figure 56 *"Two girls like overgrown, stiff figurines, sentinels hand in hand, guarding the desk that stands before them."*

The Indian traveling cabinet is often coupled with the desk and the girls. In one such picture, Isabella is caught in motion and appears to be hiding something in the cabinet's drawer (fig. 57). Or is she sneakily pulling something special out? In a similar image, Clementina looks directly at me, at her mother, at the eye of the camera, while her left hand pulls open one of the tiny drawers (plate 10). Or is she closing it? What secret rests inside? What book lies precariously over her head? Clementina smiles slightly, knowingly.

The little padded chair is also a well-known term in Hawarden's vocabulary. In one photograph, it hides and waits behind the shutter of the giant window (plate 11). Tucked into the corner, with its squatty seat all lit up, a wallflower in its own right, this shy chair appears eager to be sat upon by Clementina. Clementina, in a shoulder-exposing peasant blouse, as barely dressed as the room that she inhabits, barely pulls up her skirt (as if slightly pulling aside the window curtain in order to see but not be seen), glides from outside to inside. Clementina, head tucked down, pretends not to be aware of the chair in hiding, of her hiding mother behind her camera box. At another, later(?) moment, Clemen-

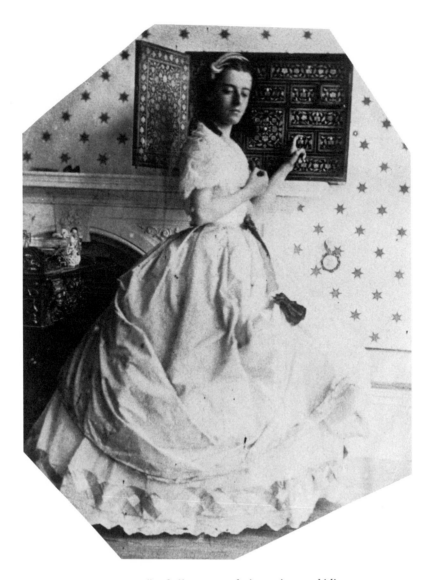

Figure 57 *"Isabella . . . caught in motion . . . hiding something in the cabinet's drawer."*

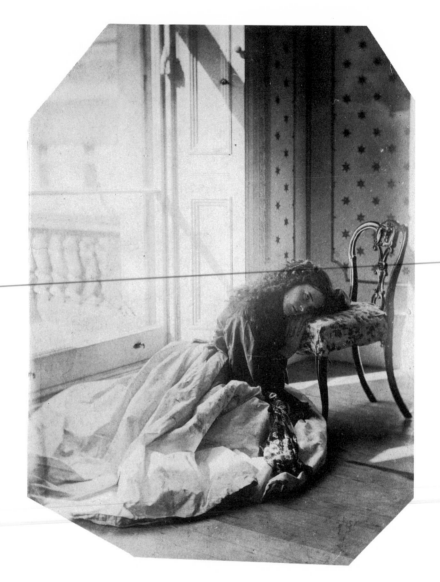

Figure 58 *"Clementina . . . rests her head
on the lap of this chair."*

tina tired, a bit wilted, her dress beautifully collapsed (as if in imitation of Sally Mann's already bloomed night-blooming Cereus flowers that fall over her daughter Jessie's hidden breasts), rests her head on the lap of this chair, as if it were her mother (fig. 58).

Does the chair (or for that matter, the Gothic-style desk, the Indian cabinet, and other such Hawarden items) that couples Clementina like a sister, like a lover, like a friend, like a doll, like a mother stand as a symbolic object, specifically a "transitional object" between mother and child? Winnicott tells us that in the beginning of an infant's life, she understands herself to be one with her mother. She is not separate from her mother. Everything is connected. But soon there begins an unraveling of that which is the "not-me" and that which is the "me." She sucks on her thumb and begins to understand that which is the "me." Her mother both gives and takes away the breast, which is the "not-me." The mother, in sympathy with this enormous intellectual work of coming to terms with the world, understands that "an attachment to a teddy, a doll or soft toy, or to a hard toy" can ease the child's transition (as well as her own). Winnicott writes, "It is . . . well known that after a few months infants of either sex become fond of playing with dolls, and that most mothers allow their infants some special object and expect them to become, as it were, addicted to such objects."[52]

My son Oliver was addicted to two "not-me" objects, two female dolls, whom he named Oliver Snappie and Rosie. During Oliver's early years, Oliver Snappie and Rosie were often the facilitators of Oliver's life without me. Rosie sat down at the table (in her very own chair) to eat with the other preschoolers before Oliver ever would. Rosie took the first dive into the school's sandbox while Oliver remained on the asphalt, outside the wooden frame. And when my son was introduced to someone, Oliver would pitch Oliver Snappie between himself and his new acquaintance, as if Oliver Snappie were some sort of primal offering. Even in his naming of Oliver Snappie, Oliver is performing the desire to live within an intermediate area (a transitional space) through an object that is not part of his body, yet is also "not fully recognized as belonging to external reality."[53] Eventually, Rosie was stolen by a little girl. And

Oliver Snappie is now all but forgotten about, save for her occasional appearances for mysterious tortures and odd bathing rituals.

Winnicott emphasizes that a true "not-me" separation from the mother (the world at hand) is never achieved (by either girls or boys), nor even desirable, and that we effectively and productively avoid such separation through "the filling in of the potential space [between me and not-me] with creative playing, with the use of symbols, and with all that eventually adds up to a cultural life [including the making of art]."[54] However, Winnicott does not take into account what I take to be the complex role that gender plays in the mother's own relationship to the transitional object. For, if the referent of the transitional object is the mother, then "the addiction" that she provides to her child (the addiction that her mother first gave her) becomes a fascinating and perpetual addiction to self. Recalling Irigaray's reading of girls' play (as replaying the girl's close proximity to the body of the mother), I am compelled to understand a mother's replaying with transitional objects, as replayed through her own children, as part and parcel of her particularly gendered, lifelong, transitional play. Possibly because I share with Hawarden this reduplicative posture of being both mother and daughter, I see in Hawarden's pictures a framing of "not-me" objects that are also "me." Maybe this is why I have become addicted to my own family objects, given to me by my mother and grandmother.[55] Maybe this is why I have become addicted to Hawarden's objects.

But, as the empty-room photograph indicates, Hawarden does not give all of herself. Hawarden keeps a secret. Of mothers, Winnicott writes, "Surely there is a little bit of herself that is sacrosanct, that can't be got at even by her own child? Shall she defend or surrender? The awful thing is that if the mother has something hidden away somewhere, that is exactly what the small child wants. If there is no more than a secret, then it is the secret that must be found and turned inside out. Her handbag knows all about this."[56] Hawarden gives and gives us objects "Fresh on their mother twigs, Cherries worth getting . . . Piled on a dish of gold / Too huge for me to hold, What peaches with a velvet nap"[57] — but she keeps her purse shut tight.

Though we can find photographs of Isabella with her Pandora-like

box or Clementina with a toy village or Florence with her guitar, we never find Hawarden with her things, save for (possibly) once (fig. 59). This visually unremarkable picture is just as likely an image of Hawarden's look-alike sister, Anne Bontine. Head down, this unnameable woman, along with family friend Donald Cameron, look over Hawarden's reproductions. This secret keeper hardly shows us anything. She does not risk showing the skin of her shoulders or dressing up in fancy dress or coupling herself with beautiful objects. She does not flirt with us as Hawarden's daughters do. She merely frames herself in a space of benign reproduction. She remains a reduplication of herself or her sister, of a typically imaged Victorian woman of her class and time, as withheld. Like the photographs that she gazes down upon, impossible to make out, she keeps her self a secret.

Off-frame, I return to the empty room. I gently close the heavy book and carefully place it on the floor. I sit in the chair. I feel Hawarden's secret under me. I play with the objects that rest on the Gothic-style desk. As if they were dolls, I fiddle with the ceramic figurines that are delightfully costumed in eighteenth-century dress. I shake the tambourine. I look for fruit in the compotier. Looking up and across the room, I face Hawarden. Her secret stands between us: her camera box. Her secret plays in that precious space between me and her: it is an ultimate transitional object. Transcendent, her camera re-produces images that are both real and yet are "not fully recognized as belonging to external reality." Hawarden's photographs, like all photographs of family members, live in a magical intermediary area of transitional space: they are "me" and "not-me" objects par excellence.

CIRCLING BACK

Reduplicating her feminine, maternal, homoerotic desire through her daughters, through her repetitive photographs, through her daughters' mirror images, through the fetishistic objects that stand in for her daughters, through the objects that stand in for herself, Hawarden, like Rossetti's Lizzie, shuts out the chants of the (goblin) men: "She thrust[s] a dimpled finger in each ear."[58] Inside the secret recesses of the heart, a

Figure 59 *"This unnameable woman looks over*
Hawarden's reproductions."

dollhouse within the house, the words and pictures of Lizzie and Laura, of Clementina and Isabella, of same-sex pleasure, of Hawarden and Rossetti, of voice-off lovers chant together. Mother into daughter, daughter into sister, sister into lover, lover into reader, reader into looker, looker into listener. Click goes the shutter.

Caught touching each other, caught touching themselves, caught to touch Hawarden, caught to touch me, caught beckoning my touch — the lovely bodies of Hawarden's daughters reduplicate desire again and again. Desire for desire, I reduplicate Lizzie's maternal desire for her sister Laura through Christina Rossetti, for you, by me, again:

> Come and kiss me.
> Never mind my bruises,
> Hug me, kiss me, suck my juices
> Eat me, drink me, love me;
> Laura, make much of me.[59]

"IN WHICH THE STORY
PAUSES A LITTLE"

Along with the mournful photograph that makes a spectacle out of Hawarden's leggy humanoid camera reflected in the mirror, and along with her photograph of the empty room that begs to be illuminated (a picture of her "just *too close to see*" body), there is one more photograph that has long given me pause (perhaps more than any other): an uncanny photograph of Hawarden's camera box (fig. 60).

The photograph is curious not only because it represents a relatively small number of pictures of her husband, Lord Hawarden, but because it features her camera as critical object.[1] Like her camera and tripod in the mirror (and other well-chosen objects), it is a just image for Hawarden herself. But this time around, the camera is not a shadowy, blurry reflection, perhaps accidentally caught. This time, the camera sits there: solidly, defiantly. It makes no attempt to hide. (It is passive-aggressive.) Animistic, the camera is Hawarden. Just as the monogrammed stationery and luxurious lingerie and a host of other fetishistic objects are Rebecca in Alfred Hitchcock's film of the same name—a movie in which the main star, the central character, never *actually* appears but flickers through her objects everywhere—Hawarden is (poignantly once again) everywhere but nowhere to be found.

In this solid glimpse of her camera box, Lord Hawarden uses the instrument of her art as a desk in miniature, as a stage to write upon. Troubling, the photograph suggests that, even though she is an artist in her own right, she is written upon by paternal authority; Lord Hawarden uses her, the camera as desk, as if giving content to a silent, feminine body—a tabula rasa. Yet arguably, despite Lord Hawarden's frank rep-

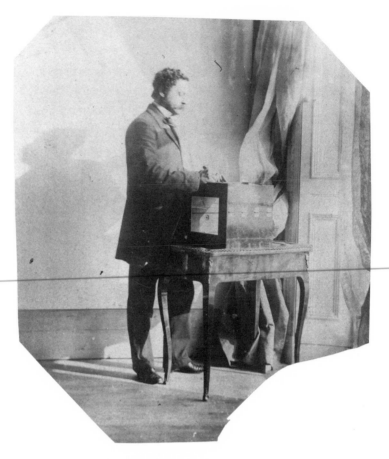

Figure 60 *"An uncanny photograph
of Hawarden's camera box."*

resentation, he is shut out of her box and generally out of her body of
work. Outside of the camera's frame, outside of the home as camera
box—Hawarden's passionate interior—is a space of play for the girls
and their mother and is walled off from his inscription.

But for now, before the picture fully develops, let the story pause a lit-
tle. Like the adolescent who becomes child again, let the story travel
backwards to its referent, as if it was photo/history. Peregrinating to-
ward what is considered to be the first camera, the camera obscura, a
form of the camera that existed long before Hawarden's "box," let us
knock on the doors that lead into Vermeer's interior boxes and into some

of his "realist" neighbors, including Samuel Van Hoogstraten's perspective box (the National Gallery calls it *A Peepshow with Views of the Interior of a Dutch House*); "The Two Bed-Chambers" of George Eliot's *Adam Bede*; and the dollhouse setting of Nicolaes Maes's *The Eavesdropping Woman*. Eventually (like Peter's Wendy), we will find our way back home, through the shutters of 5 Princes Gardens, where Hawarden's Horne & Thornethwaite camera box sat for its portrait while she stood back, outside of the frame, and took what was hers: home.

THE SECRETS OF THE CAMERA OBSCURA

The camera obscura *in short, has generated at one and the same time perspective painting, photography, and the diorama, which are all three arts of the stage.*
—Roland Barthes, *Camera Lucida*[2]

The case of the Dutch Masters revolves around the famous painter Vermeer, and takes place at a point in history when camera obscuras had been manufactured in small quantities. Astronomer Johann Kepler coined the term and laid claim to the machine as a "scientific device," though to me that misses the basic concept of the whole thing. In fact, that way of looking at it, that the camera merely captures nature, or reflects already existing beauty, couldn't be further from my own perspective. No, no, to my mind the camera creates whole new worlds. Vermeer shares my opinion, if I do say so . . .

What Vermeer saw when he looked into the Magic Lantern [a pinhole camera that functioned as a portable camera obscura] was a painting, but not just one painting. In every new direction he pointed the machine there appeared a new and more beautiful landscape. The way that the camera focused on objects at certain distances, but left others blurry, gave him an idea for a painting that had yet to be painted by anyone.
—David Knowles, *The Secrets of the Camera Obscura*[3]

David Knowles's fantastic (in both senses of the word) novel gives a surreal history of the camera obscura (focusing on its use and invention

Figures 61 and 62 *The giant camera obscura
in San Francisco, California.*

by the Chinese, followed by Leonardo and Vermeer). Part fact and part fiction, the "history" is narrated by a young man obsessed with the secrets/history of the camera obscura. Living in San Francisco, the writer/narrator works at the "real" camera obscura that sits today on the edge of the Pacific Ocean. It sits right next to what was once one of San Francisco's famous restaurants, The Cliff House, and the dramatic ruins of the long-closed saltwater baths (at one time of varying temperatures) that cascade down the cliffs to the water. Breathtaking, the drama of the scene is interrupted by the comically stubborn presence of a brightly painted box-house constructed to suggest, if primitively, a "real" 35mm camera (figs. 61 and 62). Black letters painted on the east wall boast "GIANT CAMERA." Inside, it becomes apparent that this fantasy structure is indeed a real camera obscura, whose lens moves like the hands of a clock around the vast ocean, around its seal-littered rocks, around the windmills in Golden Gate Park, around the rust-colored cliffs on shore, around the "long beach and coastline to the south,"[4] and back around again (the clock strikes twelve) to the empty ocean: "one complete circle every six minutes."[5] The pictures gained from this caressing lens appear as a silent movie (seemingly in slow motion) on a large white concave disc-screen, that stands at waist height in the center of the camera obscura's nearly pitch-black interior. The whole thing is mysteriously done with mirrors. The only light comes from the sunlight captured "from a kind of periscope on the ceiling"[6] onto the magical circle. "The difficult part comes in describing the emotions which gazing down at the screen evokes. I'm not sure one could adequately write down this phenomenon. Really, it falls under the category of *you have to see it for yourself*."[7] Those in the know, as I am now, send a friend or loved one out to the cliffs to wave as the silent lens passes by. When my husband waved to me and my children, he could not hear or see us. We remained hidden inside the camera box, squealing at my husband's familiar image made just for us. A dream of himself; he was both there and not there, just like a real photograph.

Realism, as a literary and art historical term, is (as Linda Nochlin has noted) double-edged.[8] Realism is real in that it depicts the details of everyday life, *almost* like a camera. But realism is also real in that it shows

off its medium; it makes a spectacle out of its materiality. Dutch painting, such as Vermeer's, is often associated with realism for its emphasis on the everyday (on domestic life), for its striking illusionism (which is often associated with the period's invention of the *first* camera, the camera obscura), and for showing off its painterly brush strokes.

Vermeer's interiors, which stage a limited range of subjects — a maid delivering a letter to her mistress, a young woman in blue reading a letter by the light of an open window, a maid asleep before a table full of food, a back view of a woman receiving a music lesson (the top of her striking head and her barely visible face reflected in the mirror hanging

Figure 63 *Vermeer,* Mistress and Maid, *ca. 1667–68.*

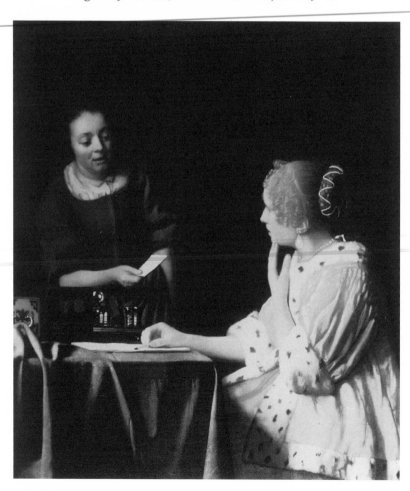

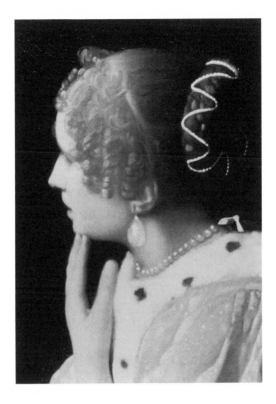

Figure 64 *Vermeer,*
Mistress and Maid,
ca. 1667–68, detail.

above the virginal)—"mirror nature so faithfully that they deceive the
eye into believing that they are real."[9] (Vermeer's emphasis on mostly
bourgeois interior settings captured voyeuristically with a dollhouse
effect—along with his fetishization of both objects, especially mirrors,
and the goings-on between women—is strikingly reminiscent of Hawar-
den's photographs.)

Yet Vermeer fought this illusionism by making a spectacle out the ma-
teriality of his paintings, by painting some areas of his canvas crisp and
others blurry, as if his painting eye were a camera eye going in and out of
focus. In *Mistress and Maid* (figs. 63 and 64), Vermeer makes a dazzling
spectacle out of glistening white patches of paint that both blur the mis-
tress's pearl necklace and make it sing. Her large teardrop earrings are a
combination of blurry transparent and thick white paint that magically
luminesce, as if they were tiny paper lanterns lit by firefly light. Black
splotches on her ermine-trimmed yellow coat are equally seductive as
representations of pure paint or fur. An economy of brush strokes cre-

ates the nearly photographic illusion of spit curls around the lady's pearlescent face, which, when viewed up close, give way to a tangible, nearly culinary play with paint, as if the paint were not paint but butter and cream cheese.

Vermeer is also a great lover of the picture within a picture, a motif that insists that the viewer confront the paintingness of painting. Within Vermeer's oeuvre of only thirty-four or thirty-five paintings, there are eighteen other paintings within his paintings.[10] (Likewise, Vermeer's paintings often contain paintings of other pictorial flat objects of deception: the mirror, the map, the reflection in the window.) Yet again, this picture-within-the-picture realism of Vermeer's is double-edged: alongside the spectacled artifice of a painting within a painting (in the spirit of Courbet's *Real Allegory* or Velásquez's *Las Meninas*) is the fact that Dutch homes were generously decorated with pictures. The picture within the picture can be read as evidence of the relationship between the home and the pictures of home within (kitchen views, musical scenes, the receiving and reading of personal letters). House frames and picture frames. Home as picture box.

Like stepping into the GIANT CAMERA, stepping into a Vermeer painting requires going through painting after painting, confronting the materiality of the illusion. The effect of both is unbelievably pretty reality: the San Francisco camera, like Vermeer's painting, "*does* portray the world in a much more beautiful light than the naked eye alone."[11]

BUTTER AND MILK

In *Adam Bede* (a novel written at the start of Hawarden's photographic career, 1859), George Eliot's love for Dutch paintings appears as an inspirational source for her own double-edged literary realism. The narrative revolves around the realness of her detailed accounts of a rural community, pastoral landscapes, the fall of the young, beautiful, lower-class, pleasure-seeking Hetty Sorrel (whose story was based on a real broadsheet account of a woman executed on Nottingham Gallows on 16 March 1802), and the relentless suffering of Adam Bede on his way to manhood, a truthfulness she relates to Dutch painting:

It is for . . . [the] rare, precious quality of truthfulness that I delight in many Dutch paintings, which lofty minded people despise. I find a delicious sympathy in these faithful pictures of a monotonous homely existence, which has been the fate of so many more among my fellow-mortals than a life of pomp or of absolute indigence, of tragic suffering or of world-stirring actions. I turn without shrinking from cloud-borne angels, from prophets, sibyls, and heroic warriors, to an old woman bending over her flower-pot, or eating her solitary dinner, while the noonday light, softened perhaps by a screen of leaves, falls on her mob-cap, and just touches the rim of her spinning-wheel and her stone jug, and all those cheap common things which are the precious necessaries of life to her.[12]

Yet, for all of its realness, *Adam Bede* is often excessively pretty, especially when it comes to describing Hetty, whom Eliot is crazy about. Eliot's passion for Hetty is so intense that every reader must fall in love with (or into a state of saccharine fullness for) the young blousy woman, whose beauty is "like that of kittens, or very small downy ducks making gentle rippling noises with their soft bills, or babies just beginning to toddle and to engage in conscious mischief—a beauty with which you can never be angry, but that you feel ready to crush for inability to comprehend the state of mind into which it throws you" (127). Personally, I fall in love with Hetty each time I read the novel. The passage that always leaves me in a state of longing passion is Eliot's description of Hetty's warm, adolescent beauty in the cool, fragrant, soft-colored dairy:

The dairy was certainly worth looking at: it was a scene to sicken for with a sort of calenture in hot and dusty streets — such coolness, such purity, such fresh fragrance of new-pressed cheese, of firm butter, of wooden vessels perpetually bathed in pure water; such soft colouring of red earthenware and creamy surfaces, brown wood and polished tin, grey limestone and rich orange-red dust on the iron weights and hooks and hinges. But one gets only a confused notion of these details when they surround a distractingly pretty girl of seventeen, standing on little

Figure 65 *Vermeer,*
The Milkmaid,
ca. 1658–60.

Figure 66 *Vermeer,*
The Milkmaid,
ca. 1658–60, detail
of footwarmer.

pattens and rounding her dimpled arm to lift a pound of butter on the scale.

Hetty blushed a deep rose colour when Captain Donnithorne entered the dairy and spoke to her; but it was not at all a distressed blush, for it was inwreathed with smiles and dimples, and with sparkles from under long curled dark eyelashes; and while her aunt was discoursing to him about the limited amount of milk that was to be spared for butter and cheese . . . Hetty tossed and patted the pound of butter with quite a self-possessed, coquettish air, slyly conscious that no turn of her head was lost. (127)[13]

The descriptive details of Hetty cast her in the light of a Vermeer painting. For like Vermeer's portrait *The Milkmaid* (fig. 65) — in which the beautiful yet common details of a closed wicker basket, a glistening brass basket, whole and broken loaves of "heavy bread," a lonely footwarmer (fig. 66), a scrap of cobalt blue cloth on the covered table, the woman's lifted cobalt blue overskirt, and especially the open, "cavernous" pitcher from which "the milk trickles (up and over the jug's lip, as if its own accord)"[14] — the details surrounding Hetty (the "soft colouring of red earthenware and creamy surfaces, brown wood and polished tin, grey limestone and rich orange-red iron rust on the iron weights and hooks and hinges" and the "firm . . . pound of butter") are one with the "distractingly pretty girl" at the center of the canvas as stage. Hetty's scene and the milkmaid's are entirely ravishing, delectable, as delicious as the butter and milk so efficiently described. The milk as an extension of the milkmaid's sensually fortified arms; the butter as an extension of Hetty's sensually (if a bit overfortified) creamy, dimpled arms. When describing Hetty, Eliot (like Vermeer) "*does* portray the world in a much more beautiful light than the naked eye alone."

"THE TWO BED-CHAMBERS"

The materiality of Eliot's Vermeeresque butter-paint in "The Dairy" (chapter 7) is but one of hundreds of details in the material-laden

wor(l)ds of *Adam Bede*, but possibly "The Two Bed-Chambers" (chapter 15) contains the image that is not only most like a Dutch painting but that also makes a drama out of its double-edged realism. In "The Two Bed-Chambers," Eliot provides simultaneous portraits of the good, pious, devoutly religious, thin, practical, pleasure-denying Dinah and the overindulging, earring-laden, chubby, pleasure-loving Hetty (she cared most "about the prettiness of the new things that she would buy for herself"; 200) in separate bedchambers: "Hetty and Dinah both slept in the second story, in rooms adjoining each other, meagerly furnished rooms, with no blinds to shut out the light, which was now beginning to gather new strength from the rising moon" (194). As voyeurs, we are made extra aware of Eliot's construction of this usually impossible double, one might even say stereoscopic, scene. We share the double peep with Eliot in hushed intimacy. Hetty is busy: lighting secretly bought candles, taking her hair down, wrapping a black lace scarf around her bare white shoulders, and replacing her tiny earrings with large ones of "coloured glass and gilding" (196). She sits down with everything in place to admire her image in the mirror: "She looked down at her arms: no arms could be prettier down to a little way below the elbow — they were white and plump, and dimpled to match her cheeks; but towards the wrist, she thought with vexation that they were coarsened by butter-making, and other work that ladies never did"(196). At the same time, Dinah, covered in a long white dress, is sitting in a chair by her window, gazing out at the meadow and worrying over Hetty's seemingly unstoppable script of falling into disrepute.

The scene of the two bedchambers reads like one of Nicolaes Maes's (also seventeenth-century Dutch) paintings of cutaway houses that synchronously reveal to the (voyeuristic) viewer what is going on in different rooms. I am most specifically reminded of Maes's *The Eavesdropping Woman* (fig. 67), which features a "young woman who has come downstairs from the dinner table, looking for the maid to refill her glass."[15] Caught between two rooms, two levels, the eavesdropper shares with us her awareness of the dinner guests upstairs and the maid downstairs being led to another room by a well-dressed man. "The woman,

Figure 67 *Nicolaes Maes,* The Eavesdroping Woman, *1657.*

who can evidently hear . . . [the tantalizing goings-on of the maid and the gentleman], raises her finger to her lips and smiles."[16]

And just as the woman in Maes's *The Eavesdropper* surprises us by showing her awareness of our presence through a knowing wink in her eye and the ssh of her pursed yet smiling lips and the "Quiet now" gesture of her raised right index finger, Eliot surprises us even more a bit further along, in chapter 17, "In Which the Story Pauses a Little." There Eliot pauses and talks to her readers, jerking us out from under the sheets of the book, out of the details of a great story, by reminding us that we are readers of her book, experiencing real time, real distance, critical drifting. Beginning the chapter with an imagined voice of one of her readers, Eliot exclaims, " 'This Rector of Broxton [a character in the novel] is little better than a pagan!' I hear one of my lady readers exclaim"(223). Eliot stops the story of Adam and Hetty and Dinah to talk to us about the book, about reading, about class, about truthfulness, about realism, making even the book itself (materially) real. She drifts into the ease of falsity,

the difficulty of even expressing one's "own immediate feelings," her "delight" in Dutch paintings because they contain that "rare, precious quality of truthfulness," and much more (222–23). Her words (on paper in a printed volume that is clutched between our own hands after coming from the hand of Eliot) announce their own materiality, not unlike the splotches of paint on Vermeer's canvases or Nicholas Maes's double rooms and winking voyeurs, who metaphorically look in and out of the painting at once.

CAMERA BOX

In *Camera Lucida,* Barthes boldly names photography's connection to the real to be its essential nature, its genius. But the difficulty of naming it (the real) turns his words of unnerving beauty into a voluntary stutter, a broken song. With spasmodic repetition — starting, stopping only to start again — *Camera Lucida* is after the lost real, as is the camera itself. Opening and closing its shutters throughout its forty-eight snapshot-size chapters, *Camera Lucida* theatricalizes the real, a mise-en-scène of broken parts: fragmented sentences, retractions framed by parentheses, large blank white spaces between chapters. It reads like Eadweard Muybridge's multiple frames in pursuit of the detailed seconds of a horse's gallop, a mother's embrace of her child, the jump of a jump-roper — where the real seems to reside as strongly in the lost seconds between shots as in the pictures themselves. Like Barthes's writing, Muybridge's photos are about the materiality of the medium itself: the mechanical distance of the camera, ticking away, like a "clock for seeing."[17]

In the following passage from *Camera Lucida,* Barthes nimbly moves photography away from the eye (which is always closely connected to seeingness, believability, the truth, the proof, the real) and into the finger, the haptic guide to materiality, and finally into the ear, which catches not light but the sound of photographic machinery at work, the sound of material time being clicked away, like a chisel on stone:

> For me, the Photographer's organ is not his eye (which terrifies
> me) but his finger: what is linked to the trigger of the lens, to the

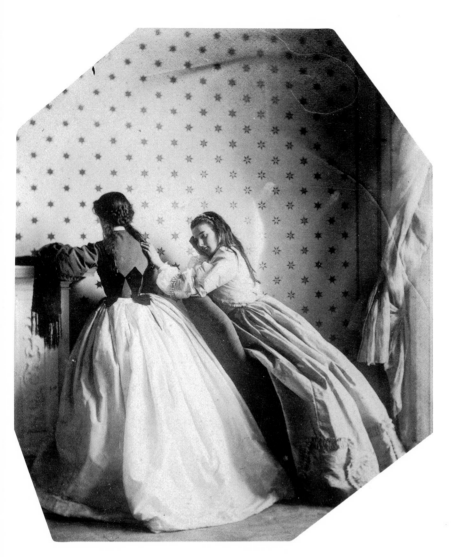

Plate 1 *Clementina "dramatically, yet subtly, pulling on a tender lock of her sister's hair."*

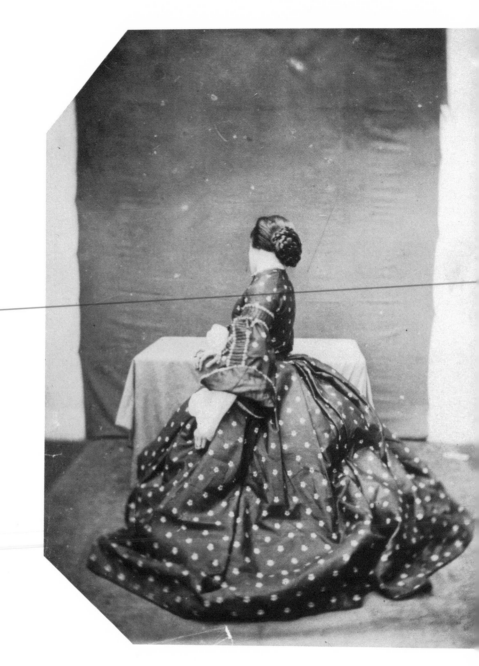

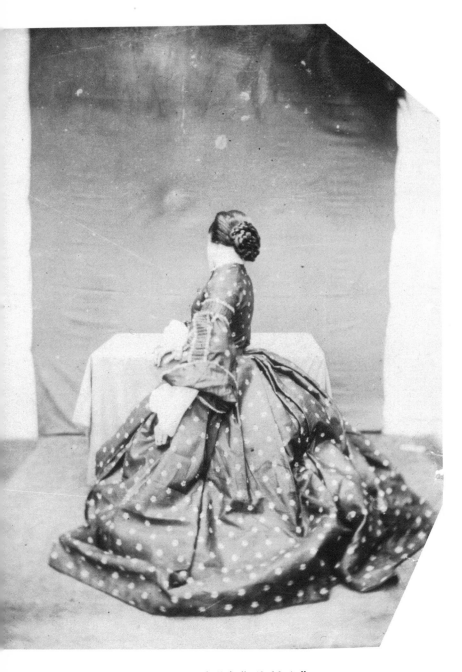

Plate 2 *Isabella's "coiled hair."*

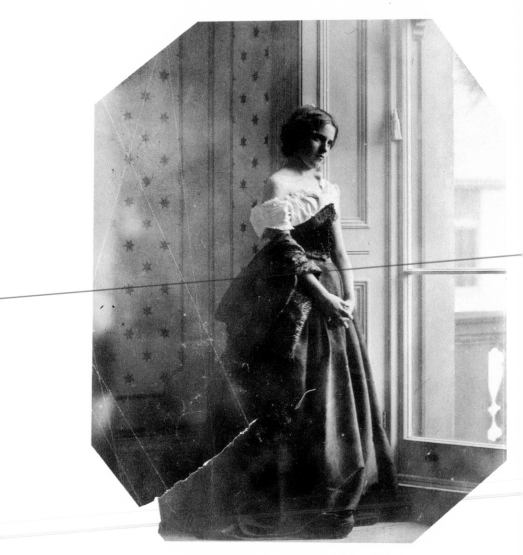

Plate 3 *Clementina "playing at modesty."*

Plate 4 *Sally Mann*, Jessie at Twelve (Before), *1994*.

Plate 5 *Sally Mann*, Jessie at Twelve (After), *1994*.

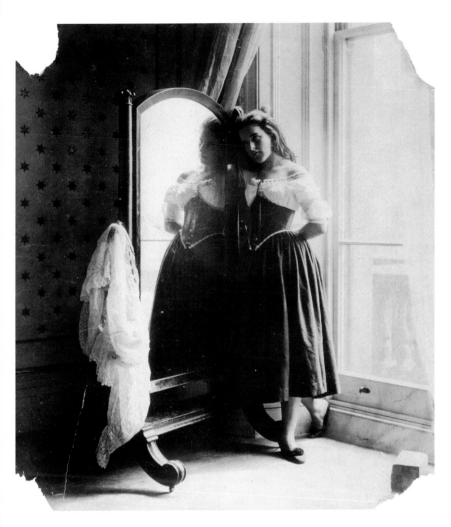

Plate 6 *"Yet another of the photographs of Clementina dressed in her Victorian undergarments before a mirror."*

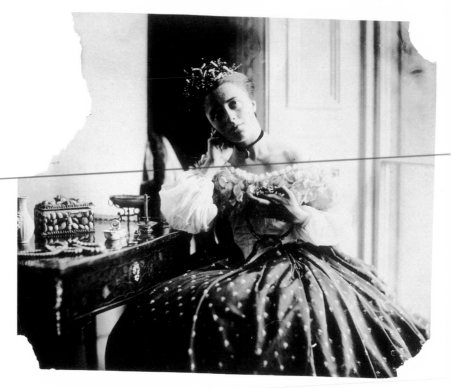

Plate 7 *Isabella and "the (Pandora's) box decorated with shells."*

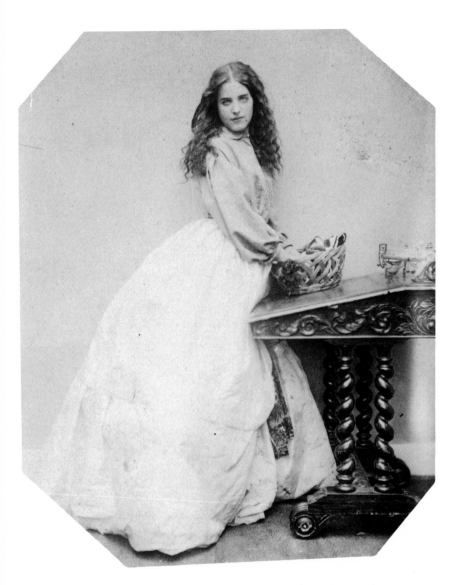

Plate 8 *"The Gothic-style desk, whose elaborately carved legs mirror daughter Clementina's own ringlets."*

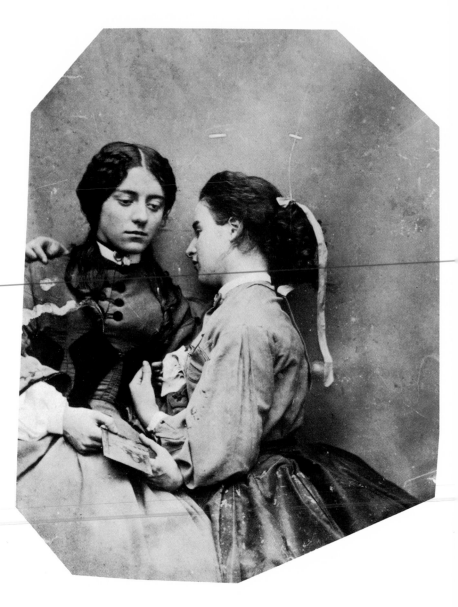

Plate 9 *Clementina and Isabella sharing a photograph of Florence.*"

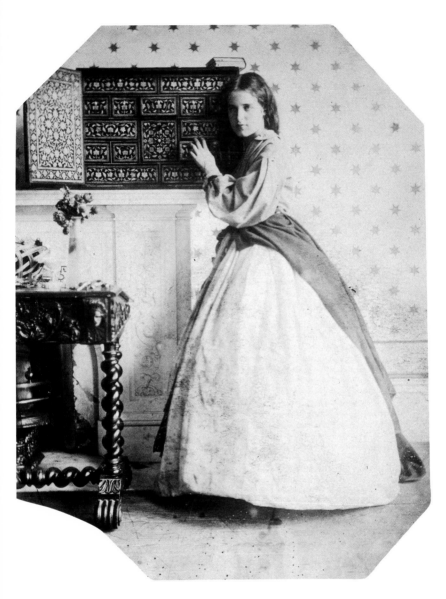

Plate 10 *Clementina's "left hand pulls open one of the tiny drawers."*

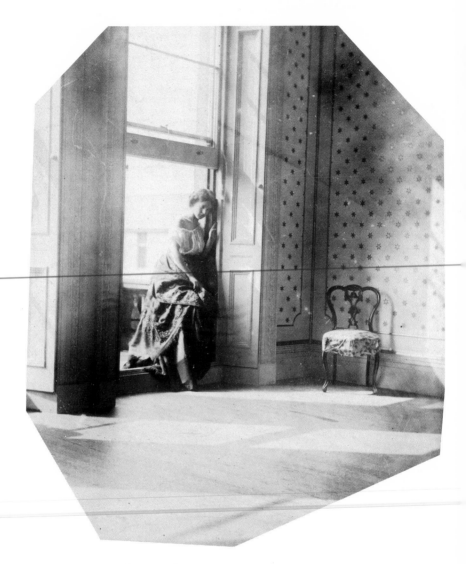

Plate 11 *The chair "hides and waits behind the shutter of the giant window."*

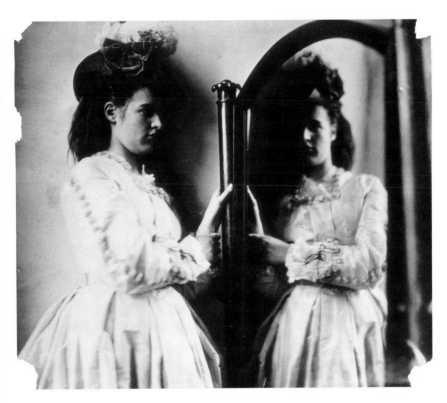

Plate 12 *"Clementina in a fancy hat."*

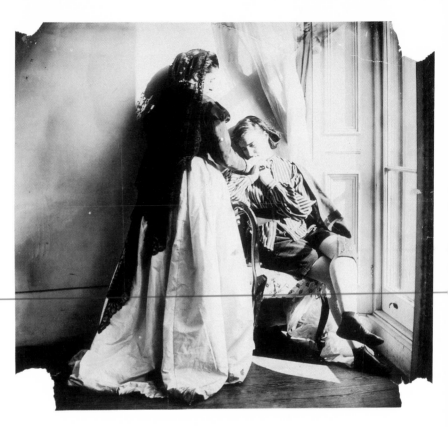

Plate 13 *"Clementina uses both of her hands to press Isabella's right hand firmly to her lips."*

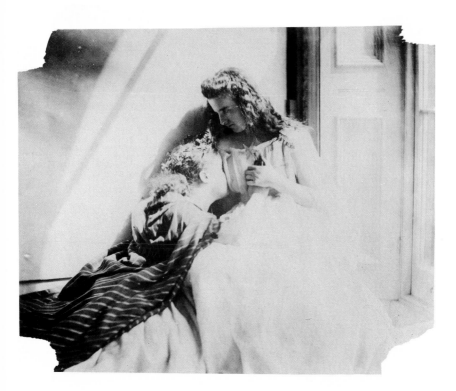

Plate 14 *"An image of a grown girl nearly suckling."*

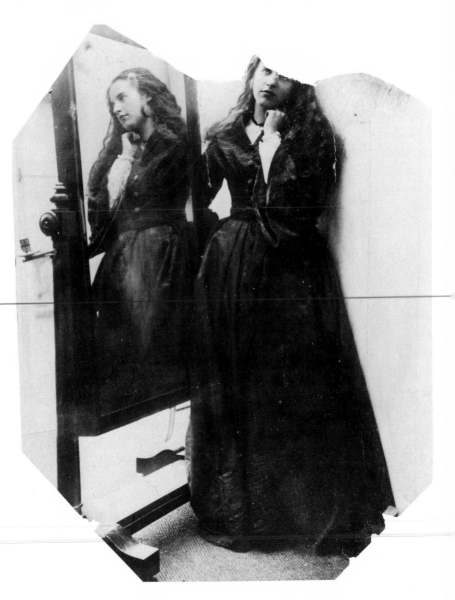

Plate 15 *"The brilliantly torn image of Clementina by the mirror."*

metallic shifting of the plates (when the camera still has such things). I love these mechanical sounds in an almost voluptuous way, as if, in the Photograph, they were the very thing—and the only thing—to which my desire clings, their abrupt click breaking through the mortiferous layer of the Pose. For me the noise of Time is not sad: I love bells, clocks, watches—and I recall that at first photographic implements were related to techniques of cabinetmaking and the machinery of precision: cameras, in short, were clocks for seeing, and perhaps in me someone very old still hears in the photographic mechanism the living sound of the wood.[18]

Barthes emphasizes the materiality of the photograph (the rawness of catching the most subtle grains of light on the glass or film, to be richly developed onto paper) as the other edge of photography's realism.

Likewise, the Hawarden girls unremittingly emphasize the materiality of their bodies and their beautiful dresses and their curtained windows and their select objects—by rubbing fabric between their fingers, by erotically embowering the bodies of their sisters, by pretending to sleep in the rays of afternoon light so as to make their very being and their layers of negligee shimmer. Their mother emphasizes the materiality of the photographs, not only through the conventional material play of making pictures within pictures—by using reflections in the mirror or the window, or by taking a photograph of Clementina and Isabella looking at a photograph of their sister Florence—but also by photographing her camera, her wooden box. The Hawarden camera box is a collecting thing, a material thing for collecting the material of her life. As part of Hawarden's lexicon, this box collects more things (images), as a dollhouse collects dolls and bits of furniture.

Let us now recall the image of Lord Hawarden with his wife's camera box. The dramatic presence of the photograph's curtains, which speak their own silent but nonetheless recognizable language, suggest that the interior of this camera/home is indeed threatened. As in the photograph that presents Clementina's twisted hands and her outstretched arms as nearly indistinct from the fabric that binds them (see fig. 42), the familiar

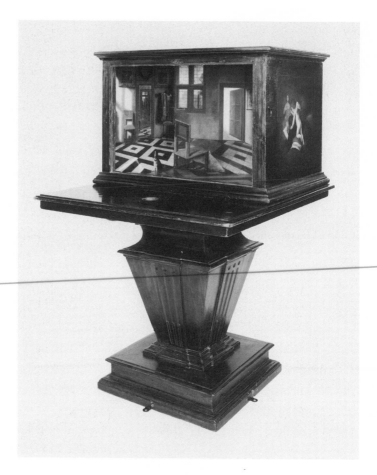

Figure 68 *Samuel Van Hoogstraten,* Perspective Box
with Views of a Dutch Interior, *late 1860's.*

curtains are as animistic as the camera itself. As if trying to pull the cam-
era away from his inscription, the curtains billow and embrace and grab
hold of one of the table's legs, twisting and turning their way up the wall.
As if gasping, the sensual folds of the curtains open, close, gape. With
their precocious femininity, the curtains contest the presence of Lord
Hawarden: both his shadow that looms on the wall and his shadow that
has appeared as unexpected picture within the interior, within the cam-
era, within the album.[19] In the picture, I see him, but I hear the voices of
the mother and her girls, the clicking shutter, "the living sound of the
wood."

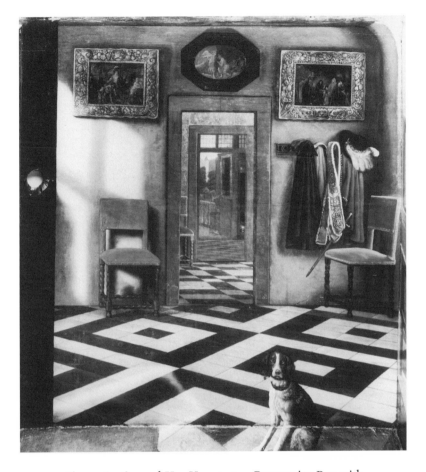

Figure 69 *Samual Van Hoogstraten,* Perspective Box with
Views of a Dutch Interior, *late 1860's, detail.*

The photograph reminds me of the work of yet another Dutch artist
(and writer), Samuel Van Hoogstraten (1627–1678), whose enthusiasm
for "trompe l'oeil performances"[20] led him to create his own elaborate
dollhouse-size perspective box (figs. 68 and 69). His curious box features
five views of a domestic interior in a wooden rectangle of similar, if
slightly larger, dimensions than Hawarden's camera box; the Van Hoog-
straten box is "about two feet high, three feet wide, and two feet deep"
(173). Like a dollhouse, the front face is open. The ever-important light
is admitted through the open wall, "which was originally covered with
some kind of translucent paper and is now fitted with a clear plastic

pane." (The box's combination of light and illusion calls to mind the Dutch artist's fascination with the camera obscura.) Inside the perspective box are painted "compelling illusions of scale and three-dimensionality" (177). Today, there are only "six extant works in this genre," and Van Hoogstraten's *Perspective Box with View of a Dutch Interior*, most commonly referred to as the London box, is "by far the most accomplished" (173).[21] Records show that the box was bought by a London man in 1861 (364). He probably did not know Hawarden, but could have.

Painted on a complex structure of converging multiple planes, the London box makes real the principles of perspective through the floors and walls of nine different furnished and inhabited rooms. In a manner similar to anamorphosis, the rooms do not make much visual sense when viewed head on; however, when observed through the two peepholes provided opposite each other on the box's short sides, the interior spaces become tangibly real.[22] Looking into the perspective box, like looking through a stereoscope, creates "delightful deceptions" of reality, so much so that the viewer forgets his or her surroundings and becomes willingly lost in the artifice and voyeurism of the experience. In fact, as Celeste Brusati points out, thanks to the modern pedestal on which the box now rests, the "viewing holes are suggestively at keyhole level" (173). Van Hoogstraten himself noted "with nearly audible pleasure in his painting treatise that the perspective box, when properly executed," can "make a 'finger-length figure appear to be life-sized'" (169). And like the stereoscope, the perspective box is a complex pictorial demonstration of how the eye is deceived by nature. For inherent to both the perspective box and the stereoscope is the tension of forcing the observer to "be simultaneously the magician and the deceived."[23] And, like the realist painting, the box fools the eye and calls attention to its artifice. As Brusati notes, "the viewer's eye is quite literally held captive at the juncture of its own world and that of the artist's crafting" (181). Little wonder that The National Gallery wall label gives the box the title *A Peepshow with Views of the Interior of a Dutch House*.

By including "his own and his wife's coats of arms" (182) and a tiny envelope addressed to him that lies under a delectable red chair, Van Hoogstraten presents the box as his own home, just as Hawarden photo-

graphically presents her first-floor rooms as both her art and her home. And like Hawarden's photographs, the box contains select curious objects: not only the letter, but "an empty chair" on which lie a string of pearls and a comb, a mirror that hangs over the chair, many tiny paintings on the walls, emblems of Venus, a bed upon which a woman sleeps, a woman reading, a dog, "feminine charms which ensnare the eye of the beholder" (181–82). And again like Hawarden's photographs of the interior of 5 Princes Gardens, whose window provides shots of South Kensington's blossoming museum complex, houses, horticultural gardens, and an international bazaar, the London box provides "framed glimpses of an outside world beyond" (173).

Brusati deftly argues that Van Hoogstraten's box "thematizes . . . aesthetic conquest . . . [through] the explicitly gendered imagery he uses inside the box" (181): the male artist/viewer, the masterful eye, looks through the peephole at a quiet domestic interior and female inhabitants presented with pleasurable illusion. He, the viewer, even sees, "when looking into the box from the left . . . a man with his eye pressed to the window secretly watching a woman absorbed in her reading . . . This Peeping Tom figure duplicates the activity of the beholder, who in turn spies not only on him, but also on the woman reading and on a second unsuspecting woman asleep in the adjacent bedroom" (181). In contrast, Hawarden's photograph of her camera box that takes explicitly feminine photographs in her feminine interior, taken by another camera in that very interior, turns such aesthetic conquest inside out. Lord Hawarden, who does not look through the (conspicuously absent) lens of the camera nor any other peep hole, appears to be taken within the linings of his wife's studio/home for the sole purpose of picturing him dramatically out of place. Focused not on looking, he appears to be writing, but writing what? His firm masculine stance and blank expression suggest numbers, accounting, inventory, the hard facts—not the love of costume, erotic embraces, maternal love, adolescent pleasure, flagrant narcissism.

The home as camera box develops into the architectonics of the Hawarden pictures. Though her home was torn down in 1955, what remains are traces of what once was there, the ruins: the photographs of the interior of 5 Princes Gardens, the home as dollhouse, as picture box.

And the pictures themselves are now housed in boxes at the Victoria and Albert Museum (prophetically pictured in the background of many of the photographs). Inside the camera box (as home, as collector, as picture taker) are its secrets: lace shawls, satin petticoats, velvet breeches, silk stockings, pearl hairpins, faux mustaches, the vase, the wooden doll, the Gothic-style desk, the girls. Like Hope under the lid of Pandora's box, the girls and their things remain hidden in the photograph of Lord Hawarden and the box. Joining them in the darkness of the box, I hear the shutter, I hear "the metallic shifting of the plates" (a sonorous sound), and the story pauses a little.

SAPPHIC NARCISSA

*All Sapphic speculation has its roots in Sappho's own
rejection of the readerly desire for unambiguous
erotic resolution.*

—Joan DeJean, *Fictions of Sappho*[1]

The cheval-glass mirror stands out among all other objects in Hawarden's passionate interiors. Reflecting as it does the back walls, corners, views out the windows that we cannot otherwise see—Clementina dressing, Clementina looking at herself, even Clementina's mirror image looking out at us—the mirror in Hawarden's pictures serves the double function of reflecting back to us visions of feminine narcissism and showing us photography's own narcissistic trick of doubling its subjects.[2] In the charming photograph of Clementina in a fancy hat, she checks out herself, her twin, in the mirror (plate 12). The "real" Clementina stands demurely to the side while the "reflected" Clementina faces the viewer frontally. The two appear to touch hands lovingly in a fashion reminiscent of the photograph in which Clementina weds her ungloved hand to the forearm of her sister Isabella (see fig. 40). In the double image of Clementina in Oriental dress standing before the mirror wearing a tightly fitted bodice, a headdress, and veil, the viewer is caught unaware by the blurriness of the "real" girl, who stands in marked contrast to her in-focus mirror image (fig. 70). Furthermore, Clementina's reflection is doubly surprising in that it also reveals an unexpected, fuller view of Clementina's face and body. Her lovely face, the roundness of her breasts, the solid slimness of her waist meet the viewer head-on as possible *only* through the mirror—and at the cost of Cle-

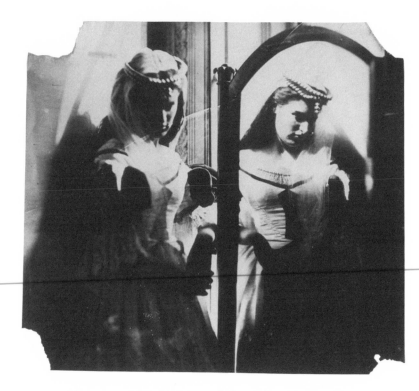

Figure 70 *A "double image of Clementina in Oriental dress standing before the mirror wearing a tightly fitted bodice."*

mentina, whose shadowy form quietly retreats from her flirtatious reflection. Clementina's mirror image is in pursuit of itself. Who is she flirting with? Her referent? Me? Another viewer? Her mother behind the camera?

As is the case in the photographs that feature the theatrics of Clementina playing page to Isabella as Mary, Queen of Scots—as when Clementina uses both of her hands to press Isabella's right hand firmly to her lips (plate 13), or when Clementina studies Isabella's right hand, as if in preparation for a kiss, for a taste of perfect fingers (fig. 71)—sapphic love is easily found in Hawarden's images of daughters in pairs.

Clementina's mirror images emphasize that sapphic love is never far from Narcissus, who, in psychoanalytic theory, is a privileged sign of homosexuality. Significantly, Freud used the term "narcissism" in his famed "Leonardo da Vinci and a Memory of His Childhood" (1910) to

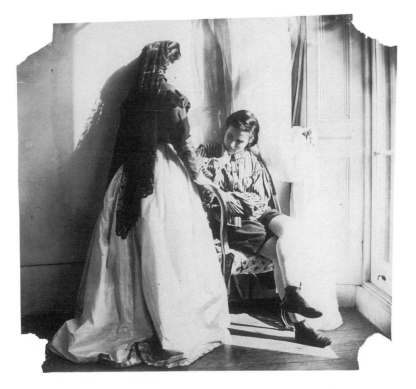

Figure 71 *"Clementina studies Isabella's right hand,
as if in preparation for a kiss."*

describe what he considered to be the autoeroticism of the male homo-
sexual, who seeks, Freud argues, "boys whom he loves in the way in
which his mother loved *him* when he was a child. He finds the objects
of his love along the path of *narcissism*, as we say; for Narcissus, accord-
ing to the Greek legend, was a youth who preferred his own reflection
to everything else and who was changed into the lovely flower of that
name."[3]

But how do women reflect narcissism? In "On Narcissism: An Intro-
duction" (1914), Freud attributed female narcissism to a woman's fasci-
nation with her own good looks. But unlike his favored male homosex-
ual Narcissus (arguably a reflection of his own infatuation with Fliess[4]),
Freud's stereotypical Narcissa is grown in a bed of heterosexual pre-
sumption: her homosexual blooms are carefully snipped at the bud. As in
the case of fetishism, Freud does not allow woman to be a pervert in her

own right. Rather, he tells two different stories of narcissism: a man's narcissism is homoerotic; a woman's is not:

> Women, especially if they grow up with good looks, develop a certain self-contentment which compensates them for social restrictions that are imposed upon them in their choice of object. Strictly speaking, it is only themselves that such women love with an intensity comparable to that of the man's love for them. Nor does their need lie in the direction of loving, but of being loved; and the man who fulfills this condition is the one who finds favour with them. The importance of this type of woman for the erotic life of mankind is to be rated very high. Such women have the greatest fascination for men.[5]

What Freud leaves out (and this is by no means a surprise) is the intense, erotic drive with which women look at other women. In the face of the old cliché that "women dress for other women," I want to focus on/argue for a dimension of homoeroticism that figures on a certain knowingness about the materiality of dressing. It is a knowingness that encourages coming closer, turning around, feeling fabric (Is it silk? Is it old?), feeling buttons, feeling beads, smelling a perfume, opening and closing lockets, the exchanging of goods, in order to take in every detail.

Inspired by Teresa de Lauretis's book, *The Practice of Love: Lesbian Sexuality and Perverse Desire*, I am turning Freud inside out and reclaiming for Hawarden's pictures "a notion of perverse desire where perverse means not pathological but rather non-heterosexual or non-normatively heterosexual."[6] I am, so to speak, taking a long hard look in Hawarden's mirror in order to see Hawarden queerly.[7]

QUEER (RE)PRODUCTION: A NARCISSISTIC TRICK

As I write, reproductions of Hawarden's mirror photographs are all over the floor, are pinned to my walls, are in proof sheets, negatives, books. Among my many photographs of reduplicating Hawarden bonbon girls, ready to eat up their *crème glacée* in the mirror (*la glace*), are the texts that talk to me the way I talk to myself in the mirror. Significant is my

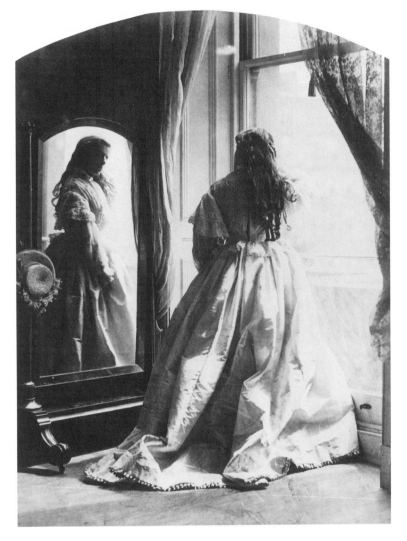

Figure 72 *"Clementina before a mirror."*

stained but now highly collectible summer 1978 *October*; a special issue
on photography, the journal includes, among other essays that are very
important to me, Craig Owens's "Photography *en abyme*." So smart, so
stimulating, so cryptically seductive, the essay (as if catering to my own
pleasures) even (and quite surprisingly) includes an image of Clementina
before a mirror (fig. 72)—a rarity to find Hawarden so eloquently, if
briefly, *theorized*.

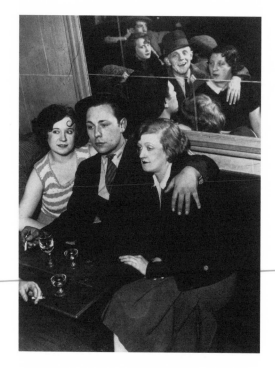

Figure 73 *Brassaï,*
Group in a Dance
Hall, *ca. 1932.*

Owens's article analogizes photography (the idea of *the photograph*) as a mirror image in both historic and linguistic terms: from the fact that "photography in its earliest manifestations . . . was frequently referred to as 'Dauguerre's mirror' "[8] to the "reduplicative" babble of infants performed before a mirror (da/da, pa/pa, ma/ma), the latter a linguistic *mise en abyme.* Punctuating Owens's essay are photographs that insist that the viewer understand photography's use of mirrors within its images—from Hawarden's image of Clementina to Brassaï's *Group in a Dance Hall* (fig. 73)—as an interiorized and self-endowed "method of self-interpretation . . . which gives rise to commentary on the conditions of photography itself."[9] A mirror within a photograph is a photograph within a photograph: a *mise en abyme.* Clementina before a mirror "tell[s] us in a photograph what a photograph is—*en abyme.*"[10]

Although Owens never mentions "sexuality" (let alone "gay," "lesbian," or "queer," though he most surely does toward the end of his brief career, so important, so mourned), through him, I mirror the photographic process as analogous to same-sex coupling. Without the genera-

tive original, the photographic image is simulated over and over again, endlessly reproducing itself through the camera's process of mirroring the referent. Magically and narcissistically, the referent becomes inseparable from the photograph itself. (As Barthes has put it: "The Photograph always carries its referent with itself . . . both affected by the same amorous . . . immobility . . . like those pairs of fish . . . which navigate in convoy, as though united by eternal coitus."[11]) Likewise, the photographs themselves, printed in multiple copies, ensure the abyss of endless reproduction, without origin, without end: the *mise en abyme* of the mirror within a mirror within a mirror. Photography undoes the subject/object (heterosexualized) couple at the root of most origin stories and uses its own narcissism for queer (re)production. If the photographic process itself can be imagined as queer, perhaps no pictures are more queer than the stereographs that burst into popularity in the 1850s.[12]

QUEER STEREO

I always thought of photography as a naughty thing to do — that was one of my favorite things about it . . . and when I first did it I felt very perverse.

— Diane Arbus[13]

Hawarden's stereoscopic pictures of her daughters stealing looks in the mirror emphasize not only the homoerotics of doubling women, the queerness of the medium of photography, but also the queerness of seeing (figs. 74 and 75). As all stereoscopic images make evident, the gaze is, in fact, not monoscopic. The gaze (understood with two eyes, each of which sees a slightly different image), like the stereograph, is composed of "binocular disparity."[14] Jonathan Crary describes how, in 1833, Charles Wheatstone, one of two figures most closely associated with the invention of the stereoscope, observed and successfully measured the "binocular parallax, or the degree to which the angle of the axis of each eye differed when focused on the same point."[15] Yet we see, as if we were seeing with one eye. Why? According to Crary, Wheatstone claimed that "The human organism [has] the capacity under most conditions to

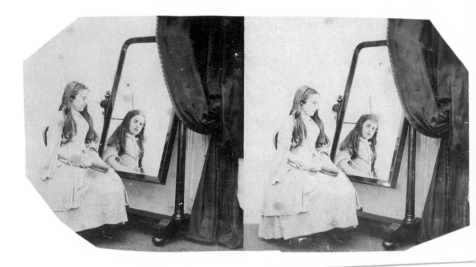

Figure 74 *"Stealing looks in the mirror."*

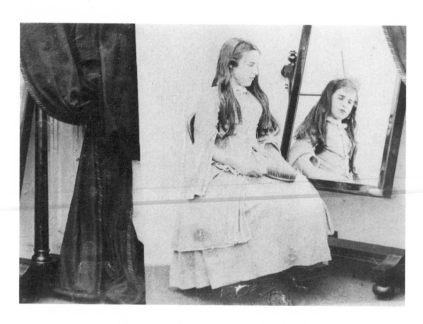

Figure 75 *"The queerness of seeing."*

Figure 76 *Diane
Arbus, untitled, ca.
1969–71.*

synthesize retinal disparity into a single unitary image. While this seems obvious from our own standpoint, Wheatstone's work marked a major break from older explanations (or often disregarded) of the binocular body."[16] In sum, our eyes and the stereoscope do not operate under the rules of Renaissance perspective: despite our attempts to understand vision otherwise, they disregard the classical observer in favor of binocular disparity. As Crary observes, to the extent that looking through the stereoscope is extremely "planar" (not unlike Seurat's own paper-doll cutouts set up on the stage of *Sunday Afternoon on the Island of La Grande Jatte*), it is also *strange* — rather than, as convention would suggest, *realistic.*[17] "Strange" is the first definition that *The Oxford English Dictionary* gives to the word "queer." The stereoscope emphasizes the body's own doubleness, the queerness of seeing.

Like twin sisters and brothers, stereoscopic pictures are also queer in that they always call one's identity into question: you cannot have one without the other, yet the other is (sort of) the same. Twins fascinate us by coupling sameness. A twin is never (it seems) without his or her mirror image. In Arbus's photographs, every couple (straight or gay, black or white, young or old) is an odd couple: two girls in identical swimsuits; a pair of twins; a male and female nudist; two disquieting women, one unmasked, the other as Harlequin (fig. 76); two men in drag; a brother and a sister; a woman and her pet monkey.[18] Yet (of course), not all twin-

Figure 77 *Jacques Moulin, stereo nudes, ca.1854.*

Figure 78 *Louis-Camille d'Olivier, stereo nudes,*
ca. 1855–ca. 1856.

ning is necessarily queer: girl twins (some famous and not so famous sapphic narcissi) are at the heart of some of the most renowned heterosexist male fantasies of double pleasures, from Courbet's *Sleepers* to nineteenth-century pornographic photographs (F. Jacques Moulin, stereo nudes, ca. 1864, fig. 77; and Louis-Camille d'Olivier, stereo nudes, ca. 1855–ca. 1856, fig. 78). The experience of viewing a woman's body or a pair of women's bodies through a stereoscope means looking inside a very privatized space that masks out everything but the image, so that "the illusion of being *in* the picture is extremely powerful"[19] (L. L. Roger-Violett, fig. 79). For that reason, stereoscopic images were quickly taken up by the burgeoning pornographic photo industry for their voyeuristic effect. Peeping into the stereoscope was like looking through a keyhole.[20] (It has been theorized that the stereograph's early connections with pornography are behind its downfall. Associated with vulgarity, entertainment, and commonness, stereos fell out of fashion by the turn of the century.[21]) Yet, because of the setting and context of Hawarden's pictures (photographs taken by a mother of her daughters in the home and then only rarely shown in public, in other words, sexualized pictures taken by a woman of women and young girls and kept privately within the domestic sphere), the shadows of Courbet's *Sleepers* and pornographic photographs that I see referenced in her work (whether or not intentional)

Figure 79
L. L. Roger-Violett, Second Empire. Stereoscopes in use.

pull heterosexuality into queerness. The angle of approach taken by Hawarden's pictures (decentering because of their pan-female representation of familiar masculinist eroticism and the frequently used stereo, twin-lens camera) is, as Sedgwick has claimed for other texts, "directed, not at reconfirming the self-evidence and 'naturalness' of heterosexual identity and desire," but rather at interrogating its construction.[22]

For example, the image of Clementina as Florence's milkmaid unsettles the viewer with an image of a grown girl nearly suckling, certainly sniffing, her delicious sister (plate 14). Clementina as a young Madonna nurtures, or at least suggests the possibility of it, her suckling heifer at her breast. Or is Florence merely breathing in the scent of her sister? Hand between Clementina's breasts, sensate Florence takes in all that she can. (Sensational.) A six-pointed star at the center of Clementina's chest punctuates the poignant gesture of one girl's hand on top of another's: rock/paper/(no) scissors. By firmly but tenderly insisting that her sister's hand remain between her breasts, Clementina ensures that Florence take her in, breathe her in, suck her in. Through gently flaring nostrils, tickling tongue, and sweet, bacchant lips that I cannot see but feel in me/on me/through me, Florence begins to exhaust Clementina in me. My eyes are closed in imagination.

Yet, the remembered transparency of Clementina's party dress (part fairy, part queen, part Madonna, part Oriental) makes me open my eyes (again) to squint to attempt to see more, to see what I can only imagine: a violet breast, a rosy-sienna nipple. Clementina's invisible but implicit nipple reminds me of an erotic detail in a later photograph of a ballerina by Degas (*Dancer from the Corps de Ballet,* probably before 1876), also featured in my revered *October* (fig. 80).[23] Degas's ballerina's arm seems to outstretch its own limits, attempting to expose an unseen, yet implied, nipple: a crescent moon. The erotic pull of Degas's picture is made explicit through this dancer's lovely arm: pulled in one direction by a hand clenching an unforgiving wall and in the other by a neck (strong and vulnerable, like the stem of a calla lily), trumpeted by her pretty head in emphatic withdrawal. And like the many Hawarden images that feature either actual mirrors or stereoscopic doubles or the sisters as mirror images of one another (fig. 81), Degas's ballerina comes to join Florence

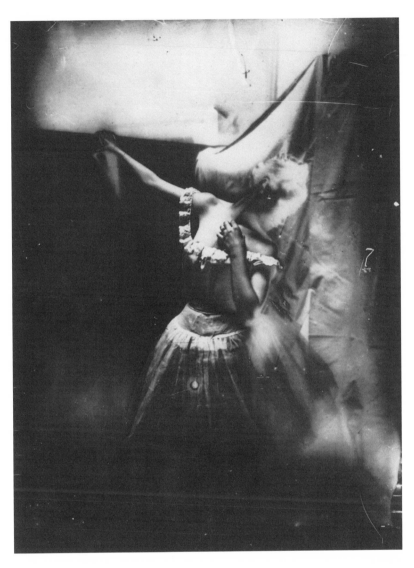

Figure 80 *Degas,* Dancer from the Corps de Ballet,
probably before 1876.

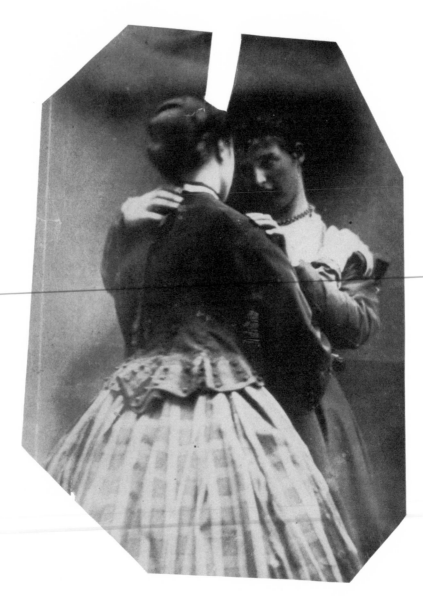

Figure 81 *"The sisters as mirror images of one another."*

and Clementina not once, but twice. For among the various prints of the Degas photograph, "the negative has been flipped" to produce not only a left-right reversal, but also a reversal of dark and light (fig. 82). Seen side by side, Degas's mirrored girls both reach out toward one another and bury their heads away from each other's gaze. They become queer. One dark and the other light, like Florence in her dark cape and Clementina in her bright dress, they are lunar and solar eclipses of the same. In stereo, they call the usual heterosexist readings of Degas into question, as if conferring upon the accidental scratches in the emulsion what look to be small question marks (one straight, the other in mirror reverse) in the lines of their ballerina gazes.

Degas's ballet photographs and especially his ballet paintings, like Hawarden's photographs of her daughters, partake in a voyeuristic sensibility that is built around private, feminine worlds, which the viewer does not usually have access to but yearns to see.[24] In the case of Degas, it is the dressing rooms and backstages of the ballet; for Hawarden, it is the interiors of her first-floor rooms. One critic, in 1877, got to the heart of what is so enticing about Degas's ballet paintings: "For those who are partial to the mysteries of the theater, who would happily sneak behind the sets to enjoy a spectacle forbidden to outsiders, I recommend the watercolors of Mr. Degas. No one has so closely scrutinized that interior above whose door is written 'the public is not permitted here.'"[25] Likewise, walking down the London streets of South Kensington (even today), with its rows of fancy white homes, several stories high, with luscious porches (on the front and back) just like the one that stretches out from the backside of Hawarden's studio doors, one can only imagine what goes on in those rooms: a peek through a window, a figure on the porch is all that we as outsiders can see. In contrast, Hawarden takes us in through her titillating pictures, lets us peek through the window at forbidden spectacles within her home, her camera, her stereoscope.[26]

The simple photograph of Clementina in her underclothes, wearing a waist-hugging bodice and underskirt (see fig. 13), is similar to the dress of the *Dancer from the Corps de Ballet*. Standing beside the cheval-glass mirror which has caught her pretty profile, Clementina's right leg and foot gracefully draw back to a near ballet point; her left hand tucks itself

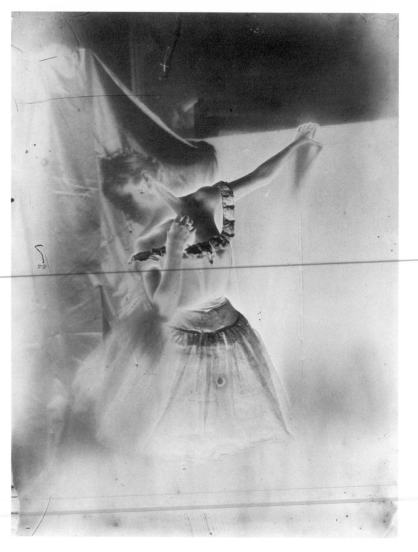

Figure 82 *Degas,* Dancer from the Corps de Ballet,
probably before 1876.

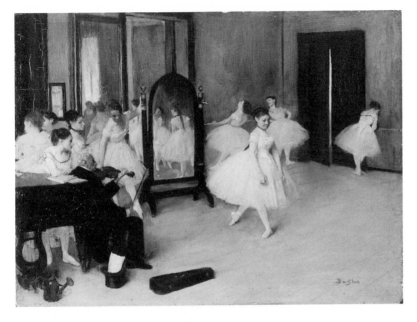

Figure 83 *Degas,* Dance Class, *1871.*

into the small of her back; her elbow points out. (Clementina's right arm looks to be reaching around behind the mirror, emphasizing that the "two" are a couple of sisters, or friends or lovers. They are comfortable with each other and lean into one another's bodies, as one does only with those who are intimately familiar.) Clementina's comely adolescent body is presented to its fullest effect. The mirror gives us another view, more to view.

Clementina's pose, moreover, suggests a dance completed, or contemplated. Though her pantaloons insist that Clementina is in her underwear and not in a ballerina's costume, her watchful gaze suggests that she might be looking at other girls dancing or preparing to dance. Even Hawarden's first-floor rooms reinforce the ballet reading: stripped of almost all furniture, the space captures the hollow, but romantic, feeling of the dance studio through a limited repertoire of wooden floors, natural sunlight, a mirror. The photograph of Clementina could almost be a detail from Degas's *The Dancing Class* (1871; fig. 83), which features ballerinas engaged in isolated activities from stretching at the barre, to

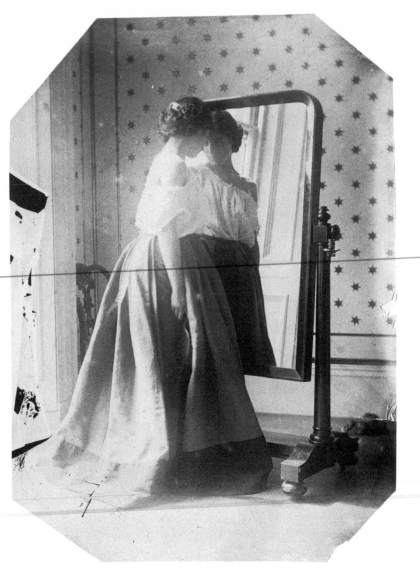

Figure 84 *"Clementina standing before the mirror . . . with*
her hair pinned back and a hairbrush in her hand."

practicing a step, to watching a dancer practice, to private exchanges with each other.[27] Zooming in on Degas's painting, my camera-eye stops on the young woman who is standing next to a Hawardenesque cheval-glass mirror in the middle of the practice room that reflects the back and profile of two dancers we would not otherwise see; the mirror itself is in front of a wall of mirrors. The bodice slips down the body of the painted dancer to expose a shoulder and maybe more, as she braces herself on the mirror while pointing her slippered foot and curvaceous calf outward. Degas's ballerina painted in a fallen bodice is reminiscent not only of Hawarden's photograph of Clementina in her underclothes, but also of another photograph of Clementina standing before the mirror, this time in a long skirt, with her hair pinned back and a hairbrush in her hand (fig. 84). Ballet, famed for its narcissism both in front of the practice mirrors and in front of the audience, shares the self-absorption that is so prominently displayed in Hawarden's pictures of her daughters before a mirror.[28]

Even without mirrors, Hawarden's daughters share much with the ballerina of the period: beauty, the look of sexual independence, and the fetishization of legs in tights.[29] We have already seen images from the series that feature Clementina in tights, playing page to Isabella as Mary, Queen of Scots. In each of these photographs, as in the many paintings of Degas's ballerinas, the feminine curve of Clementina's calves is emphasized by her bright white, body-clinging tights. Clementina as an erotic page, all the more womanly for her role as a man, brings to mind the popularity of ballet's equivalent: the travesty dancer (a female ballet dancer playing the male role), who grew in popularity from the 1820s on. As Abigail Solomon-Godeau has written: "The corseted midriff emphasized bosom and hips, the skintight breeches displayed buttocks, hips and legs. Thus, everything in the costume of the travesty dancer proclaimed her womanliness even as the choreography positioned her as the lover/partner of the ballerina. Accordingly a pas de deux between ballerina and travesty dancer produced its own, distinctive eroticism, subtly evoking a lesbian pairing that the libretto disavowed."[30] Clementina and Isabella on their mother's stage dance a dance that is not unlike a pas de deux between travesty dancer and ballerina.

Figure 85 *A. A. E.*
Disdéri, Les jambes de
l'Opera, *ca. 1864.*

Furthermore, Hawarden's photographs may have been informed by
what Solomon-Godeau has referred to as the "traffic in (dance) pho-
tographs . . . particularly *carte-de-visite* and stereopticon photographs"
that were so popular during the period (A. A. E. Disdéri, *Les jambes de
l'Opéra*, ca. 1864, fig. 85).[31] Solomon-Godeau uses the word "traffic" to
emphasize the association between the dancer and the prostitute, both of
whose narcissism is deeply connected to their (eroticized) lower-class
status, whether they are imaged in a cheap stereoscope or a painting by
a modern master.[32] As Eunice Lipton has made clear, Degas too was
influenced by the naughty stereographs of the period: from the ironing
woman with the exposed breast to the rear view of a naked woman
emerging out of a bath that has been "skirted" in calico, as if she were
climbing out of her own ballerina dress. Even a bath was read as mirror:

"water could become an indiscreet mirror."[33] Baths, associated with vulgarity (in that prostitutes were known to bathe often in an attempt to remain free of disease and pregnancy), give way to narcissi.

Hawarden's work appears to quote not only the slightly naughty ballet stereos and cartes of the period, but also the downright pornographic stereos that were so popular during the 1850s and 1860s. Like Hawarden's photographs, these stereos made full use of pairs of women together in erotic poses (touching one another, lifting a leg to tie a shoe) or singularly coupling themselves in various states of undress before a mirror. Though Hawarden's girls were never fully nude, always wearing at least a camisole and petticoat, exposing no more than an ankle or a bared shoulder or nearly a breast, their poses and the artifacts around them suggest illicitness.

In one such picture, Clementina is pictured on the verge of erotics, literally ready to fall, but somehow balanced on the tasteful side of display: her hair is tied up in a loose knot, sloppily done and shamelessly begging to be untied; the trim of her white dress emphasizes her delicious curves, like decorative frosting piped onto the rounds of a cake, waiting for a finger to give it a try; she is caught pulling the chair into her body, a gesture that I cannot keep from reading as autoerotic (fig. 86). In another one of the chair photographs, the chair legs are now four to the ground, but Clementina appears to have fallen: hair untied, her rear end out and ready (a "display of a vulnerable body . . . an invitation to *a tergo* sex," as Griselda Pollock so politely describes such a posture[34]); the dramatic casting of light and the poor printing quality suggest that Clementina's face has been painted like a prostitute's (fig. 87).

London's *Photographic News* of 11 August 1865 reports disapprovingly on the rich availability of what was then considered pornography: photographs of "young ladies (?) at their toilette — some lacing their corsets, some exposing their legs while lacing their boots and arranging their garters, some stooping just to exhibit their bosoms, others reclining on couches in exciting postures; some again in their *robes de chambre* sitting on the edge of a bed withdrawing their stockings."[35] And it was not only men who were looking at these images, for as the author of the article

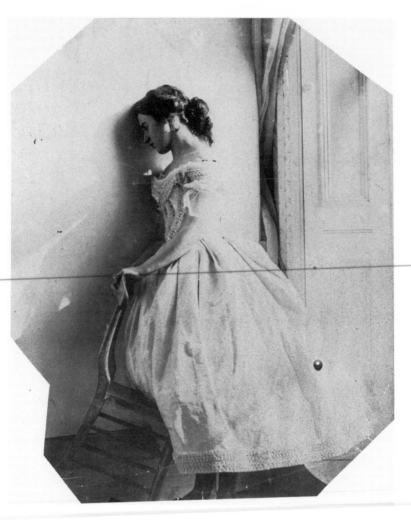

Figure 86 *Clementina is "ready to fall . . . her hair*
is tied up in a loose knot."

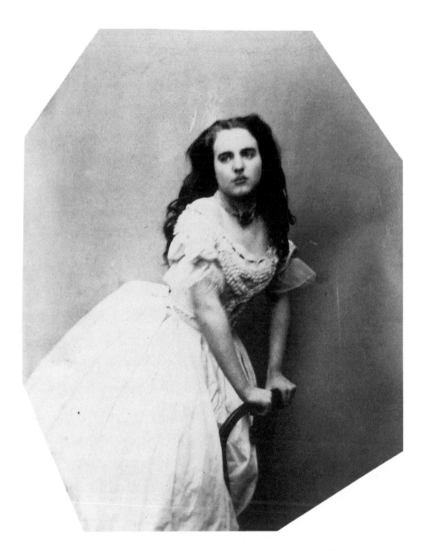

Figure 87 *"Clementina's face has been painted."*

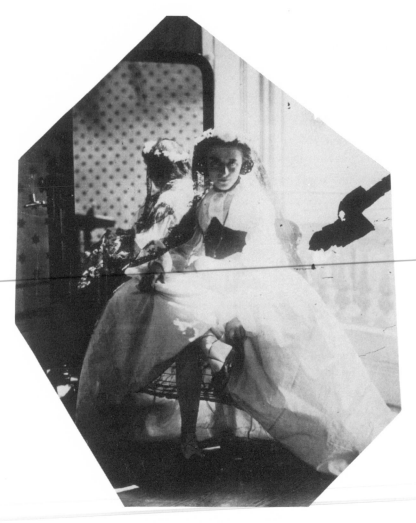

Figure 88 *"Isabella sitting before a mirror, pulling up her skirt to show us a bit of tantalizing ankle."*

makes clear, they were exposed in shop windows even in the best sections of town:

> Photographs of women in voluptuous attitudes, with lascivious countenances, in the costume of Mother Eve, are now universally exposed in the windows of shops of great respectability in our leading thoroughfares and their intersections. I saw the other day what may be seen any day in the week—a crowd of lads and lasses, men and their wives, taking a "sly glance" at a beautifully-coloured picture of a bold and naked "Susannah before the Elders." I saw there, too, alone and amongst the crowd, a young lady, and when her eyes glanced upon the picture, she blushed . . . Not a printseller's or fancy stationer's in London can you now look in but what are exhibited photographs of young ladies . . . [that] are wickedly suggestive.[36]

Such photographs, so easily seen in the shop windows of the best sections of London, could hardly have been missed by the Hawarden family.

Indeed, Hawarden's image of Isabella sitting before a mirror, pulling up her skirt to show us a bit of tantalizing ankle, looks very much like the naughty stereoscopic images of the period (fig. 88). Gazing at the viewer with the knowing sexual security of Manet's *Olympia*, Isabella provides for us a sunlit entry into the bower of her crinoline tent.

For the sake of comparison, consider Auguste Belloc's naughty photograph of a young woman in a gingham dress, black lace, and plain white underskirt (ca. 1854; fig. 89). Her open legs are displayed without drawers. Her white, thick rolled stockings emphasize the crescendo of her healthy young thighs. The two photographs share a similar gesture and pose. Yet, I find myself somewhat bored with the Belloc image (due to the model's averted and indifferent gaze, the photograph's dull and typical studio background, and my lack of any biographical knowledge of Belloc's young woman). On the other hand, the photograph of Isabella pulling on her skirt, so unlike a studio portrait (rich in an atmosphere compounded by my knowledge of her) "animates me . . . incarnates a kind of blissful eroticism."[37] I am captivated by the beautiful gesture of Isabella's right hand clenching her white skirt to create just the

Figure 89 *Auguste Belloc, ca. 1854.*

Figure 90 *Auguste Belloc, ca. 1854.*

right degree of fold. I find pleasure in her left hand as it fingers a shoe and an exposed ankle. I fantasize that she is daring me to choose between her fabulous gaze, kissable face, and the loveliness of what lies inside the lit-up bower, just beyond the shoe. Eroticism seems to mark Isabella's entire body and even extends beyond her body and into the room and its objects. I find myself focusing on Isabella's looking-glass twin, whose gaze is directed (this time) not on me but on the Gothic-style desk. A mysterious object sits on the desk; its ominousness is mirrored in the black shadows that dance and smokily stain the star wallpaper. The image

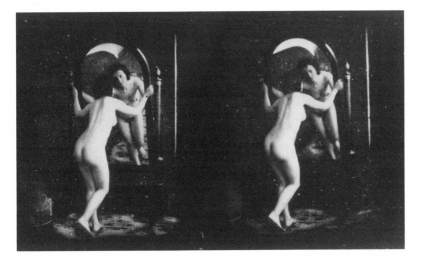

Figure 91 *F. Jacques Moulin, ca. 1854.*

127

Sapphic

Narcissa

reflected in the mirror makes the photograph extra rich, extra sensual, delightfully mysterious.

The mirror that adds such subtle eroticism to Hawarden's image of Isabella was standard iconography for the pornography of the period. For example, in another stereo by Belloc, a mirror allows us to see a nude woman's ungenuine smile as she performs narcissistically for her reflection, while we contemplate the full bloom of her bare derriere (1854; fig. 90). Her sapphic sister pretends to wipe clean her bare ankle and foot to give the viewer a slivered view of what lies between her legs: she stares back at us, brightly and from the corners of her eyes. The excess of the stereo format allows the viewer to indulge in the "three" women (two actual women and one mirror image) times two. Likewise, in a beautiful stereo photograph by F. Jacques Moulin, we have the greedy privilege of seeing a young woman's breasts from front and side, along with her perfect buttocks, as she verges on falling into her own reflection (ca. 1854; fig. 91): she is open-armed and ready for a kiss from her sapphic sister self; she is a narcissa at the pond.

Notice how Moulin's cheval glass echoes Hawarden's cherished mirror. Like two sisters, like Isabella and Clementina, the two mirrors are nearly the same, save for the fact that Moulin's is oval-topped and Ha-

warden's is softly squared. When looking at the image by Moulin, one wonders (again) if Hawarden and, say, Isabella had seen such an image before, if Isabella had taken a "sly glance" and "blushed" at what she saw in the shop window. Later, at home in front of her own cheval glass, Isabella may have contemplated kissing herself in the mirror while Hawarden looked on behind her view camera (fig. 92). What pictures are dancing through Isabella's head (at home and in the mirror) when she takes down her hair and fixes it in two thick ringlets, a flower at one side, the black Spanish lace cascading, her left hand rising to touch herself, her lovely sapphic narcissa?

BLIND SPOTS

A punishing voice was speaking from with the subject, and saying: "Because you sought to misuse your organ of sight for evil sensual pleasures, it is fitting that you should not see anything anymore."
—Sigmund Freud, "The Psycho-Analytic View of Psychogenic Disturbance of Vision"[38]

Looking, as an erotic, pleasurable act (scopophilia), has long been taboo. Oedipus made the dramatic mistake of looking at his mother erotically and acting on his desire. Not only was Oedipus punished with blindness, but (through Freud's retelling of the myth) he became the symbol of ultimate taboo, the star of the biggest incest story in Western culture. Art history, despite the naked and sexualized work that is at its center, has long and rigidly honored the taboo against coupling erotic pleasure with looking. Feminist art historians like Griselda Pollock and Linda Nochlin have beautifully demonstrated the problems of looking at images that have been eroticized for the "male" gaze, and, beginning with Laura Mulvey, feminist film theorists have taught us how to "spot" the male gaze and even how to imagine constructing "different" gazes, yet the pleasure of looking has been largely overlooked. It is as if the old taboo of combining eroticism and vision might really lead to blindness.

We find traces of such fears in popular culture and psychoanalytic theory: from the old wives' tale that insists that masturbation leads to

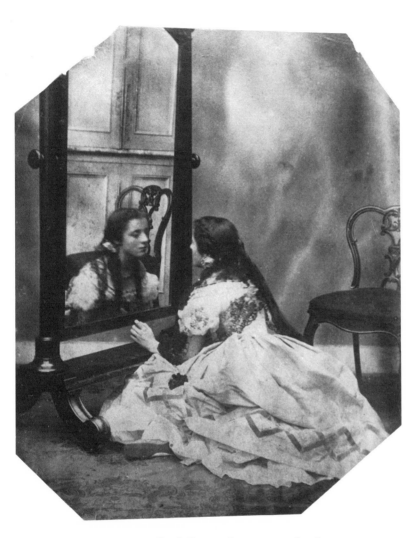

Figure 92 *"Isabella may have contemplated
kissing herself in the mirror."*

blindness, to Charcot's hysterics who suffered from *scotome scintillant,* a distorted vision marked by dark spots, dazzling shadows, and a glittering of things, to Freud's reading of Lady Godiva. As Emily Apter puts it:

> In his attempt to give ocular disorder a psychoanalytic inter-
> pretation, Freud cites the tale of Lady Godiva. This "beautiful
> legend," he wrote, "tells how all the town's inhabitants hid be-
> hind their shuttered windows, so as to make easier the lady's
> task of riding naked through the streets in broad daylight, and
> how the only man who peeped through the shutters at her re-
> vealed loveliness was punished by going blind." For Freud, the
> fate of the renegade voyeur illustrated how scopophilia (the
> "love of looking") is punished by the ego with blindness or,
> in the term popularized by his teacher Jean-Martin Charcot,
> with scotomization (from the Greek Skotos, meaning "dark-
> ness"; signifying partial, distorted, or peripheral vision within
> the field of ophthalmology).[39]

Freud saw retaliation in vision, with such hysterical symptoms as "color blindness, dilated pupils, strabismus, and the twisting of the orb to reveal the whites of the eye."[40] Strabismus, also called squint, is particularly pertinent to this discussion as it refers to the inability of one eye to attain binocular vision with the other because of an imbalance of the muscles of the eyeball. Like the stereoscope itself, strabismus makes visible the problem of seeing: we see one picture with two different eyes from two slightly different perspectives. We see queerly.

When looking at Isabella before the mirror, pulling up her skirt (see fig. 88), I am a voyeur looking through a keyhole. As if looking through the camera lens, I force my two eyes to see through one hole. I hear the rustle of her skirt in the auditory fabric of my own sartorial gaze. A black spot, a printing error (with a rushing and crackling noise all its own) awkwardly flutters into the room, as if I were being punished for look-ing. Fantastically, it appears to have entered through the window; dra-matically, it mars the picture, its score. Like Isabella's velvety cummer-bund, which tears into the whiteness of her dress, this hard-lined and jagged black spot (a strange flying skeleton key) tears into the overall

whiteness of the right half of the photograph. Yet, I find pleasure in the black stain, in this stigma that reads as a punishment for looking at a possibly perverted image. The dark spot withholds part of the picture from me while it drives a desire in me to see more.[41]

TORN

The black stain in the picture of Isabella sitting before the mirror operates not unlike the torn edges of Hawarden's photographs.

One day, while looking at Hawarden pictures, a friend of mine, shocked at the mutilation of the images, remarked, "What a shame that almost all of the photographs have been damaged." To which I immediately replied, "I love the torn and cut edges of the Hawarden pictures. To me, their damaged borders make them that much more beautiful." At the heart of my love for these photographic tears is a pleasure that I take in fragmentation, a pleasure that I learned from Page duBois, a pleasure that she learned from Sappho.

Using Sappho's fragmented style of writing, as well as the dramatically fragmented state in which her writing has come to us, duBois finds in Sappho an alternative subjectivity that acknowledges both our fragmentary understanding of the past (which we receive only in bit parts, like a "body in pieces") *and* our desire to make whole, to "invent integrity," to make history and become subjects.[42] In other words, duBois suggests that we accept our fragmented past and our fragmented postmodernist selves without trying in vain to fill in all of the missing pieces that never can be fully recovered. Yet far from giving up history, duBois emphasizes a model of history that focuses on the ancient past. Though we often name the ancient Greeks as our origin, duBois points out their radical difference from us. DuBois pulls from Sappho (and from the ancient Greeks in general) a *difference* that rests on figures of fragmentation.[43] Fragmentation is duBois's figure of difference that works against the usual (misguided) classicist striving for wholeness. Her use of fragmentation makes room for multiple subjectivities, including women and their desires (both homoerotic and heterosexual, as well as all that lies queerly in between). Focusing on the notion of a subject as a body in

pieces, rather than on the mythical whole, duBois turns her back to the mirror and finds Sappho's "limb-loosening desire."[44]

Consider the following fragment from Sappho (105c)[45]:

> Like the sweet apple turning red on the branch-top, on the top of the topmost branch, and the gatherers did not notice it, rather, they did notice, but could not reach up to take it.

Here, Sappho's bits and pieces of luscious language take pleasure in making the suitor/poet *as desirable as* the object of the suitor's desire. Like Jacques Lacan's shifting "I" and his shifting subject in the mirror, the reader of Sappho's poem misrecognizes herself simultaneously as thwarted suitor, successful suitor, writer, reader, lover, so as to propel a neverending desire that is perpetuated by numerable and fragmented positions of subjectivity. Furthermore, Sappho's use of the word "like" in "Like the sweet apple turning red on the branch-top," calls "attention to the fragmentary status of the fragment, the thing being compared forever absent, available only to the imagination."[46] Like a photograph, which is a fragment of a moment forever lost, Sappho's bits and pieces call attention to what is not there. DuBois (unlike Lacan) sees pleasure in "the body in pieces" rather than in the mythical whole, the invented integrity that we so often strive for. DuBois jubilantly gives in to Sappho and sapphic desire; this means *wanting* the missing lines, the missing fruit, the missing shard of a lost vase, *while indulging in the pleasures of their withholding*. The erotic crypticness of Sappho's writing is driven by the "relationship of desire and withholding, of presence and absence."[47]

The photograph that best presents the pleasures of Sapphic fragmentation is the brilliantly torn image of Clementina by the mirror (plate 15). Clementina's right arm is wrapped around the waist of the familiar mirror, which mimetically looks back at her. Clementina's exacting gesture gives the illusion that her arm is around the waist of another young woman exactly as beautiful as she. One twin is looking toward the photographer, the other toward something or someone else in the corner of the room. Torn right through her head, right down to her eerily spared eyes (how and why would anyone tear photographic paper with such precision?), the photograph cuts the top of Clementina's head off, just as

the mirror cuts off her legs and feet (the latter, even in the image of the "real" Clementina, remain hidden under her dark full dress), just as Degas's *Dancer from the Corps de Ballet* has mysteriously lost her legs.

The damaged edges of the photograph invite me past seeing toward touch. Looking at Clementina before the mirror, my fingers move along the edges that tear across her eyes, only to feel her curls, the smooth cutting alongside the mirror's outer edge gives way to the glossiness of the mirror, the satiny feel of the paper; the bitten edges on the photograph's bottom right side nibble at her dress like moths or mice. I feel the weight of the fabric and imagine its touch. Is it a heavy silk? A thin velvet? A polished cotton? Caught up in touching her dress, I move over a cinched waist, in and out of a bell sleeve, over and under four fabric-covered buttons. As my fingers contemplate the interior of Clementina's clasped hand, I notice that she is clutching a dark ribbon from which hangs a heavy, medieval-style cross. It looks faintly familiar, as if it has hung round the neck of one of Dante Gabriel Rossetti's Pre-Raphaelite stunners. I touch its detailed edges, which haptically reflect the mouse bites at the bottom of the photograph. Yet for all of my caressing, there is still a languor. My touching emphasizes that Clementina could not be more there, yet she is not there. Though I want Clementina, she is forever to be withheld from me. She is now dead, nothing more than a fragment of what she once was: "Like the hyacinth in the hills which the shepherd people step on, trampling in the ground the flower in its purple."[48] I can be no more (and no less) than a jealous lover of Clementina:

> For now as I look at you my voice
> is empty and
> can say nothing as my tongue cracks and slender fire is quick
> under my skin. My eyes are dead
> to light, my ears
> pound, and sweat pours over me.
> I convulse, greener than grass, and feel my mind slip as I
> go close to death.[49]

I am torn by her convulsive beauty.

I sapphically love the loss of Hawarden's broken, torn, and sometimes

stained images. I desire the missing parts of Hawarden's photographs, the missing bits of silk and lace, the missing bits of hair, ankle, hand, reflection, as well as that which will always remain off-frame (Hawarden's own body, the bodies of the girls past adolescence, the unpictured portions of their lives), while, at the same time, I indulge in the pleasures of withholding: "Like the sweet apple turning red on the branch-top, on the top of the topmost branch, and the gatherers did not notice it, rather, they did notice, but could not reach up to take it." I blush to both become that apple out of reach *and* to tear it down. I blush to become Clementina and to tear her out of the picture album. My eyes well up with tears of erotic pleasure. They take the edge off. Tears of eros(ion).

CHAPTER FOUR

COLLECTING LOSS

All women . . . are clothing fetishists.
—Sigmund Freud[1]

What they [clothing and photographs] have in common
is that they are simultaneously presence and absence. They are
both an object and a souvenir of a subject, exactly as a
cadaver is both an object and souvenir of a subject.
—Christian Boltanski[2]

Like Hawarden, I fetishize two things in my life: clothing, especially old clothing, clothing with a past, and photographs. And it was not until recently that I understood that my desires for each were woven closely together. My final story finishes off the fetishistic embroidery of "Reduplicative Desires": "Collecting Loss" knots the letters of a beautiful, if sad, F-E-T-I-S-H that is decidedly female and feminized. Now I adamantly pick up the dangling silken threads and pearls ("She clipped a precious golden lock / She dropped a tear more rare than pearl"[3]) by pulling the fetish into view as unquestionably belonging to mothers, grandmothers, daughters, girls.

According to Freud's work on fetishism, the fetish is solely the prerogative of men; women are often hysterics, but they are almost never fetishists. As Apter points out, "despite his admission at the Vienna Psychoanalytic Society in 1909 that 'all women . . . are clothing fetishists,'" Freud typically supplies a male agent to the perversion by associating it with male homosexuality and coprophilic pleasure.[4] In response to

Freud, Apter gives fetish objects to (retrieves them for) women in special boxes and bureaus and albums and other private places enshrouded with veils, fabrics, and furs, whose sole purpose is to preserve the relics of departed loved ones. The stories of loss range from spoiled love to death to merely growing up. Inside these feminine spaces we find letters, pressed flowers, locks of hair, nail clippings, pieces of clothing. The fetish objects, from the trivial to the exquisite, are most often passed down and gathered by the women of the family, "by hook or crook" (a translation of *à-bric-à-brac*) in a continual process of "acquisition and exchange" — which can be met with heated emotions (ranging from intense love to harbored jealousy to violence) between sisters, between mothers and daughters.[5] Apter points out that this "bric-a-brac–cluttered world" has been largely overlooked, even when it reaches a space of "manic collectomania," because it has been naturalized as part of feminine culture. Apter's examples of female fetishes, taken from literature and art, are often visual, sometimes olfactory, but the majority of them relate to a sense of touch.

My "bric-a-brac–cluttered world" is also haptic. My fingers are beckoned by a baby dress of white cotton eyelet, an abandoned pink baby blanket woven with satin ribbons, a once white wedding veil yellowed crisp, Grandfather's old camel mohair coat eaten by moths, a tiny but heavy glass-beaded bag (royal blue, deep rose, white and gold) cinched with a silk cord, tiny shoes of soft worn mildewed leather pressed flat by storage and polished powder blue. These are the things that clutter and fill the recesses of my home, my memories, my body.

Crucial to this world are my photographs: some are made of soft matte paper printed with sepia tones, others are made of glossy paper printed in stark black and white, others are losing themselves in the faded tones of early color photography, still others feature the surreal spaces of the Polaroid camera. My family's bureaus, albums, and boxes (and those of many other middle-class families) have been filling up with photographs ever since the invention of the *carte de visite* and the never-ending succession of photographic inventions: mass-produced hand cameras (the Brownie, the Kodak, the Lilliput, the Tom Thumb, the Frena); drug store developing; Sears value packs; school portraits; dis-

posable cameras. Using such products of the photographic enterprise, my own grandmother spent the last years of her life preparing elaborate scrapbooks/photograph albums on each of her two sons to be left to us after her death.

AN ALBUM

My father's album (which he sent directly to me after my grandmother's death) begins and ends with photographs not of himself, but of my mother when they were first married; the year was 1953. This blunt, one might even say shocking, beginning is an ending. It is the ending of something that I am only beginning to understand now: a final severing of that (umbilical) something between a mother and her son—that something that began with my father's tumbles inside his mother, his elbow poking between her ribs, in the months before his birth in 1926. Though my father remained devoted to my grandmother, marriage changes things between a son and a mother. As I turn the black pages weighted with pictures and other memorabilia (cards, an occasional newspaper clipping), I feel as if I am watching one of the old Super-8 family movies that we never had — only in reverse. (When I was a child I loved watching other people's home movies this way.) Stopping and starting, the timing is all off; parts are left out. My heart feels heavy with the weight of the black-and-white photographs. I discover that the album finally ends (begins?) with pictures of my baby-father at seven months: white wicker pram, floppy cotton brimmed cap, lips tucked in, as contemplative as he is today (fig. 93).

In between the first page with the pictures of my mother as a young bride, her lips darkened with red lipstick (when I came along, her lips would be frosted pink), and the last page with pictures of my father as baby, there are many more pictures and things: a small lock of hair inside a tiny, tiny envelope inscribed in my grandmother's writing (small, tight, cursive) with the words "My curl," meaning my father's curl (I cannot bear to look inside); military pictures of my father in sailor caps and active-duty clothes and dress uniforms with harsh brass buttons; photographs of the three of them (my grandmother in a white dress with an

Figure 93 *"My baby-father at seven months."*

Figure 94 *"My mother as a young bride."*

enormous dark cotton bow under her collar that covers her chest, my laughing father in short pants, his brother in long pants) taken in succession as they happily stride toward the camera at the 1935 Chicago World's Fair—my grandfather out of the frame, as he almost always is (figs. 94–96).

By arranging his life backwards, my grandmother has reconstructed my father's life as if it ends, like some forbidding myth, with *their* beginning. As James Clifford has told us, "Living does not easily organize itself into a continuous narrative."[6] It is only after we have lived through cycles of our lives, in recollection, in photographs, that a narrative comes through. Afterward, we tell narratives that may be partly true, but they are also narratives that must be fictionalized in order for us to make sense of our lives . . . in order to survive. "We are condemned to tell stories," but we cannot, in our heart of hearts, believe that they are altogether true.[7]

I learned from my grandmother that it is the mother's duty to create palpable narratives of our lives. It is the mother's duty to love things. My grandmother passed on to me this love of things (which is both wonder-

Figure 95 *"A small lock of hair inside
a tiny, tiny envelope."*

Figure 96 *"My laughing father in short pants,
his brother in long pants."*

Figure 97 *"The old car grimaces and returns
the camera's gaze for"* my grandfather.

ful and burdensome). Yet, not all things can be passed on; not all pictures make it into the album. Though I begged for and got my grandfather's old chair, he is virtually absent in the album. He is barely visible in the front seat of the Packard. Striding into the back door of the cabin, he turns his face away from the camera—the car grimaces and returns the camera's gaze for him (fig. 97). In a family picture with unidentified aunts, he stands so far apart from my father's hand, which reaches out, futilely trying to pull him in, that it is as if he were not in the picture at all. There is a silent gap between them. Like a parenthetical phrase skipped, the space between them is calling to be read. Despite the silences that many of my grandmother's objects give way to, I collect the things that she has given to me: the chair, the albums, the huge Parisian turn-of-the-century glass vase whose surface imitates carved turtle shell, the odd dark little oil painting of a monk playing the trombone (painstakingly painted with a fine brush and plenty of linseed oil), the silver spoons collected from all over the world, the white fluted wedding teacups, so thin that you can see through them, as if they were made of paper or skin.

Henriette Barthes, Roland Barthes's mother, was also a "keeper" of bric-a-brac (fig. 98). Shortly after her death, Barthes, finding himself lost, went through boxes of photographs, relics of their lives spent together and apart. Barthes claims that at that moment, he was not looking for her, that he had no hope of finding her. He, after all, had already cut himself off from her, had faced his/her absolute loss. "I had acknowledged that fatality, one of the most agonizing features of mourning, which decreed that however often I might consult such images, I could never recall her features (summon them up as a totality)."[8] Yet his desire belies him; he continues his looking. Sorting through the pictures, he finds her caught not so much by the camera, but rather by the objects in the pictures that define her. The objects that he writes about, some of which are clothing, are rich in fetishistic lure:

> With regard to many of these photographs, it was History which separated me from them. Is History not simply that time when we were not born? I could read my nonexistence in the clothes my mother had worn before I can remember her. There is a kind of stupefaction in seeing a familiar being dressed *differently*. Here, around 1913, is my mother dressed up — hat with a feather, gloves, delicate linen at wrists and throat, her "chic" belied by the sweetness and simplicity of her expression. This is the only time I have seen her like this, caught in a History (of tastes, fashions, fabrics): my attention is distracted from her by accessories which have perished: for clothing is perishable, it makes a second grave for the loved being. In order to "find" my mother, fugitively alas, and without ever being able to hold on to this resurrection for long, I must, much later, discover in several photographs the objects she kept on her dressing table, an ivory powder box (I loved the sound of its lid), a cut-crystal flagon, or else a low chair, which is now near my own bed, or again the raffia panels she arranged above the divan, the large bag she loved (whose comfortable shapes belied the bourgeois notion of the "handbag") (64–65).

Figure 98 *Roland Barthes's mother.*

The photographs, objects themselves, record objects within them (dress, dressing table, ivory powder box): things that stand in for her, not wholly, but partially. It is no wonder that he never "recognized her except in fragments" (65). These mother-objects are tied to her and to Barthes, who (despite his claims) could never really cut the cord.

Because photographs so poignantly speak of death and loss, they (as Barthes has written, quoting Susan Sontag) wound us, prick us, reach us like "the delayed rays of a star" (81). Every photograph is a record of a moment forever lost—snapped up by the camera and mythically presented as evermore. The family album is always torn by the sorrows of loss: lost childhoods, lost friends, lost relatives, lost memories, lost objects, lost newness. Pressed into the album, not without joy, the images depress the beholder; they speak in melancholic tones. "With the Photograph, we enter into *flat Death*" (92).

And like childhood and new woolen winter coats and linen blouses and mothers and silk dresses and felt hats and distant cousins and grand-

mothers, photographs deteriorate, spoil, die, benumb, weaken. "Not only does it [the photograph] commonly have the fate of paper (perishable), but even if it is attached to more lasting supports, it is still mortal: like a living organism, it is born on the level of the sprouting silver grains, it flourishes a moment then ages . . . Attacked by light, by humidity, it fades, weakens, vanishes" (94). The photograph dies like a body. And like a body, we simply cannot throw it out. (We bury the dullest, even the ugliest, photographs in drawers and boxes.) To tear or to cut the photograph is a hysterical action. (My friend Patricia snatched some albums away from her father. I was shocked to see that he had cut her mother out of every one of the pictures, even the wedding photographs. What absolute violence!) Such undue alterations—as in my friend's missing mother, or the ripped picture found at the bottom of a box, or those blank spaces in my father's album where paper corners mark a picture's escape—captivate me, as do Hawarden's, for the ways they suggest untold, unimaged, lost, and often purposely forgotten stories.

Yet most of us are anxious to preserve our images of ourselves and our loved ones (as whole and as undamaged), like "flies in amber," as Peter Wollen has written.[9] So, we often ask ourselves, what are we to do with these traces of bodies that fill bureaus, boxes, shelves, attics, basements, closets? It is as if our pictures contained thin ghosts of the actual person photographed (of our aunts, our cousin, our mother, our childhood friend, ourself). We are haunted by our family photographs. If thrown away, Barthes writes, "What is it that will be done away with, along with this photograph which yellows, fades, and will someday be thrown out, if not by me—too superstitious for that—at least when I die? Not only 'life' (this was alive, this posed live in front of the lens), but also, sometimes—how to put it?—love" (94).

Likewise, clothing is "perishable," and because it takes on the body (it takes form, smells, dirt) "it makes second graves for the loved being," even before death, but especially after death.

In the case of my Hawarden love, I specifically fetishize and desire her (pictures) for the ways in which old clothes inform the torn edges of the photographs. Together they perform pictures as full of historical incompleteness: like bits of shard gathered; like jigsaw puzzle pieces scattered;

like mixed-up cups and saucers; like a board game in a box, with colored plastic cars and houses, little silver markers, a pair of dice, cardboard cards to draw from, but *no directions* . . . and no one remembers how to play.

For me, wearing the clothes of a loved one or a friend, in which her smells come forth, in which her body has worn the cloth smooth or through, is akin to carrying a photographic image with me. Her body caresses me. I like to wear lockets with photographic images tucked inside. The locket (say, with a picture of Oliver or Ambrose or Augustine inside) or Amy's old dress, or my father's royal purple letter sweater from high school, or someone else's great aunt's abandoned hat—all carry specters of my loved ones: I sense them skin to skin.

I guess that is why we have to keep so much in our dressers (which function as miniature museums of our archived selves): "the function of any drawer is to ease, to acclimate the death of objects by causing them to pass through a sort of pious site, a dusty chapel, where, in the guise of keeping them alive, we allow them a decent interval of dim agony."[10] Like a photograph, the drawer of saved objects functions as a space between life and death. For not only do our photographs, our objects, signify death, they also (in the spirit of the fetish) keep death away. Collecting these objects in the nooks and crannies of our homes keeps them and our memories and ourselves alive. Objects keep death away by helping us to remember. Milan Kundera writes on memory's close link to death: "Forgetting . . . is the great private problem of man; death as the loss of self. But what of this self? It is the sum of everything we remember. Thus, what terrifies us about death is not the loss of future but the loss of past. Forgetting is a form of death ever present within life."[11] I am so afraid of forgetting.

SARTORIAL MEMORIES

Elin o'Hara slavick's mother never wanted to forget the childhoods of her five daughters. She feared the loss of the past. And she must have, I imagine, feared a loss of herself. In addition to the family photographs and the Super-8 home movies, slavick's mother saved most of their

dresses. The dresses were worn by slavick and her sisters to Mass, to school, to birthday parties, and to family gatherings. As a result, the girls were often photographed in these dresses.

Not too long ago, slavick told her mother that she wanted to use the worn and mended dresses in an artwork; she wanted to embroider her own text onto them. Slavick's mother, a female fetishist in her own right, agreed to send the material of her maternal collectomania to her youngest daughter, the one who used to get mad and kick people's shins. (I still am surprised that the mother agreed to give them up.) The dresses, like my father's family album, came to slavick in the mail. Like my father's family album, they contained the histories of a family. Like my father's album, they prompted memories (figs. 99–102).

Trained as a photographer, slavick has reconstructed her childhood, not with photographs, but in response to photography. (As Susan Sontag writes in *On Photography*, "Now all art aspires to the condition of photography."[12]) Slavick sees the dresses as photographs of how she remembers her body:

> The work is informed . . . primarily by my own small memory of being a girl. An investigation of my childhood produces a synthesis of distorted memory, my real history, and my adult desire to interpret and remember. Poetic and confessional texts are sewn in the dresses that my mother saved since my childhood. Each dress becomes a surrogate of my body, a photograph of the memory of my body. The absence of actual photographic imagery of that body implies the loss of multiple bodies; the hiding body, the invisible body and the dead child body which we all possess within our adult selves.[13]

But unlike the photographs that are found in the usual family album, slavick's dresses take on images that are almost never found in family pictures. "Slavick's childhood dresses no longer can pretend innocence. They are transformed through adult texts and become surreal evidence in the absence of the original snapshots that they might have been."[14] The dresses function like the missing pictures in an album, or the tears alongside Hawarden's photographs. They manage *to picture* the unsaid.

Figure 99 *elin o'Hara slavick,* "MUTTER, MUTTER, MUTTER,"
dress from A Wall of Incoherent Dresses, *1991.*

Figure 100 *Photograph of a sister wearing the dress that elin o'Hara slavick will eventually embroider with* "MUTTER, MUTTER, MUTTER." *William H. Slavick.*

Figure 101 *elin o'Hara slavick,* "IN THY WOMB HAVE NO SHAME," *dress from* A Wall of Incoherent Dresses, *1991.*

Figure 102 *Photograph of a sister wearing the dress that elin o'Hara slavick will eventually embroider with* "IN THY WOMB HAVE NO SHAME." *William H. Slavick.*

For example, on the creamy soft bodice of a beautiful cotton dress, with a full green skirt whose hem holds the extra weight of a full four inches from being turned up for one of the girls so that it could dance just above her knees, slavick has stitched (fig. 103):

> MOTHER, YOU PUT COLD VINEGAR
> CLOTHS ON MY SUNBURNT
> BODY.
> THE CLOTHS WERE STEAMING
> WITH YOUR BREATH
> AND I KEPT BREATHING.
> I FELL ASLEEP AND DREAMED
> I LOVED YOU.

It is a family picture: a child's sunburnt body, maternal care, child sleep, a child's profound love for her mother. But it is not an image that many of us could find in our family album. Pain, nakedness, the unposed, the unconscious, the smells of the home, the breath of the mother, the unmasked, a grown child's sleep, the everyday, a sensual confession — such steam and chill are rarely there.

Like most of us, Reynolds Price can find only "innocent" and "posed" pictures in his family's collection. As he writes in the afterword to Sally Mann's *Immediate Family*,

> [My parents] exposed yards of film, not only in their frank satisfaction in a child but also in pursuit of visible proof that I was glad to be their product, a moon to their sun — and I generally was — but they likewise early enlisted my cooperation in a long concealment or denial that my becoming moon had hid a dark face, which was where I lived for far more hours — and now for nearly six decades — than any of them would have wanted to hear, not to mention confirm in permanent image. Like most veterans of family photographs then, my face and body — so far as they manage to outlast me — will survive as a highly edited version of the whole person I managed to be behind an ever-ready grin.[15]

Figure 103 *elin o'Hara slavick,* "I FELL ASLEEP AND DREAMED
I LOVED YOU," *dress from* A Wall of Incoherent Dresses, *1991.*

Price would "give a lot to have a stack of black-and-white pictures of
moments" that captured such things as the "furious look" in his "father's
gray eyes on a warm Sunday evening" when he told his wife that "she'd
stolen his share" of Price and his brother.[16] But there are no such pictures
for Price, for most of us. Family albums are closely edited; they "tend to
include [only] those images on which family members can agree, which
tell a shared story."[17]

Most families agree on the same shared stories: Happy Holiday,
Happy Vacation, Happy Graduation, Happy Birthday, Happy First Bi-
cycle, Happy New Home, Happy New Baby, Happy Wedding. Though
as family members we can read other stories between the lines, there are
solid similarities among family pictures (the pose, the occasion, the
smiles, sometimes the clothes), a general covering-over that "perpetu-
ate[s] dominant familial myths and ideologies."[18] It is in this way that all
family pictures are masked: they assume the mask of the familial. "Pho-
tography," writes Barthes, "cannot signify (aim at a generality) except by
assuming a mask" (34).

Yet, in a play of contradiction, childhood photographs often seem like

an extraordinary touch of the real: evidence of the unmasked self. Looking through my father's family album, I see all of the essential traces of him: his quiet way, his tight-lipped smile, something moral and self-assured, his surprising love for wearing silly hats that stands in direct contrast to his hatred of costume, the pure pleasure he feels in being with the right people, his always very thick hair, a comfortableness with his own body, his love of dogs, his devotion to his mother. Some will say that I am reading what I want to see into these photographs, but I say, Nevertheless, I see it. I know that you can see it too (a little bit of truth) even in pictures of people you and I only know through pictures.

I have found such kernels of truth lodged in the baby and childhood photographs of artists and cultural critics that are reproduced in the center pages of *Out There: Marginalization and Contemporary Cultures.*[19] It has been said that the book is one of the most important texts on the topic of cultural marginalization, but rarely do I get past the old family photographs. I guiltily admit that these childhood snapshots are my favorite part of this book. I take perverse pleasure in matching up what I know (or what I imagine must be so) of the adult as it exists in the childhood photograph. I am especially delighted to find a picture of the cultural critic Simon Watney framed by grass and backyard shadows, head down, bottom up, pants short, shoes sweet, face buried (fig. 104).[20] The photograph is familial; it is reminiscent of a photograph of my own father-as-boy, in which my father's face (like Watney's) is also buried in a grassy heaven of seclusion and childhood privacy (fig. 105). (My grandmother, with her familiar and comforting cursive, has inscribed the picture of my father with the words "Asleep. 18 months," yet I suspect that my father is wide awake and hiding.) But in *Out There,* it is the little picture of Nancy Spero (the painter whose biting, figurative works have been central to feminist art since the 1970s) that gives me what Barthes has so famously referred to as *punctum*: a sometimes unexplainable, but always personalized, sense of being wounded or pierced by a photographic image (fig. 106). Looking at the charming snapshot of her sitting on an Oriental rug that has only temporarily landed, that appears ready for takeoff, I see a flash of *her.* I recognize her startlingly wide-eyed smile, the tightness of her skin, the clarity of her ears, the fall of her

Figure 104 *Simon Watney
as a little boy.*

Figure 105 *My father:
"Asleep. 18 months."*

asleep. 18 months.

hands, a certain love of the world, an excitement that I swear I have seen
in photographs of her as an adult. In the childhood picture, I see an es-
sential image of her that has achieved "utopically, *the impossible science of
the unique being.*"[21]

Our childhood photographs are an extraordinary touch of the real be-
cause they are able to capture an essence of a unique being that we carry
within ourselves from birth to death *indexically.* Like footprints in the
sand or fingerprints in wax, photographs leave a trace of the referent. All
photographs are traces of a skin that once was. Balzac understood this;
this is why he feared losing thin ghosts of himself, like layers of skin,
with each photograph "taken."[22] Barthes is in touch with Balzac when he

Figure 106 *Nancy Spero as a little girl.*

writes: "The photograph is literally an emanation of the referent. From a real body, which was there, proceed radiations which ultimately touch me, who am here" (80–81). Maybe this is why, when I see an old childhood photograph of my father, my grandmother, myself, I have an urge to touch it, to really feel it. And, even though I (really) feel nothing but smoothness, in my body, in my heart, I feel a weighty ache, a pang of loss. I believe, like Balzac, like Barthes, that the child before me is touching me. He weighs me down, she weighs me down, with grains of light that emanate from a small body that wears such childhood things as short trousers, cotton dresses, white cotton shirts (without collars), striped sweaters (with pointy collars), socks that bag and crinkle at the ankle.

Like slavick, many of us feel the loss of the body/bodies of our own childhood. Indeed, many of us feel that our childhood selves are dead. We mourn the loss. We try to bring the child back. We save toys and clothes and other mementos from our childhood days: souvenirs that try to replace the loss. Childhood and death, as Lynn Gumpert has remarked, are closely linked:

> Although these themes at first appear at odds with one another, they share some fundamental similarities. We never know death

directly; as Wittgenstein has succinctly observed, "Death is not lived through." Thus we must broach the subject from a distance, from observation. And while childhood is most definitely lived through, when analyzed or discussed, it is again almost invariably from a distance, from the vantage of adults who must rely on fragmented recollections and observations.[23]

Bringing the dresses out of the closet was a way for slavick to touch the child that had died, that she had left behind—not only the death of her own child body, but also that of the little brother who drowned. On a small silken slip that once rubbed against small silken girls, slavick stitched the following (fig. 107):

<div style="text-align:center">

I ATE FOOD IN THE BASEMENT.

I SUCKED LILACS.

I KICKED MY SISTER'S SHINS.

I PICKED DANDELIONS AND SOLD THEM

FOR A QUARTER.

I WANTED UGLY THINGS AND COULDN'T SWIM.

A BROTHER HAD DROWNED.

SICK EVERY SWIMMING DAY, HANDS UNDER

MY DRY THIGHS,

BROTHER, YOU HELD ME OVER THE WATERS.

</div>

Reading slavick's dress pulls me into the closet of the family album of my mind's eye. Childhood images flash before me. Though I had no brother who drowned, I had a little cousin who died. I hid behind my bed. And even though he did not drown and even though I could swim, I hid in the bushes on swimming day. I did not sell dandelions, but I sold things that I made, really dumb things, door to door. Ugly things were really beautiful to me too, like my favorite toys made of bright colored plastic on various themes of grotesque cuteness. But like most of us, while I have some photographs of my creepy collection of dolls and stuffed animals, I have no pictures of devastating emotions, and maybe it is just as well.

But Sally Mann has taken pictures of such things. Pictures such as that of Emmett sporting a shockingly bloody nose and mouth, Emmett with a

Figure 107 *elin o'Hara slavick,*
"BROTHER YOU HELD ME OVER THE WATERS," *dress*
from A Wall of Incoherent Dresses, *1991.*

back speckled by frightening chicken pox, Jessie with an eye painfully swollen and saddened by what I hope is only a bug bite, mar the perfection of childhood that we all try to invent, not only for ourselves but for our own children, for history itself. With each smiling photograph of the combed and primped child that we dutifully place in the album, the frame, the note to Grandma, we image childhood as undamaged and undamaging: far away from death. We preserve our children in an emulsion of Neverland, an imaginary place of tiny first teeth that never pop out. Yet Jessie bites (see fig. 29) and slavick kicked her sister's shins.

*

Jenny's mom, Barbara, showed me where my boys were to sleep for the night. The two beds were covered with beautiful aging quilts made of hundreds of tiny squares, the very size of old photographs, like those taken and printed and pasted in my father's album. Caressing one of the old quilts, Barbara explained to me that each square was from an old dress worn by her and her sisters. Each square, patterned with tiny flowers, dots, and funny abstractions, lightly colorful in their muted washed-out colors, were dresses *taken,* like photographs: they represented years at home, with mother, father, and siblings. Infused with the "texture of perfume," each square, as if bites of (Proustian) madeleine cake, brought back memories.[24] Some good. Some bad. Some banal. They too, like my father's album, carried the weight of the past. Each seam was a memory, a seed sown. I thought of slavick's dresses and I thought of the things that I hoarded in my closets.

Remembering that rainy night in Virginia and the quilts made of lost dresses, I recall a photograph taken not by but of Sally Mann (fig. 108). Perched on a swing, wearing the Easter dress that had been made for her by her mother and grandmother, she is only six years old. You can see the lovely little dress showing its bright face again in Mann's *The Easter Dress* (fig. 109). Like the dresses in the Slavick family, passed down from mother to daughter, Mann has continued the process of acquisition and exchange by passing the Easter dress down to her daughter Jessie. In Mann's photograph, Jessie holds out the bright white pleated cotton skirt,

Figure 108 *Sally Mann "wearing the Easter dress that had been made for her by her mother and grandmother."*

sprinkled with flowers, into a wide smile for the camera. A little sister in a white baby dress hunts in the weeds—for what? I am charmed. But I am also haunted, not only by Jessie's brother, who pulls himself along the wire fence (his face strangely hooded, his legs in shorts), but especially by the torn nightdress that hangs on the clothesline. The nightdress—caught in the gentle breath of the Blue Ridge mountains, caught between the movement of an elderly man's dancing steps and the blur of a winged creature—is ripped at the back and at the hem. This dress is a horrible dress. Hanging and blowing like shed skin, it is a souvenir of loss, amongst shadows of change.

I am reminded of my children's little baby sweaters and the grief that I felt (and still feel) when I discovered that they had been ravished by moths. I try to convince myself that the loss tears at my body, not theirs. I try to console myself with Barthes's words on the pleasure of "abrasions," the pleasure found in "the site of loss, the seam, the cut, the deflation."[25] But one hole gives way to another tear. I become acutely

aware of my futile attempts to fill the holes with family albums of be-
coming pictures. Becoming decay.

BECOMING DECAY

"Becoming" and "decaying" are words that have been used to describe
the work of Francesca Woodman, another photographer who, like
Hawarden, used her camera to take captive adolescent reverie.[26] Wood-
man, like Hawarden, reproduced the beauty of young women, some
alone, some together, most in feminine dresses. Like Hawarden, all (the
dresses and the girls) beckon my touch. But unlike Hawarden, Woodman
was not a mother; she was adolescence itself (her short career began at
the tender age of thirteen, ending at the still tender age of twenty-two).
Unlike Hawarden, she often photographed her own (adolescent) body.

Like Hawarden, Woodman's photographs feature *becoming* women.
They are "becoming" in that they are attractive to the eye. They are

Figure 109 *Sally Mann*, The Easter Dress, *1986*.

"becoming women" in that their bodies drape the threshold between girlhood and womanhood. And like Hawarden, Woodman's beautiful girls (whether herself or her model friends) are often pictured as "becoming space"; they too become the space around them: the wallpaper, the fireplace, the window of light.

For example, in *From Space²* (fig. 110), and *Then at one point I did not need to translate the notes; they went directly into my hands* (fig. 111), it is as if Woodman, in the spirit of Hawarden, is imagining a female figure that is as confined by her gender as wallpaper is to the walls of a room. In *Then at one point*, wallpaper has come off the wall; as stiff as crinoline, it covers the crouched Woodman like the elytron or outer wing covering of a beetle, closeting her quick, translucent wings that remain hidden, tucked inside. In *From Space²*, Woodman wears giant shards of floral wallpaper, crisp with the paste of age, as veil and skirt. She is wallflower. Hiding and emerging. Woodman's navel as eye surrealistically returns my gaze. The words of Gilman's *The Yellow Wallpaper* echo through . . . again: "I pulled and she shook. I shook and she pulled, and before morning we had peeled off yards of that paper."[27] In these Woodman pictures as well as many of her other photographs, pieces of decay are scattered around her feet, all over the floor. I become acutely aware of the surprising bits of paper that also often litter Hawarden's interior pictures (see especially fig. 54). Strange, almost magical, Hawarden's bits suggest that what has been torn and scissored from the edges of the prints has fallen back into the picture frame, onto the floor; as if the loss has been haphazardly collected, only to be swept away (see fig. 23).

Like Hawarden, Woodman is forever scarred by an early death. Born in 1958, Woodman committed suicide on 19 January 1981. Haunted by the familiarity of the date, I turn back to my notes on Hawarden. I am surprised, yet somehow not, to discover that Hawarden also died on 19 January. (Data, at once supremely significant and not at all, collected: I am collecting loss.)

Nevertheless, Woodman's pictures are very different from Hawarden's. Not only are they modern, overtly sexual, self-consciously art, they are blatant in their critiques of gender and femininity. Woodman's

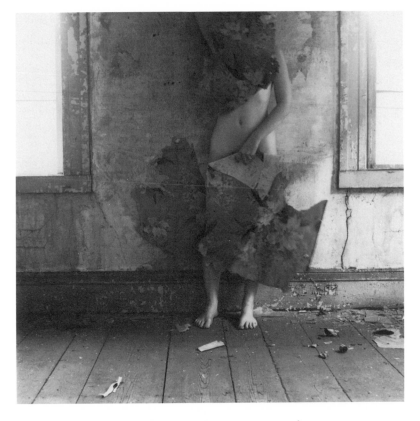

Figure 110 *Francesca Woodman,* From Space², *1975–76.*

vantage point insists that the model (who is often herself) be caught in movement away from frames: the frame of womanhood and the picture frame. In Woodman's *House 4* (fig. 112), the camera catches an adolescent Woodman, not so much "shaven, and fitted to a frame" — as Isabella is when her dress and body become one with the interior, "kin to the quiescent book on the mantel, the hushed (yet gaping) mouth of the fireplace, the frozen, unflickering wallpaper stars"[28] — as escaping the space that has become her. Legs straddling the mantel that has pulled away from a wall, her hair blurs into a frenzy of fabric and light; her black cloth Chinese shoes (the kind I wore to college) are my punctum.

I read more. I make arrangements to telephone her mother. I call a gallery that sells her prints. I order books and articles. I consume her. I

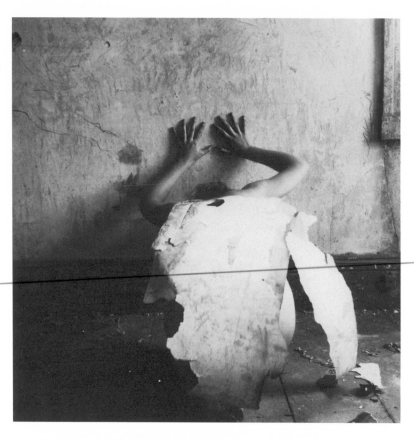

Figure III *Francesca Woodman,* Then at one point I did not need
to translate the notes; they went directly into my hands, *1976*.

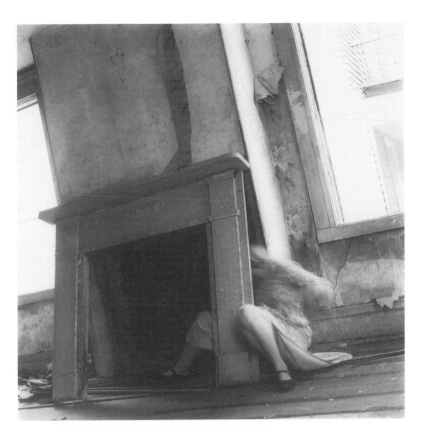

Figure 112 *Francesca Woodman*, House 4, *1975–76.*

try to convince elin that she is amazing. I feel verified, almost deified by our shared love for Colette. I cannot boast a devotion to Guy de Maupassant (but I have been planning one for years). I wear old dresses often (many given to me by elin herself). I do not try to become her, but she is under my skin.

BACK TO DRESSES

In her photographs, Woodman, when dressed, is most often adorned in a dress from the past. The floral print, the rayon fabric, the bead work, and the ill-fitting shape that appealingly drapes her body mark her clothing as other, as borrowed, as bought for cheap, as found, as traded, as passed on, as not hers but of her.

She waves to me in *Polka Dots #5* (fig. 113). Her hem is falling out.

In an untitled photograph from her summer days in Stanwood Washington (fig. 114), two girls wear old dresses whose prints appear in surrealistic response, as animal mimicry, like the bodies of insects "in the grip of mimetic redoubling[s],"[29] to the pretty landscape that houses them: a bower of leaves, straw, weed, and their own freshly washed, loose, wavy, you-can-smell-how-clean-it-is August hair.

Against the wood slat siding of a light-colored house in Boulder, Colorado, Woodman and a friend wear old cotton dresses from the past, unbuttoned in the front (fig. 115). Woodman's dress must have been a favorite of hers, as I see it worn repeatedly, here in Boulder, Colorado, but also years later in Italy, pulled down and pulled up, and I think even worn backwards at the MacDowell Colony in Peterborough, New Hampshire. Over the phone, Betty Woodman, Francesca's mother, tells me that the pattern was a favorite of hers. We flip through our respective copies of the Cartier Foundation's big beautiful Francesca catalogue together, she in Italy, me here. Betty points out all the pictures in which Francesca is wearing this dress and others in which she is wearing dresses of a very similar pattern. She confirms what I already know: "Francesca had a lot of old clothes."

But beyond the great dresses, the picture catches me off guard, less

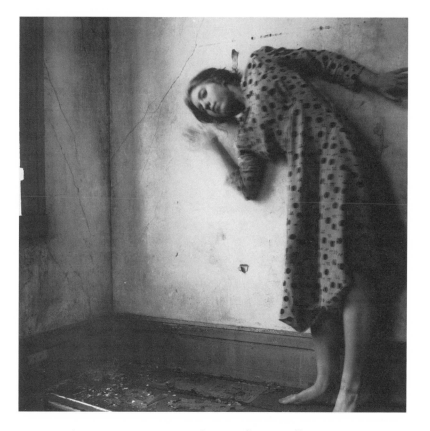

Figure 113 *Francesca Woodman,* Polka Dots #5, *1976–77.*

because of the exposed breasts than because of Francesca's exposed face;
rarely is Woodman's face visible, and even more rarely do we see her ex-
pressing flat, plain pleasure. She and her appealing friend, who is caught
in a smiling blink, stand before us as if posing for a family picture, as if
their breasts (two more pairs of eyes for our eyes) were not there. But
they are there. And we love it. And we smile too. Women, young and
old, may remember pictures (real and not real) taken of their own ado-
lescent games, perhaps while away at school or college or camp: places
where we make new domestic worlds, where we reconstitute family. Like
the women in Bellocq's photographs of American prostitutes from the
early part of this century, Woodman and friend exude ease. Woodman
affirms both "sensuality and domestic ease, and the tangibleness of . . .

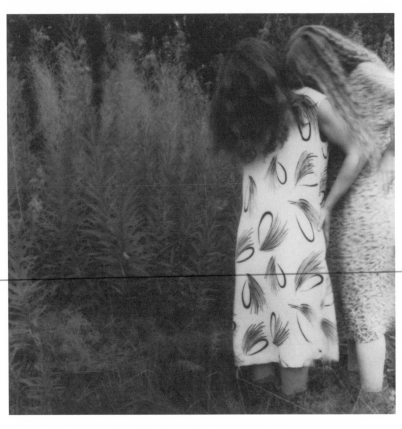

Figure 114 *Francesca Woodman, untitled, Stanwood, Washington, summer 1979.*

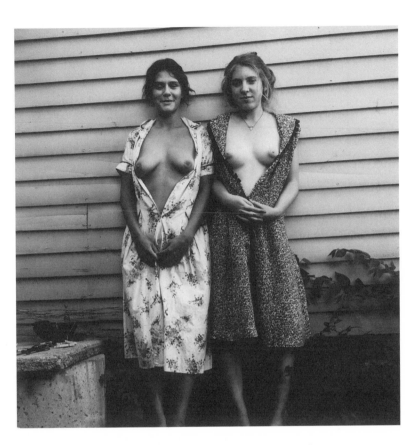

Figure 115 *Francesca Woodman, untitled,*
Boulder, Colorado, 1972–75.

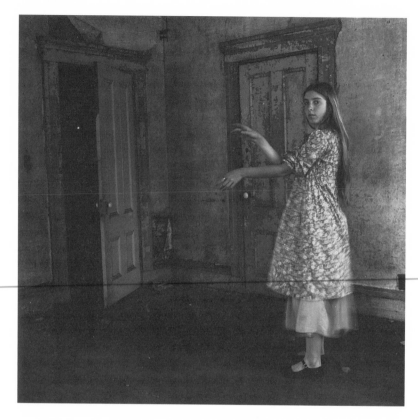

Figure 116 *Francesca Woodman, untitled,*
Providence, Rhode Island, 1975–76.

[an adolescent] world. How touching, good natured, and respectful" this
picture is. "What a splendid gift."[30]

When I see Woodman in a full flowery dress (which she wears like a
Victorian breakfast coat over a plain longer skirt), her sleeves pushed up
over her dimpled elbows, her hands gesturing out as if in a Charcotian
trance, her eyes gazing out at me (for me?) as she heads to the partially
opened door of an unknown world that I can only imagine (fig 116), I see
old photographs (never taken, but nevertheless there) of enigmatic girls
that went to college with me in the Santa Cruz mountains. Betty tells me
the history of this patterned dress: it was a Liberty print and was made
especially for Francesca when she was quite young in Italy. (Amy Hauft,

my old college friend, wore dresses like that, but in place of Francesca's notable, famous Chinese slippers, she marked her fame with carved wooden shoes from Holland, like old cartoons, like handmade toys, that mimicked the art that she carefully, yet somewhat recklessly carved out of the fallen trees. I miss her terribly, but I still have the small cream-colored hand-sewn felt horse with string mane and tail and embroidered persimmon saddle that she bought from an old lady who had kept it under glass for fifty years.)

Woodman's photographs feature dresses that feel like history, like portraits. Like Hawarden, like slavick, Woodman too is a clothing fetishist who weaves her perversion with photography. Remembering the dresses in the Slavick family passed down from mother to daughter, and the Easter dress that Mann passed down to her daughter, I believe there must be stories of sartorial acquisition hidden in Woodman's prints.

Woodman gives us a taste of such stories in her artist's book, *Some Disordered Interior Geometries.* Below two photographs of herself, nearly naked, wearing nothing more than a vintage blouse inherited from her grandmother (and a bit of jewelry, including the snaky ring that I notice she always wears on her left index finger, the signified of Francesca among the many nude and partially nude girls of her pictures, whose heads are always off-frame or turned away), she writes: "These things arrived from my grandmothers [*sic*] they make me think about where I fit in this odd geometry of time. This mirror is a sort of rectangle although they say mirrors are just water specified" (fig. 117).[31] The mirror has become pond, the artist Narcissa, time anachronistic, Woodman her grandmother. Exactly what objects belonged to Woodman's grandmother is not clear, but one suspects the monogrammed towels, the bits of fur and lace, perhaps even the spoon and the silver handle broken from its pot that lie beneath the chair. Certainly not the cat who walks through the second frame. And one wonders about the dark cloth with the cartoon-like skeletons. Geometries disordered, the pages of this Italian math book, numbers and words painted out, pictures taped on top, sections colored in, its interior unbound and put back together, is out of order. Clifford's words circle back: "Living does not easily organize

36. L'area d'un parallelogrammo è uguale al prodotto della base per l'altezza.

AD = 812ᵐ	BC = 24ᵐ,50	Superf. = m²1.670,5	
BI = 504ᵐ	BI = 15ᵐ,20	AD = 51ᵐ,40	

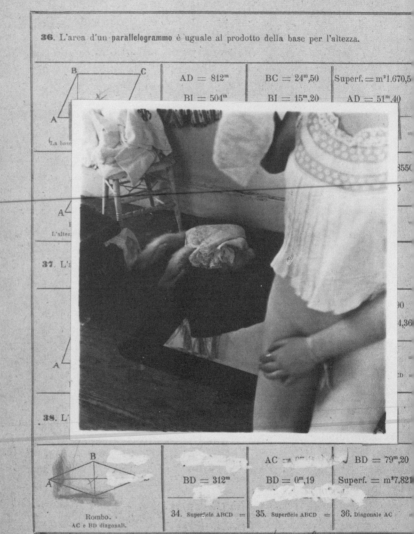

37. L'a

38. L'

Rombo.
AC e BD diagonali.

BD = 312ᵐ	BD = 0ᵐ,19	Superf. = m²7,821
	AC = ... BD = 79ᵐ,20	

34. Superficie ABCD = **35**. Superficie ABCD = **36**. Diagonale AC

These things arrived from my grandmothers they

Figure 117 *Francesca Woodman,* Some Disordered Interior Geometries, *1981, detail.*

Figure 118 *"The first steps of a dance."*

itself into a continuous narrative." Betty on the phone, speaking to George in the background: "The ring was your mother's, wasn't it?" "Yes, it belonged to my father. It was a snake with two little sapphires for eyes."

<center>*</center>

In a particularly joyful Hawarden photograph of Clementina teaching Cornwallis and her younger sister Elphinstone to take "the first steps of a dance," there is evidence of more familial sartorial acquisition (fig. 118).[32] Clementina is pictured developing as beautifully as the new buildings of South Kensington behind her. Clementina full of confidence, full of love, full to the brim with her mother's indulgence, skips outward, pulls up her skirt. This photograph is unusual among the hundreds of others in that Clementina is not in "fancy dress" but in an 1830s rather ordinary vintage dress, which very well may be an old dress of her mother's.[33] Clementina is about fifteen years old. If Hawarden wore the dress in 1837, she too would have been fifteen years old then.

I read the dress like an old family photograph.

When the dress was handed over to Clementina, it must have held traces of Hawarden's adolescent body of the 1830s — perhaps even through a long-forgotten object lost in a pocket (a popped button, a scrap of paper, a strand of golden hair, "She clipped a precious golden lock / She dropped a tear more rare than pearl," an embroidered handkerchief, a small envelope without its letter, a hairpin with the odor of her mother's perfumed hair) — not unlike photographic emulsion on paper that holds traces of a lost moment, a body that once was. Even though Hawarden's adolescent body was absent, one might even say dead, it was present in the dress. When Clementina pulled the dress over her own body some thirty years later, she was wearing traces of her mother's lost adolescent body over her own developing adolescent body. What intimacy. What shared skin, not only between mother and daughter, but also between (past and present) adolescence.

<center>*</center>

Fingers at the tip of my words, I rub my (adolescent) language against them. Adolescent reverie.

Figure 119 *"She appears to be wearing a darkroom apron."*

There is evidence that the girls may have helped their mother with the printing. In this photograph of Clementina seated in a chair, returning the gaze of the camera/her mother, she appears to be wearing a dark-room apron (fig. 119).[1] A small treasure, perhaps a magnifying glass, might be attached to the string around her neck. Clementina and Clementina, alone in the darkroom, *la chambre noire*, the glass plate neg-atives of blackened girls turning inside out, shedding their black chrysalis skin to sprout the white wings of their mother's eyes, *la chambre claire*. The washing of the prints becomes domestic, like rinsing porcelain plates in the kitchen sink.

ILLUSTRATIONS

Note: All of Clementina, Viscountess Hawarden's photographs are untitled and undated. Unless otherwise indicated, all of her photographs are courtesy of The Board of Trustees of the Victoria and Albert Museum.

NOTES

PREFACE

1 Laura Mulvey, "Melodrama Inside and Outside the Home," in *Visual and Other Pleasures* (Bloomington: Indiana University Press, 1989), 69.

2 Clementina Hawarden, born Clementina Elphinstone Fleeming, married Cornwallis Maude, the future fourth Viscount Hawarden, in 1845. In 1856, her husband succeeded to his title. Clementina Maude became Clementina, Viscountess Hawarden, or Lady Hawarden. Propriety, and probably Lady Hawarden herself, would insist that the "Lady" or "Viscountess" remain intact, yet to do so unhinges what is central to this book: her identity as artist. Although she is known in photography history as Lady Hawarden, I have chosen to refer to her simply as Hawarden.

3 Richard B. Woodward uses almost these exact words (those in italics) to describe the work of the contemporary photographer Sally Mann. See his "The Disturbing Photography of Sally Mann," *The New York Times Magazine*, 27 September 1992, 52.

4 Hawarden actually gave birth to ten children, with only eight surviving. Their names and dates are as follows, from Virginia Dodier's unpublished catalogue raisonné housed with the Hawarden photographs at the Victoria and Albert Museum:

Isabella Grace (Trotty), female, 1846–1927
Clementina (Chukky), female, 1847–1901
Florence Elizabeth (Bo), female, 1849–1931
Cornwallis (Toby), male, 1852–1881
Kathleen (Tibby), female, 1854–1939
Beatrix Emma, female, born & died, 1856
Elphinstone Agnes (Eppie), female, 1857–1921
Eustace Mountstuart, male, born & died, 1859
Leucha Diana, female, 1860–1947
Antonia Lillian, female, 1864–1927

Dodier's catalogue raisonné along with two of her articles on the topic have been groundbreaking. Her careful historical research on the photographs has proved invaluable in the writing of this book. See "An Introduction to the Life and Work of Clementina, Viscountess Hawarden (1822–1865)," unpublished; "From the Interior: Photographs by Clementina, Viscountess Hawarden," *Antiques* 139, no. 1 (January 1991): 197–207; and "Haden, Photography and Salmon Fishing," *Print Quarterly* 3, no. 1 (March 1986): 34–50.

5 See Graham Ovenden's *Clementina, Lady Hawarden* (London: Academy Editions; New York: St. Martin's, 1974).

6 Susan Sontag, *On Photography* (New York: Farrar, Straus & Giroux, 1973), 8.

7 Lewis Carroll's secrets have captivated scholars for years, prompting such questions as Why did Carroll suddenly quit photography in 1880? Did he really ask Alice Liddell, the real little girl of *Alice in Wonderland* fame, to marry him? Was Carroll's relationship with little girls more than play and picture taking? What kind of "more"? What was at the heart of the scandal between Alice's mother and Carroll? and so on.

8 C. L. Dodgson [Lewis Carroll], private journal, diary entry for 22 July 1864, British Museum, Add 54343.

9 Maria Morris Hambourg describes the camera featured in the well-known portrait of the mime Charles Deburau as Pierrot as a "long legged humanoid camera." Her description of this Nadar–Adrien Tournachon photograph has been very influential in my reading of Hawarden's photograph of her camera reflected in the mirror. See Maria Morris Hambourg, Françoise Heilbrun, Philipe Néagu, with contributions by Sylvie Aubenas et al. *Nadar* (New York: Metropolitan Museum of Art, 1995), 225.

10 Dodier, catalogue raisonné, Victoria and Albert Museum, photo D559.

11 The concept of the mime's costume as screen onto which shadows are cast is Rosalind Krauss's. See "Tracing Nadar," *October* 5 (summer 1978): 45.

12 As Hambourg writes in regard to *Pierrot the Photographer*, "this black-and-white pair of magicians doubles Nadar operating his camera" (Hambourg, Heilbrun, and Néagu, *Nadar*, 225).

13 Roland Barthes, (*Camera Lucida*, trans. Richard Howard [New York: Farrar Straus & Giroux, 1981]), writes: "A sort of umbilical cord links the body of the photographed thing to my gaze: light, though impalpable, is here a carnal medium, a skin I share with anyone who has been photographed" (81). And: "It is by this tenuous *umbilical* cord that the photographer gives life; if he cannot, either by lack of talent or bad luck, supply the transparent soul its bright shadow, the subject dies forever." (110)

14 National Library of Scotland, MS 10289, quoted in Dodier, catalogue raisonné, photograph D257.

15 Ibid.

16 Eve Kosofsky Sedgwick, *Epistemology of the Closet* (Berkeley: University of California Press, 1990), 205. For more on how homosexuality makes use of and is abused by the notion of the secret, see D. A. Miller, "Secret Subjects, Open Secrets," in *Novel and the Police* (Berkeley: University of California Press, 1988), and Sedgwick's "Jane Austen and the Masturbating Girl," in *Tendencies* (Durham, NC: Duke University Press, 1993). My understanding of secrets has also been richly enhanced by conversations with Jacquelyn Hall and Della Pollock.

17 Christina Rossetti, "Winter: My Secret," in *The Complete Poems of Christina Rossetti*, ed. R. W. Crump (Baton Rouge: Louisiana State University Press, 1979), 1:47.

AN EROTIC NOTE

1 Roland Barthes, *A Lover's Discourse,* trans. Richard Howard (New York: Farrar, Straus, & Giroux, 1978), 73. Ian Wilson, a graduate student in my course Photographies and Sexualities, reminded me of this quote while discussing how Barthes has expanded notions and conventions of the erotic.

2 Barthes, *Camera Lucida*, 59.

3 Ibid.

4 Richard Howard, "A Note on the Text," in *Pleasure of the Text*, by Roland Barthes (New York: Farrar, Straus & Giroux, 1975), vi.

5 Roland Barthes, *Sollers écrivain* (Paris: Seuil, 1979), 58, as translated by Jonathan Culler in *Roland Barthes* (New York: Oxford University Press, 1983), 100.

A QUEER NOTE

1 Lewis Carroll, *Alice's Adventures in Wonderland*, in *The Annotated Alice*, introduction and notes by Martin Gardner (New York: Random House, 1960), 41. Hereafter, citations to this edition appear in parentheses in the text.

2 Joseph Litvak, "Strange Gourmet: Taste, Waste, Proust," in *Novel Gazing: Queer Reading in Fiction*, ed. Eve Kosofsky Sedgwick (Durham, NC: Duke University Press, 1997), 76.

3 Hélène Cixous, "Introduction to Lewis Carroll's *Through the Looking-Glass*

and *The Hunting of the Snark*," *New Literary History* 13, no. 2 (winter 1982): 240.

4 Litvak, "Strange Gourmet," 77.

5 This concept of photography's inherent queerness is fully discussed in chapter 3.

6 The possibility of an adolescent reverie, a phrase coined by Julia Kristeva, is the subject of my introduction.

7 But for too many, it is not just a problem of fashion, consumption, materials for the closet. Sedgwick begins the first essay of *Tendencies* (Durham, NC: Duke University Press, 1993) with the following gripping words:

> *A Motive* I think everyone who does gay and lesbian studies is haunted by the suicides of adolescents. To us, the hard statistics come easily: that queer teenagers are two to three times likelier to attempt suicide, and to accomplish it, than others; that up to 30 percent of teen suicides are likely to be gay or lesbian; that a third of lesbian and gay teenagers say that they have attempted suicide; that minority queer adolescents are at even more extreme risk.
>
> . . . I look at my adult friends and colleagues doing lesbian and gay work, and I feel that the survival of each is a miracle. (1)

My Hawarden-envy is fed by the delicious morsels of Litvak's Proust-envy, see Litvak's "Strange Gourmet," esp. 76–77.

8 Eve Kosofsky Sedgwick, "Paranoid Reading and Reparative Reading: or, You're So Paranoid, You Probably Think This Introduction Is About You," in *Novel Gazing: Queer Readings in Fiction* (Durham, NC: Duke University Press, 1997), 2.

9 Ibid.

10 Litvak, "Strange Gourmet," 77.

11 See James Kincaid's two smart books on the subject: *Child-Loving: The Erotic Child and Victorian Culture* (New York: Routledge, 1992), and *Erotic Innocence: The Culture of Child Molesting* (Durham, NC: Duke University Press, 1998).

12 The notion of a sartorial ego is Joan Copjec's. See "The Sartorial Super-ego," *October* 50 (fall 1989): 56–95.

13 Barthes, *The Pleasure of the Text*, 3.

14 Roland Barthes, *Le plaisir du texte* (Paris: Éditions du Seuil, 1973), 11; translation is from Barthes, *The Pleasure of the Text*, 4.

1 Helene Deutsch, *Confrontations with Myself: An Epilogue* (New York: Norton), 216; cited by Julia Kristeva, "The Secrets of an Analyst: On Helene Deutsch's Autobiography," in *New Maladies of the Soul*, trans. Ross Guberman (New York: Columbia University Press, 1995), 199.

2 Julia Kristeva, "The Adolescent Novel," in *New Maladies of the Soul*, 143.

3 I am paraphrasing Virginia Woolf, "Lewis Carroll," (1939), in *Aspects of Alice*, ed. Robert Phillips (London: Victor Gollancz, 1972), who wrote that in Carroll there was an "untinted jelly [that] contained within it a perfectly hard crystal. It contained childhood. And this is very strange, for childhood normally fades slowly . . . But it was not so with Lewis Carroll. It lodged in him whole and entire. He could not disperse it. And therefore as he grew older, this impediment in the center of his being, this hard block of pure childhood, starved the mature man of nourishment" 48–49.

4 T. J. Clark, "Lewis Carroll's Photographs of Children, with Commentary by Mindy Aloff, T. J. Clark, Ann Hulbert, Janet Malcolm, Lisa Mann, Adam Phillips, and Christopher Ricks," *Three-Penny Review* 64 (winter 1996): 29.

5 Lewis Carroll, *Alice's Adventures Underground*, facsimile of the author's book with a new introduction by Martin Gardner (New York: Dover Publications, 1965), 2.

6 Ibid., 36–38.

7 Sally Mann, *At Twelve* (New York: Aperture, 1988), 52.

8 Ibid.

9 Barthes, *Camera Lucida*, 92.

10 Kristeva, "The Secrets of an Analyst," 199. Helene Deutsch, a colleague of Freud's, was one of the great psychoanalysts of our century. As Marie H. Briehl, "Helene Deutsch: The Maturation of Woman," in *Psychoanalytic Pioneers*, ed. Frantz Alexander, Samuel Eisenstein and Martin Grotjahn (New York: Basic Books, 1966), rightly points out: "Deutsch is a pioneer in psychoanalysis in several senses. She was among the first to explore the emotional life of woman and the first and only analyst to construct from her findings a comprehensive psychology of the life cycle of womanhood" (282). And she was one of the first of four women candidates to be analyzed by Freud. Born in 1884, Deutsch was nearly one hundred years old when she died in 1982.

11 Deutsch, *Confrontations with Myself*, cited by Kristeva, "The Secrets of an Analyst," 199.

12 Kristeva, "The Adolescent Novel," 135.

13 See Carol Mavor, *Pleasures Taken: Performances of Sexuality and Loss in Victorian Photographs* (Durham, NC: Duke University Press, 1995).

14 Charles Baudelaire, "The Painter of Modern Life," in *The Painter of Modern Life and Other Essays*, trans. Jonathan Mayne (New York: Da Capo Press, 1964), 8.

15 Baudelaire, "The Painter of Modern Life." But here, I have used Kristeva's translation, which appears in her *Tales of Love*, trans. Leon S. Roudiez (New York: Columbia University Press, 1987), 320.

16 Baudelaire, "The Painter of Modern Life," 8.

17 D. W. Winnicott, "Transitional Objects and Transitional Phenomena, A Study of the First Not-Me Possession," *The International Journal of Psycho-Analysis*, 34, part 2 (1953): 89.

18 As Mann, *Immediate Family* (Aperture: New York, 1992), unpaginated, has written, "Ninety-three years separate the two Virginias, my daughter and the big woman who raised me. The dark powerful arms are shrunken now, even as the tight skin of my daughter's arms puckers with abundance."

19 Julian Bell, "Decency and Delusion," *Times Literary Supplement*, 19 March 1993, 7.

20 Ibid., 8. I cannot let the phrase "Mummy is still behind her box" go by. Could Bell have truly repressed the connotations of a woman's box while discussing what he sees as sexual perversion? For a rich discussion of femininity, sexuality, and boxes, see Michael Moon, "Oralia: Joseph Cornell, Hunger, Sweetness, and Women's Performances," in *A Small Boy and Others: Imitation and Inititation in American Culture from Henry James to Andy Warhol* (Durham, NC: Duke University Press, 1998), 133–54. In chapter 3, I will discuss Hawarden's camera box, with an emphasis on interiority, private space, and femininity, alluding to the same sexual connotations but with an open respect for both Hawarden and the sexuality of her work.

21 Anthony Lane, "Goose Bumps," *The New Yorker*, 17, no. 27 (16 September 1996): 99.

22 Sigmund Freud, *Beyond the Pleasure Principle*, trans. James Strachey, in *The Standard Edition of the Complete Psychological Works of Sigmund Freud* (London: Hogarth Press, 1981), 18: 16–17.

23 Elizabeth Hess, "The Good Mother," *The Village Voice*, 17 October 1995, 78.

24 Ibid.

25 Dodier, "From the Interior," 205–6.

26 See Mavor, *Pleasures Taken*.

27 James Kincaid, "Dreaming the Past," paper presented at " 'Watching or

Fainting, Sleeping or Dead': Unveiling Dante Gabriel Rossetti's *Beata Beatrix*," University of North Carolina, Chapel Hill, on 24 April 1993.

28 Hawarden used the wet collodion process, which was introduced to the public in 1851. The "process was complicated, time-consuming and physically demanding . . . The glass plate had to be coated with collodion (guncotton dissolved in ether), sensitized with silver nitrate, placed in the camera and exposed while still wet, then removed and developed and fixed immediately" (Dodier, "Haden, Photography and Salmon Fishing," 35–36).

29 In fact, *Night-blooming Cereus* graces the cover of Sally Mann, *Still Time* (New York: Aperture, 1994).

30 Although I have never had the privilege of witnessing the phenomenon of the opening of a night-blooming cereus, several of my students have. One recounts being awakened by her mother to see the flower open right before her eyes; she could see the movement. When the gigantic spectacular blossoms do open, that one time, on a singular summer night, they release a triumphant perfume.

31 Carroll, *Alice's Adventures Underground*, 36. Emphasis on the word still is mine.

CHAPTER ONE REDUPLICATIVE DESIRES

1 My telling of these stories of female desire has been highly influenced by Mary Kelly's own storytelling in her artist's project *Interim* (New York: New Museum of Contemporary Art, 1990), especially those told in the initial portion of the project entitled "Corpus" (1984–85).

2 The topic of Hawarden's use of mirrors is the subject of chapter 3.

3 My understanding of women's ontological fetishism as represented through such patterns of behavior as "narcissistic displays of isolated body parts" or performing "doll-like affectations" has been informed by Emily Apter. See esp. *Feminizing the Fetish* (Ithaca, NY: Cornell University Press, 1991), 104.

4 The term is Apter's and will be further elaborated in chapter 4.

5 Dodier, catalogue raisonné, photograph D639, has also suggested the Pandora reading of this image, emphasizing that "the shell-covered box is [also] an example of the type of handicraft which Victorian women were encouraged to take up."

6 A concertina is a small, hexagonal accordion with a bellows and buttons for keys.

7 Dodier, catalogue raisonné, photograph D224.

8 Naomi Schor, quoted in Apter, *Feminizing the Fetish*, 104. See Naomi Schor, "Female Fetishism: The Case of George Sand," in *The Female Body in Western Culture*, ed. Susan Rubin Suleiman (Cambridge, MA: Harvard University Press, 1986), 371. Apter sees Elizabeth Grosz's conception of lesbian fetishism as a novel and important exception to the typically male-centered perceptions of female fetishism. See Grosz's "Lesbian Fetishism," in *Fetishism as Cultural Discourse: Gender, Commodity, and Vision*, ed. Emily Apter and William Pietz (Ithaca, NY: Cornell University Press, 1993), 101–15.

9 Craig Owens, "Photography *en abyme*," *October* 5 (summer 1978), has also made use of the term "reduplicate" in relationship to photography. His perspective, like mine, focuses on photography's relationship to the mirror and especially to the concept of *mise en abyme*; however, issues of sexuality are, at most, only distantly visible in his text, and with its emphasis on linguistic theory, his writing does not touch upon feminist theory, the maternal body, nor psychoanalysis. For more on Owens's important article, see chapter 3 below.

10 All definitions are from *Webster's Seventh New Collegiate Dictionary* (Springfield, MA: G. & C. Merriam Co., 1963).

11 The image looks to be, according to Dodier, D392 in the Victoria and Albert Museum collection.

12 Peggy Phelan, *Unmarked* (London: Routledge, 1993).

13 See Joan Riviere's famous essay, "Womanliness as a Masquerade," *International Journal of Psycho-Analysis* 10 (1929): 303–13.

14 Leslie Camhi, "Stealing Femininity: Department Store Kleptomania as Sexual Disorder," *differences: A Journal of Feminist Cultural Studies* 5, no. 1 (1993): 39.

15 Rossetti, "Goblin Market," in *The Complete Poems of Christina Rossetti*, 11.

16 Ibid., 23.

17 Kirsty Gunn, *Rain* (New York: Grove Press, 1994), 79–80.

18 Melanie Pipes, unpublished essay, 1994.

19 Freud's *fort-da* story is in *Beyond the Pleasure Principle*, 14–16.

20 Luce Irigaray, "Gesture in Psychoanalysis," in *Sexes and Genealogies*, trans. Gillian C. Gill (New York: Columbia University Press, 1993), 98.

21 Dodier, "An Introduction to the Life and Work of Clementina, Viscountess Hawarden (1822–1865)."

22 Ibid.

23 Barthes, *Camera Lucida*, 81.

24 Irigaray, "Gesture in Psychoanalysis," 98.

25 Kelly, *Interim*, 55.

26 Photogen and Nycteris are characters of "light" and "dark" in George Mac-
 Donald, "The Day Boy and the Night Girl" (1879), in *Victorian Fairy Tales:
 The Revolt of the Fairies and Elves*, ed. Jack Zipes (London: Methuen, 1987),
 175–208.

27 Rossetti, "Goblin Market," 14.

28 Ibid., 16.

29 Ibid.

30 Charlotte Perkins Gilman, "The Yellow Wallpaper," in *The Charlotte Per-
 kins Gilman Reader*, ed. Ann J. Lane (New York: Pantheon, 1980), 17.

31 Emily Dickinson, "It was not Death, for I stood Up—," *The Complete
 Poems of Emily Dickinson*, ed. Thomas H. Johnson (Boston: Little Brown,
 1960), 249. The poem is circa 1862.

32 Dickinson, "The Soul has Bandaged moments—," in ibid., 250. The poem
 is circa 1862.

33 Dodier, catalogue raisonné, photograph D333.

34 Dodier, ibid., writes that where Hawarden should be seen, "there is air."

35 Dodier has made this astute observation in ibid.

36 Barthes, *Camera Lucida*, 13.

37 Ibid.

38 Ibid., 13–14.

39 Leslie Dill, artist's statement, collected by Nina Felshin for "Women's
 Work: A Lineage, 1966–94," *Art Journal*, 54, no. 1 (spring 1995): 84.

40 Ibid. The red ribbon signifies how many young women today are HIV-
 positive.

41 Dick Hebdige wrote a book on subculture entitled *Hiding in the Light:
 On Images and Things* (London: Routledge, 1988). He specifically defines
 the relationship between subculture and hiding in the light as follows: "Sub-
 culture forms up in the space between surveillance and the evasion of sur-
 veillance, it translates the fact of being under scrutiny into the pleasure of
 being watched. It is hiding in the light" (35). In other words, subculture
 turns something like youth culture on its head, making punk (its offspring)
 into a cultural pleasure self-inflicted. Women artists like Hawarden and
 Dill, though in very different ways (both from each other and from those
 mostly male figures of Hebdige's book) take the surveillance of women and
 disarm the femininity of spectacle in favor of a materiality that is performa-
 tive in nature, what Peggy Phelan calls "unmarked" but not invisible.

42 Baudelaire, "A Philosophy of Toys," in *The Painter of Modern Life*, 198.

43 Dodier, catalogue raisonné, photograph D257, has noted the "surreal" qual-

ity of these "shiny button boots,"positioned as if Elphinstone's "feet were still in them."

44 Barthes, *Camera Lucida*, 45, cited by Ulrich Baer, "Photography and Hysteria: Toward a Poetics of the Flash," *Yale Journal of Criticism* 7, no. 1 (spring 1994): 48.

45 Jennifer Olmsted on Sally Mann's *Wet Bed*, unpublished essay, October, 1993.

46 Ibid.

47 Susan Stewart, *On Longing: Narratives of the Miniature, the Gigantic, the Souvenir, the Collection* (Durham, NC: Duke University Press, 1993), 151.

48 Stanley Hall, *Study of Dolls*, quoted in ibid., 112.

49 Dodier, catalogue raisonné, photograph D367.

50 Christian Metz, "Photography and Fetish," *October* 34 (fall 1985): 87.

51 Kaja Silverman, *The Acoustic Mirror: The Female Voice in Psychoanalysis and Cinema* (Bloomington: Indiana University Press, 1988), 48.

52 D. W. Winnicott, "Transitional Objects and Transitional Phenomena" in *Playing and Reality* (London: Routledge, 1989), 1.

53 Ibid., 2.

54 Winnicott, "The Place Where We Live," in *Playing and Reality* (London: Routledge, 1989), 109.

55 My addiction to family objects is elaborated on in chapter 4.

56 D. W. Winnicott, *Talking to Parents*, introduction by T. Berry Brazelton, ed. Clare Winnicott, Christopher Bollas, Madeleine Davis, Ray Shepherd (Reading, MA: Addison-Wesley, 1993), 72.

57 Rossetti, "Goblin Market," 15.

58 Ibid., 12–13.

59 Ibid., 23.

CHAPTER TWO "IN WHICH THE STORY PAUSES A LITTLE"

1 Dodier has identified the box as a camera and has suggested that Lord Hawarden is writing upon it. See her entry for Hawarden's photograph D303 in the catalogue raisonné. The camera "appears to be a Horne & Thornethwaite folding model, with lens and plate-holder removed" (Dodier, writing about the same camera in a nearly identical photograph, D304).

2 Barthes, *Camera Lucida*, 31.

3 David Knowles, *The Secrets of the Camera Obscura* (San Francisco: Chronicle Books, 1994), 88, 91.

4 Knowles, *The Secrets of the Camera Obscura,* 13.

5 Ibid.

6 Ibid.

7 Ibid.

8 See Linda Nochlin, *Realism* (London: Penguin Books, 1971), and "Courbet's *Real Allegory*" in *Courbet Reconsidered,* ed. Sarah Faunce and Linda Nochlin (Brooklyn: Brooklyn Museum, 1988), 17–41.

9 Arthur K. Wheelock Jr., *Vermeer and the Art of Painting* (New Haven: Yale University Press, 1995), 164. In this quote, Wheelock is stressing that Vermeer was in tune with the Dutch theorists of his day, including the writings of Samuel van Hoogstraten (whose "perspective box" will soon become significant in this chapter). Allow me to quote Wheelock in full: "Vermeer's approach to the depiction of reality was surprisingly consistent with ideas expressed by writers in contemporary Dutch art theory, particularly Cornelis de Bie and Samuel van Hoogstraten. Both writers stressed the importance of creating paintings that mirror nature so faithfully that they deceive the eye into believing that they are real" (164).

10 Daniel Arasse, *Vermeer: Faith in Painting,* trans. Terry Grabar (Princeton: Princeton University Press, 1994), 22; originally published as *L'Ambition de Vermeer* (Paris: Société nouvelle Adam Biro, 1993). For the reasons surrounding the uncertainty of the exact number of paintings attributed to Vermeer, see 125.

11 Knowles, *Secrets of the Camera Obscura,* 14.

12 George Eliot, *Adam Bede,* ed. and introduction by Stephen Gill (London: Penguin Books, 1980), 223. Hereafter, citations to this edition appear in parentheses in the text.

13 Stephen Gill, on page 598 of his notes to the Penguin English Library edition of *Adam Bede,* provides the following definition of calenture, taken from the *Shorter Oxford English Dictionary*: "A disease incident to sailors within the tropics, characterized by delirium in which, it is said, they fancy the sea to be green fields and desire to leap into it."

14 I am indebted to Edward Snow's *A Study of Vermeer* (Berkeley: University of California Press, 1994), 12 and 63, for much of this description of *Woman Pouring Milk.*

15 Martha Hollander, "The Divided Household of Nicolaes Maes," *Word & Image* 10, no. 2 (April–June 1994): 138.

16 Ibid.

17 Barthes, *Camera Lucida,* 15.

18 Ibid.

19 Not that Lord Hawarden was not supportive of Lady Hawarden's photography; it seems that he was. But as Barthes has registered in his own love of textual folds, abrasions, edges, holes, gaps: "Difference is not what makes or sweetens conflict: it is achieved over and above conflict, it is *beyond and alongside* conflict" (*The Pleasure of the Text*, 15). In other words, the picture may be articulating the differences between Clementina Hawarden and her husband, between the sexes, between inside and outside, between maternal and paternal, without being *simply* reduced to conflict.

20 Celeste Brusati, *Artifice and Illusion: The Art and Writings of Samuel Van Hoogstraten* (Chicago: University of Chicago Press, 1995), xxvi. Subsequent references appear in parentheses in the text.

21 For an explanation of how the London box was constructed, see David Bomford, "Perspective and Peepshow Construction," *National Gallery Technical Bulletin* 11 (1987): 65–76, cited in Brusati, *Artifice and Illusion*, 191–93 and 309 n. 34.

22 As Brusati notes, Van Hoogstraten used a "novel application of the principles of anamorphic projection traditionally used by painters of ceilings and wall frescoes to depict continuous images on curved and nonplanar surfaces. Unlike orthodox perspective constructions, anamorphoses appear distorted unless they are viewed from the point from which they have been projected . . . [When viewed from the intended perspective point], these projections can produce remarkable illusions in which the viewer is powerless to distinguish the painted surfaces from the perceived images" (*Artifice and Illusion*, 190).

23 Jonathan Crary, *Techniques of the Observer: On Vision and Modernity in the Nineteenth Century* (Cambridge, MA: MIT Press, 1991), 133.

CHAPTER THREE SAPPHIC NARCISSA

1 Joan DeJean, *Fictions of Sappho, 1547–1937* (Chicago: University of Chicago Press, 1989), 203.

2 Della Pollock helped me to understand the photographic process itself as narcissistic.

3 Sigmund Freud, "Leonardo da Vinci and a Memory of His Childhood" (1910), in *The Standard Edition*, 11: 100.

4 Peter Gay in *The Freud Reader* (New York: Norton, 1989), writes: "There were other, hidden, aspects to Freud's preoccupation with Leonardo: his study of the artist, whose homosexual inclinations he considered as proved,

came at a time when he was analyzing the residues of his own feelings for his former intimate friend Wilhelm Fliess" (444).

5 Sigmund Freud, "On Narcissism: An Introduction," in *The Standard Edition*, 14: 88–89.

6 Teresa de Lauretis, *The Practice of Love: Lesbian Sexuality and Perverse Desire* (Bloomington: Indiana University Press, 1994), xiii.

7 My queer vision is highly influenced by the work of Eve Kosofsky Sedgwick, Michael Moon, José Esteban Muñoz, Jonathan Flatley, and Jennifer Doyle.

8 Owens, "Photography *en abyme*," 75 n. 1.

9 Ibid., 75.

10 Ibid.

11 Barthes, *Camera Lucida*, 5–6.

12 "By 1856, two years after its founding, the London Stereoscopic Company alone had sold over half a million viewers" (Crary, *Techniques of the Observer*, 118 n. 32).

13 Diane Arbus, quoted in Sontag, *On Photography*, 12–13.

14 Crary, *Techniques of the Observer*, 119.

15 Ibid.

16 Ibid.

17 Ibid., 125–28.

18 Sontag, *On Photography*, 35.

19 Abigail Solomon-Godeau, "The Legs of the Countess," *October* 39 (winter 1986): 95.

20 Some stereos made the metaphor of the keyhole concrete by literally incorporating it in the photographic scene. For example, see the stereo of what looks to be a maid peeking through a keyhole at her mistress copulating with a lover taken by F. Jacques Moulin(?) ca. 1860 and reprinted in Serge Nazarieff, *The Stereoscopic Nude, 1850–1930*, (Köln, Germany: Benedikt Taschen, 1993), 106.

21 Crary writes, "It is no coincidence that the stereoscope became increasingly synonymous with erotic and pornographic imagery in the course of the nineteenth century. The very effects of tangibility . . . were quickly turned into a mass form of ocular possession. Some have speculated that the very close association of the stereoscope with pornography was in part responsible for its social demise as a mode of visual consumption. Around the turn of the century sales of the device supposedly dwindled because it became linked with 'indecent' subject matter" (*Techniques of the Observer*, 127). Of course, there were all kinds of stereo pictures, with only a select group that

could be claimed as pornography. Travel pictures were very popular, along with domestic scenes, street scenes, portraits, and more.

22 Eve Kosofsky Sedgwick, "Queer Now," in *Tendencies* (Durham, NC: Duke University Press, 1993), 9.

23 The dating is Eunice Lipton's in *Looking into Degas: Uneasy Images of Women and Modern Life* (Berkeley: University of California Press, 1986); she writes: "My dating of the photograph is based on a comment made by W. M. Rossetti [Dante Gabriel and Christina Rossetti's brother] in 1876 in response to seeing some works by Degas at the Deschamps Gallery, London. He wrote: 'Degas sends several pictures of ballet-rehearsals, as well as a number of photographs somewhat less exclusively devoted to the backstairs of Terpsichore. The pictures are surprisingly clever pieces of effect, of odd turns of arrangement, and often of character, too pertinaciously divested of grace'" (208, n. 23). The Degas images appear in an article by Douglas Crimp, "Positive/Negative: A Note on Degas's Photographs," *October* 5 (summer 1978): 89–100.

24 As Lipton has remarked, "Degas essentially was titillating his bourgeois audience by showing it a world to which its members did not have access but which they yearned to possess" (*Looking into Degas*, 99).

25 Jacques, article on the third "Exposition des Impressionistes," as cited by Paul-André Lemoisne, *Degas et son oeuvre* (Paris: P. Brame et C. M. de Hauke, 1946), 1: 242. Quoted in ibid., 97.

26 Degas's work is, of course, as different from Hawarden's as it is alike: his work was made at least a decade later and in France; his work is much more emphatically heterosexual—the ballerinas have male teachers and lovers in tailcoats and top hats; his work depicts the natural, often homely and unflattering aspects of ballet life; Hawarden stages images of overriding beauty and control. Degas's work is steeped in the traditions of modernist painting; Hawarden's is photographic and personal.

27 Lipton, *Looking into Degas*, 97.

28 I thank Della Pollock for reminding me of ballet's narcissistic relation to the mirror.

29 Of course, Hawarden's daughters had the privilege of class.

30 Solomon-Godeau, "The Legs of the Countess," 292.

31 Ibid., 293.

32 Lipton has problematized the reality of the ballet dancer's income; see *Looking into Degas*, 88–93.

33 Alain Corbin, *The Foul and the Fragrant: Odor and the French Social Imagination*, trans. Miriam L. Kochan, Roy Porter, Christopher Prendergast

(Cambridge: Harvard University Press, 1986), 179; originally published as *La miasme et la jonquille*, (Paris: Éditions aubier Montaigne, 1982).

34 Griselda Pollock, *Avant-Garde Gambits, 1888–1893: Gender and the Color of Art History* (London: Thames and Hudson, 1992), 47.

35 J. B., "Abuse of Photography," *The Photographic News*, 11 August 1865, 382. Virginia Dodier cites a portion of the article in her catalogue raisonné.

36 J. B., "Abuse of Photography," 382.

37 Barthes, *Camera Lucida*, 59. Barthes uses such language to distinguish the erotic photograph from the pornographic. For Barthes, the pornographic displays the sexual organs as "motionless objects . . . flattered like an idol that does not leave its niche." The pornographic may amuse, but, for Barthes, it leads quickly to boredom. In contrast, the erotic pierces at Barthes's body with his famous *punctum* and produces what he calls "good desire." In sum, for Barthes, pornography is *what he does not like* and eroticism is *what he likes*—and he all but says so in *Camera Lucida*.

38 Sigmund Freud, "The Psycho-Analytic View of Psychogenic Disturbance of Vision" (1910), in *The Standard Edition*, 11: 217, cited by Apter in "Hysterical Vision, The Scopophilic Garden from Monet to Mirbeau," *Feminizing the Fetish*, 174.

39 Apter, "Hysterical Vision," 147.

40 Ibid.

41 Readers familiar with Jacques Lacan's work on the gaze will see a parallel between my reading of the strange flying skeleton key in Hawarden's photograph of Isabella and Lacan's reading of the anamorphic skull in Holbein's *The French Ambassadors*. For more on Lacan, gender, seeing, and blind spots, see my *"Odor di femina:* Though You May Not See Her, You Can Certainly Smell Her," *Cultural Studies* 12, no. 1 (January 1998), 51–81.

42 Page duBois, *Sappho Is Burning* (Chicago: University of Chicago Press, 1995). See especially her chapter 2, "The Aesthetics of the Fragment," 31–54.

43 duBois gives other examples in "which fragments figure in ancient culture," such as the ancient Dionysiac ritual . . . [of] dismemberment and devouring of animals in Bacchic celebration," and "Sophocles' heroine Antigone [who] is haunted by the figure of her brother's broken and unburied body" (ibid., 57). See her chapter 3, "Sappho's Body in Pieces," 55–76, for further examples.

44 Ibid.; see her chapter 3.

45 Found in ibid., 40.

46 Ibid., 41.

47 Ibid., 52.

48 Sappho, fragment 105c, which is brilliantly analyzed by duBois in ibid.; see her chapter 2.

49 Sappho, from poem 31, quoted and brilliantly analyzed by duBois in ibid.; see her chapter 3. DuBois is using Willis Branstone, trans., *Sappho and the Greek Lyric Poets* (New York: Schocken Books, 1988), fragment 31. This is one of Sappho's most famous poems, and its (and other) controversial translations are detailed by DeJean in *Fictions of Sappho*, see esp. appendix, "Sappho, Fragments 1 and 31: Translations and Presentation," 317–25.

CHAPTER FOUR COLLECTING LOSS

This chapter is a revision of an essay that first appeared in *Cultural Studies* 11, no. 1 (1997).

1 Sigmund Freud, Minutes from the Vienna Psychoanalytic Society, 1909, published as "Freud and Fetishism: Previously Unpublished Minutes of the Vienna Psychoanalytic Society," ed. and trans. Louis Rose, *Psychoanalytic Quarterly* 57 (1988): 159, cited by Apter, "Splitting Hairs," in *Feminizing the Fetish*, 102.

2 Christian Boltanski, cited by Lynn Gumpert, *Christian Boltanski* (Paris: Flammarion, 1994), 110.

3 Christina Rossetti, "Goblin Market," in *The Complete Poems*, 14.

4 Apter, "Splitting Hairs," 102.

5 Susan Stewart writes, "The term *à-bric-à-brac*, which we might translate as 'by hook or crook,' implies the process of acquisition and exchange, which is the (false) labor of the collector" (*On Longing*, 159).

6 James Clifford, "On Ethnographic Allegory," *Writing and Culture: The Poetics and Politics of Ethnography*, ed. J. Clifford and G. Marcus (Berkeley: University of California Press, 1986), 106.

7 Ibid., 121. Here, because Clifford is writing about ethnographic allegories/stories, I am twisting his intended meaning a bit. Clifford's exact words are, "If we are condemned to tell stories we cannot control, may we not, at least, tell stories we believe to be true."

8 Barthes, *Camera Lucida*, 63. Hereafter, citations to this edition appear in parentheses in the text.

9 Peter Wollen, "Fire and Ice," *Photographies* 4 (1984), quoted in Metz, "Photography and Fetish," 84.

10 Roland Barthes, *Roland Barthes by Roland Barthes*, trans. Richard Howard (New York: Farrar, Straus & Giroux, 1981), 61.

11 Milan Kundera in "After Word: A Talk with the Author by Philip Roth," in *The Book of Laughter and Forgetting,* trans. Michael Henry Heim (New York: Viking Penguin, 1981), 234–235, quoted in Lynn Gumpert, "The Life and Death of Christian Boltanski," in *Christian Boltanski: Lessons of Darkness,* exhibition catalogue (Museum of Contemporary Art, Chicago, Museum of Contemporary Art, Los Angeles, and New Museum of Contemporary Art, New York), 64.

12 Sontag, *On Photography,* 149.

13 elin o'Hara slavick, artist's statement, in *Embodiment,* catalogue prepared in conjunction with the *Embodiment* exhibition, organized by Angela Kelly, Randolph Street Gallery, Chicago, 22 November–28 December 1991, 13.

14 Angela Kelly, introduction to ibid., 6.

15 Reynolds Price, "For the Family," in *Immediate Family,* by Sally Mann (New York: Aperture, 1992), unpaginated.

16 Ibid.

17 Marianne Hirsch, "Masking the Subject: Practicing Theory," in *The Point of Theory,* ed. by Mieke Bal and Inge E. Boer (New York: Continuum, 1994), 122.

18 Ibid., 109.

19 Russell Ferguson et al., eds., *Out There: Marginalization and Contemporary Cultures* (New York and Cambridge, MA: New Museum of Contemporary Art and MIT Press, 1990).

20 For an analysis of his own family photographs, see Simon Watney, "Ordinary Boys," in *Family Snaps,* ed. Jo Spence (London: Virago Press, 1991), 26–34.

21 Barthes *Camera Lucida,* 71.

22 Nadar, "My Life as Photographer," trans. Thomas Repensek, *October 5* (summer 1978), addresses this in his discussion of Balzac and the Daguerreotype: "According to Balzac's theory, all physical bodies are made up entirely of ghostlike images, an infinite number of leaflike skins laid one on top of the other. Since Balzac believed man was incapable of making something material from an apparition, from something impalpable — that is, creating something from nothing — he concluded that every time someone had his photograph taken, one of the spectral layers was removed from the body and transferred to the photograph. Repeated exposures entailed the unavoidable loss of subsequent ghostly layers, that is, the very essence of life" (9).

23 Gumpert, "The Life and Death of Christian Boltanski," 51.

24 Barthes uses this phrase to describe the voice of Proust in "Odors," in *Roland Barthes by Roland Barthes,* 135.

25 Barthes, *The Pleasure of the Text*, 8.

26 Harm Lux, "Roads of Access to Francesca Woodman's Work," in *Francesca Woodman* (New York: Distributed Art Publishers, 1992), 16.

27 Abigail Solomon-Godeau, "Just Like a Woman," in *Photography at the Dock: Essays on Photographic History, Institutions, and Practices* (Minneapolis: University of Minnesota, 1991), has also seen Gilman's *The Yellow Wallpaper* in Woodman's house pictures. Solomon-Godeau writes: "In these photographs the woman's body is physically devoured by the house. As in . . . *The Yellow Wallpaper,* the space of women's seclusion and worldly exclusion not only imprisons, it also consumes. Swallowed by the fireplace, layered over by the wallpaper, effaced, occulted, Woodman presents herself as the living sacrifice to the domus" (252).

28 This volume, p. 53.

29 Rosalind Krauss, *The Optical Unconscious* (Cambridge, MA: MIT Press, 1993), 183. Krauss is paraphrasing the writing of Roger Caillois, whose work was closely associated with the Surrealists and championed by Jacques Lacan in his concept of the gaze. This is the second time that I have made a reference to Surrealism through the work of Woodman. Woodman herself was devoted to Surrealism. Spending her third year of art school in Rome, she "became involved with the activities of an avant-garde Surrealist book shop, the Libreria Maldoror. Her only one person exhibition outside a school gallery was held in this bookshop" (Ann Gabhart, "Francesca Woodman 1958–1981," in *Francesca Woodman: Photographic Work* [Wellesley, MA and New York:Wellesley College Museum and Hunter College Art Gallery, 1986], 55). Also of note is the fact that she told an Italian critic that she wanted "to be able to establish a similar relationship between words and her images as those achieved in Breton's book, *Nadja*" (cited in ibid., 55, translated from Robert Valtorta, "Francesca Woodman," *Progresso Fotografico* 86, no. 10 [October 1979]: 46). Margaret Sundell makes an even more specific use of Caillois and Lacan to read Woodman's prints in "Vanishing Points: The Photography of Francesca Woodman," in *Inside the Visible: An Elliptical Traverse of 20th Century Art in, of, and from the Feminine*, ed. M. Catherine de Zegher (Cambridge, MA: MIT Press, 1996), 435–39. For more on Woodman's attachment to Surrealism, see Susan Rubin Suleiman, "Some Contemporary Women Artists and the Historical Avant-Garde," in *Mirror Images: Women, Surrealism and Self-Representation*, ed. Whitney Chadwick (Cambridge, MA: MIT Press, 1998), 128–54.

30 These are Susan Sontag's words describing the photographs not of Wood-

man but of Bellocq in her introduction to *Bellocq: Photographs from Story-ville, The Red-Light District of New Orleans* (New York: Random House, 1996), 8.

31 Francesca Woodman, *Some Disordered Interior Geometries* (Philadelphia: Synapse Press, 1981).

32 Dodier, catalogue raisonné, photograph D616.

33 Ibid.

POSTSCRIPT

1 The identification of the apron as (possibly) a darkroom apron is Dodier's; see her catalogue raisonné, photograph D404.

WORKS CITED

Apter, Emily. *Feminizing the Fetish*. Ithaca, NY: Cornell University Press, 1991.

Arasse, Daniel. *Vermeer: Faith in Painting*. Translated by Terry Grabar. Princeton: Princeton University Press, 1994. Originally published as *L'ambition de Vermeer* (Paris: Société nouvelle Adam Biro, 1993).

Baer, Ulrich. "Photography and Hysteria: Toward a Poetics of the Flash." *Yale Journal of Criticism* 7, no. 1 (spring 1994): 41–77.

Barthes, Roland. *Camera Lucida: Reflections on Photography*. Translated by Richard Howard. New York: Farrar, Straus & Giroux, 1975. Originally published as *La chambre clair* (Paris: Editions du Seuil, 1980).

———. *A Lover's Discourse: Fragments*. Translated by Richard Howard. New York: Farrar, Straus & Giroux, 1978. Originally published as *Fragments d'un discours amoureux* (Paris: Editions du Seuil, 1977).

———. *The Pleasure of the Text*. Translated by Richard Miller with a note on the text by Richard Howard. New York: Farrar, Straus & Giroux, 1975. Originally published as *Le Plaisir du texte* (Paris: Editions du Seuil, 1973).

———. *Roland Barthes by Roland Barthes*. Translated by Richard Howard. New York: Farrar, Straus & Giroux, 1981. Originally published as *Roland Barthes par Roland Barthes* (Paris: Editions du Seuil, 1977).

———. *Sollers écrivain*. Translated by Philip Thody. Minneapolis: University of Minnesota Press. Originally published as *Sollers écrivain* (Paris: Editions du Seuil, 1979).

Baudelaire, Charles. *The Painter of Modern Life and Other Essays*. Translated by Jonathan Mayne. New York: Da Capo Press, 1964.

Bell, Julian. "Decency and Delusion." *Times Literary Supplement* (19 March 1993): 7–8.

Bomford, David. "Perspective and Peepshow Construction." *National Gallery Technical Bulletin* 11 (1987): 65–76.

Briehl, Marie H. "Helene Deutsch: The Maturation of Woman." In *Psychoanalytic Pioneers*, edited by Frantz Alexander, Samuel Eisenstein, and Martin Grotjahn. New York: Basic Books, 1966.

Brusati, Celeste. *Artifice and Illusion: The Art and Writings of Samuel Von Hoogstraten*. Chicago: University of Chicago Press, 1995.

Camhi, Leslie. "Stealing Femininity: Department Store Kleptomania as Sexual Disorder." *differences: A Journal of Feminist Cultural Studies* 5, no. 1 (1993): 26–50.

Carroll, Lewis [C. L. Dodgson]. *Alice's Adventures Underground*. Facsimile of the author's book with a new introduction by Martin Gardner. New York: Dover Publications, 1965.

———. *Alice's Adventures in Wonderland*. In *The Annotated Alice*, introduction and notes by Martin Gardner. New York: Meridian, 1960.

Cixous, Hélène. "Introduction to Lewis Carroll's *Through the Looking-Glass* and *The Hunting of the Snark.*" *New Literary History* 13, no. 2 (winter 1982): 231–51.

Clark, T. J. "Lewis Carroll's Photographs of Children, with Commentary by Mindy Aloff, T. J. Clark, Ann Hulbert, Janet Malcolm, Lisa Mann, Adam Phillips, and Christopher Ricks." *Three-Penny Review* 64 (winter 1996): 29.

Clifford, James. "On Ethnographic Allegory." In *Writing and Culture: The Poetics and Politics of Ethnography*, edited by J. Clifford and G. Marcus. Berkeley: University of California Press, 1986.

Copjec, Joan. "The Sartorial Superego." *October* 50 (fall 1989): 56–95.

Corbin, Alain. *The Foul and the Fragrant: Odor and the French Social Imagination*. Translated by Miriam L. Kochan, Roy Porter, and Christopher Prendergast. Cambridge, MA.: Harvard University Press, 1986. Originally published as *La miasme et la jonquille* (Paris: Editions aubier Montaigne, 1982).

Crary, Jonathan. *Techniques of the Observer: On Vision and Modernity in the Nineteenth Century*. Cambridge, MA: MIT Press, 1991.

Crimp, Douglas. "Positive/Negative: A Note on Degas's Photographs." *October* 5 (summer 1978): 89–100.

Culler, Jonathan. *Roland Barthes*. New York: Oxford University Press, 1983.

DeJean, Joan. *Fictions of Sappho, 1547–1937*. Chicago: University of Chicago, 1989.

de Lauretis, Teresa. *The Practice of Love: Lesbian Sexuality and Perverse Desire*. Bloomington: Indiana University Press, 1994.

Deutsch, Helene. *Confrontations with Myself: An Epilogue*. New York: Norton, 1973.

Dickinson, Emily. *The Complete Poems of Emily Dickinson*, edited by Thomas H. Johnson. Boston: Little Brown, 1960.

Dill, Lesley. Artist's statement, collected by Nina Fershin for "Women's Work: A Lineage." *Art Journal* 54, no. 1 (spring 1995):84–85.

Dodgson, C. L. [Lewis Carroll]. Private journal. London, British Museum, Add 54343.

Dodier, Virginia. Catalogue raisonné. London, Victoria and Albert Museum, 1988.

——. "From the Interior: Photographs by Clementina, Viscountess Hawarden." *Antiques* 139, no. 1 (January 1991): 197–207.

——. "Haden, Photography, and Salmon Fishing." *Print Quarterly* 3, no. 1 (March 1986): 34–50.

——. "An Introduction to the Life and Work of Clementina, Viscountess Hawarden (1822–1865)." Unpublished.

duBois, Page. *Sappho Is Burning.* Chicago: University of Chicago Press, 1995.

Eliot, George. *Adam Bede.* Edited and with introduction by Stephen Gill. London: Penguin Books, 1980.

Ferguson, Russell, et al., eds. *Out There: Marginalization and Contemporary Cultures.* New York and Cambridge, MA: New Museum of Contemporary Art and MIT Press, 1990.

Freud, Sigmund. *Beyond the Pleasure Principle.* Translated by James Strachey. In *The Standard Edition of the Complete Psychological Works*, vol. 18. London: Hogarth Press, 1953–74.

——. "Leonardo da Vinci and a Memory of His Childhood" (1910). Translated by James Strachey. In *The Standard Edition of the Complete Psychological Works*, vol. 11. London: Hogarth Press, 1953–74.

——. "On Narcissism: An Introduction." Translated by James Strachey. In *The Standard Edition of the Complete Psychological Works*, vol. 14. London: Hogarth Press, 1953–74.

——. "The Psycho-analytic View of Psychogenic Disturbance of Vision" (1910). Translated by James Strachey. In *The Standard Edition of the Complete Psychological Works*, vol. 11. London: Hogarth Press, 1953–74.

Gabhart, Ann. "Francesca Woodman 1958–1981." In *Francesca Woodman: Photographic Work.* Wellesley, MA and New York: Wellesley College Museum and Hunter College Art Gallery, 1986.

Gay, Peter, ed. *The Freud Reader.* New York: Norton, 1989.

Gilman, Charlotte Perkins. "The Yellow Wallpaper." In *The Charlotte Perkins Gilman Reader*, edited by Ann J. Lane. New York: Pantheon, 1980.

Grosz, Elizabeth. "Lesbian Fetishism." In *Fetishism as Cultural Discourse: Gender, Commodity, and Vision*, edited by Emily Apter and William Pietz. Ithaca, NY: Cornell University Press, 1993.

Gumpert, Lynn. *Christian Boltanski.* Paris: Flammarion, 1994.

——. "The Life and Death of Christian Boltanski." In *Christian Boltanski:*

Lessons of Darkness. Museum of Contemporary Art, Chicago, Museum of Contemporary Art, Los Angeles, and New Museum of Contemporary Art, New York, 1988.

Gunn, Kirsty. *Rain.* New York: Grove Press, 1994.

Hambourg, Maria Morris, Françoise Heilbrun, and Philipe Néagu. *Nadar.* New York: Metropolitan Museum of Art, 1995.

Hebdige, Dick. *Hiding in the Light: On Images and Things.* London: Routledge, 1988.

Hess, Elizabeth. "The Good Mother." *The Village Voice,* 17 October 1995, 78.

Hirsch, Marianne. "Masking the Subject: Practicing Theory." In *The Point of Theory,* edited by Mieke Bal and Inge F. Boer. New York: Continuum, 1994.

Hollander, Martha. "The Divided Household of Nicholas Maes." *Word and Image* 10, no. 2 (April–June 1994): 138–55.

Howard, Richard. "A Note on the Text." In *The Pleasure of the Text,* by Roland Barthes. New York: Farrar, Straus, & Giroux, 1975.

Irigaray, Luce. "Gesture in Psychoanalysis." In *Sexes and Geneologies,* translated by Gillian C. Gill. New York: Columbia University Press, 1993.

J. B. "Abuse of Photography." In *The Photographic News* (11 August 1865): 382.

Kelly, Angela. Introduction to *Embodiment.* Chicago: Randolph Street Gallery, 1991.

Kelly, Mary. *Interim.* New York: New Museum of Contemporary Art, 1990.

Kincaid, James R. *Child-Loving: the Erotic Child and Victorian Culture.* New York: Routledge, 1992.

———. "Dreaming the Past." Paper presented at "Watching or Fainting, Sleeping or Dead: Unveiling Dante Gabriel Rossetti's *Beata Beatrix*" University of North Carolina, Chapel Hill, 24 April 1993.

———. *Erotic Innocence: The Culture of Child Molesting.* Durham, NC: Duke University Press, 1998.

Knowles, David. *The Secrets of the Camera Obscura.* San Francisco: Chronicle Books, 1994.

Krauss, Rosalind. *The Optical Unconscious.* Cambridge, MA: MIT Press, 1993.

———. "Tracing Nadar." *October* 5 (summer 1978): 29–48.

Kristeva, Julia. *New Maladies of the Soul.* Translated by Ross Guberman. New York: Columbia University Press, 1995.

———. *Tales of Love.* Trans. Leon S. Roudiez. New York: Columbia University Press, 1987.

Lane, Anthony. "Goose Bumps." *The New Yorker* 17, no. 27 (16 September 1996): 97–100.

Lipton, Eunice. *Looking into Degas: Uneasy Images of Women and Modern Life*. Berkeley: University of California Press, 1986.

Litvak, Joseph. "Strange Gourmet: Taste, Waste, Proust." In *Novel Gazing: Queer Readings in Fiction*, edited by Eve Kosofsky Sedgwick. Durham, NC: Duke University Press, 1997.

Lux, Harm. "Roads of Access to Francesca Woodman's Work." In *Francesca Woodman*. New York: Distributed Art Publishers, 1992.

MacDonald, George. "The Day Boy and the Night Girl." In *Victorian Fairy Tales: The Revolt of the Fairies and the Elves*, edited by Jack Zipes. London: Methuen, 1987.

Mann, Sally. *At Twelve*. New York: Aperture, 1988.

———. *Immediate Family*. New York: Aperture, 1993.

———. *Still Time*. New York: Aperture, 1994.

Mavor, Carol. "*Odor di femina*: Though You May Not See Her, You Can Certainly Smell Her." *Cultural Studies* 12, no. 1 (January 1998), 51–81.

——— *Pleasures Taken: Performances of Sexuality and Loss in Victorian Photographs*. Durham, NC: Duke University Press, 1995.

Metz, Christian. "Photography and Fetish." *October* 34 (fall 1985): 81–90.

Miller, D. A. "Secret Subjects, Open Secrets." In *The Novel and the Police*. Berkeley: University of California Press, 1993.

Moon, Michael. "Oralia: Joseph Cornell, Hunger, Sweetness, and Women's Performances." In *A Small Boy and Others: Imitation and Initiation in American Culture from Henry James to Andy Warhol*. Durham, NC: Duke University Press, 1998.

Mulvey, Laura. "Melodrama Inside and Outside the Home." In *Visual and Other Pleasures*. Bloomington: Indiana University Press, 1989.

Nadar. "My Life as a Photographer." Translated by Thomas Repensek. *October* 5 (summer 1978): 7–28.

Nazarieff, Serge. *The Steroscopic Nude, 1850–1930*. Hohenzollernring, West Germany: Benedikt Taschen, 1993.

Nochlin, Linda. "Courbet's *Real Allegory*." In *Courbet Reconsidered*, edited by Sarah Faunce and Linda Nochlin. Brooklyn: Brooklyn Museum, 1988.

———. *Realism*. London: Penguin Books, 1971.

Olmsted, Jenifer. Unpublished essay on Sally Mann's *The Wet Bed*, October 1993.

Ovenden, Graham. *Clementina, Lady Hawarden*. London: Academy Editions; New York: St. Martin's, 1984.

Owens, Craig. "Photography *en abyme*." *October* 5 (summer 1978): 73–88.

Phelan, Peggy. *Unmarked*. London: Routledge, 1993.

Pipes, Melanie. Unpublished essay, 1994.

Pollock, Griselda. *Avant-Garde Gambits, 1888–1893: Gender and the Color of Art History*. London: Thames and Hudson, 1992.

Price, Reynolds. "For the Family." In *Immediate Family*, by Sally Mann. New York: Aperture, 1992.

Riviere, Joan. "Womanliness as a Masquerade." *International Journal of Psycho-Analysis*, 10 (1929): 303–13.

Rossetti, Christina. *The Complete Poems of Christina Rossetti*, vol. 1, edited by R. W. Crump. Baton Rouge: Louisiana State University Press, 1979.

Schor, Naomi. "Female Fetishism: The Case of George Sand." In *The Female Body in Western Culture: Contemporary Perspectives*, edited by Susan Rubin Suleiman. Cambridge, MA: Harvard University Press, 1986.

Sedgwick, Eve Kosofsky. *Epistemology of the Closet*. Berkeley: University of California Press, 1990.

———. "Jane Austen and the Masturbating Girl." In *Tendencies*. Durham, NC: Duke University Press, 1993.

———. "Paranoid Reading and Reparative Reading; or, You're So Paranoid, You Probably Think This Introduction Is About You." In *Novel Gazing: Queer Readings in Fiction*. Durham, NC: Duke University Press, 1997.

———. "Queer Now." In *Tendencies*. Durham, NC: Duke University Press, 1993.

Silverman, Kaja. *The Acoustic Mirror: the Female Voice in Psychoanalysis and Cinema*. Bloomington: Indiana University Press, 1988.

slavick, elin o'Hara. Artist's statement. In *Embodiment*. Chicago: Randolph Street Gallery, 1991.

Snow, Edward. *A Study of Vermeer*. Berkeley: University of California Press, 1994.

Solomon-Godeau, Abigail. "Just Like a Woman." In *Photography at the Dock: Essays on Photographic History, Institutions, and Practices*. Minneapolis: University of Minnesota, 1991.

———. "The Legs of the Countess." *October* 39 (winter 1986): 65–108.

Sontag, Susan. Introduction to *Bellocq: Photographs from Storyville, the Red-Light District of New Orleans*. New York: Random House, 1996.

———. *On Photography*. New York: Farrar, Straus & Giroux, 1973.

Stewart, Susan. *On Longing: Narratives of the Miniature, the Gigantic, the Souvenir, the Collection*. Durham, NC: Duke University Press, 1993.

Suleiman, Susan Rubin. "Some Contemporary Women Artists and the Histor-

ical Avant-Garde." In *Mirror Images: Women, Surrealism, and Self-Representation*, edited by Whitney Chadwick. Cambridge, MA: MIT Press, 1998.

Sundell, Margaret. "Vanishing Points: The Photography of Francesca Woodman." In *Inside the Visible: An Elliptical Traverse of 20th Century Art in, of, and from the Feminine*, edited by M. Catherine de Zegher. Cambridge, MA: MIT Press, 1996.

Watney, Simon. "Ordinary Boys." In *Family Snaps*, edited by Jo Spence. London: Virago Press, 1991.

Wheelock, Arthur K., Jr. *Vermeer and the Art of Painting*. New Haven: Yale University Press, 1995.

Winnicott, D. W. *Playing and Reality*. London: Routledge, 1989.

————. *Talking to Parents*. Introduction by T. Berry Brazelton, edited by Clare Winnicott, Christopher Bollas, Madeleine Davis, Ray Shepherd. Reading, MA.: Addison-Wesley, 1993.

————. "Transitional Objects and Transitional Phenomena, A Study of the First Not-Me Possession." *International Journal of Psycho-Analysis* vol. 34, part 2 (1953): 89–97.

Woodman, Francesca. *Francesca Woodman*. Paris: Fondation Cartier pour l'art contemporain, 1998.

————. *Some Disordered Interior Geometries*. Philadelphia: Synapse Press, 1981.

Woodward, Richard B. "The Disturbing Photographs of Sally Mann." *The New York Times Magazine*, 27 September 1992, 28–36 and 52.

Woolf, Virginia. "Lewis Carroll." In *Aspects of Alice*, edited by Robert Phillips. London: Victor Gollancz, 1972.

INDEX

Carol Mavor is Associate Professor of Art at the
University of North Carolina at Chapel Hill. She is the author of
*Pleasures Taken: Performances of Sexuality and Loss in Victorian
Photographs* (Duke University Press, 1995).

✱

LIBRARY OF CONGRESS CATALOGING-IN-PUBLICATION DATA

Mavor, Carol

Becoming : the photographs of Clementina, Viscountess
Hawarden / Carol Mavor.—1st ed.

p. cm.

Includes bibliographical references.

ISBN 0-8223-2355-9 (cloth : alk. paper).

— ISBN 0-8223-2389-3 (paper : alk. paper)

1. Photography of women. 2. Hawarden, Clementina,
Viscountess, 1822–1865—Criticism and interpretation.

I. Hawarden, Clementina, Viscountess, 1822–1865. II. Title.

TR681.W6M38 1999

770'.92—dc21 99-10105 CIP